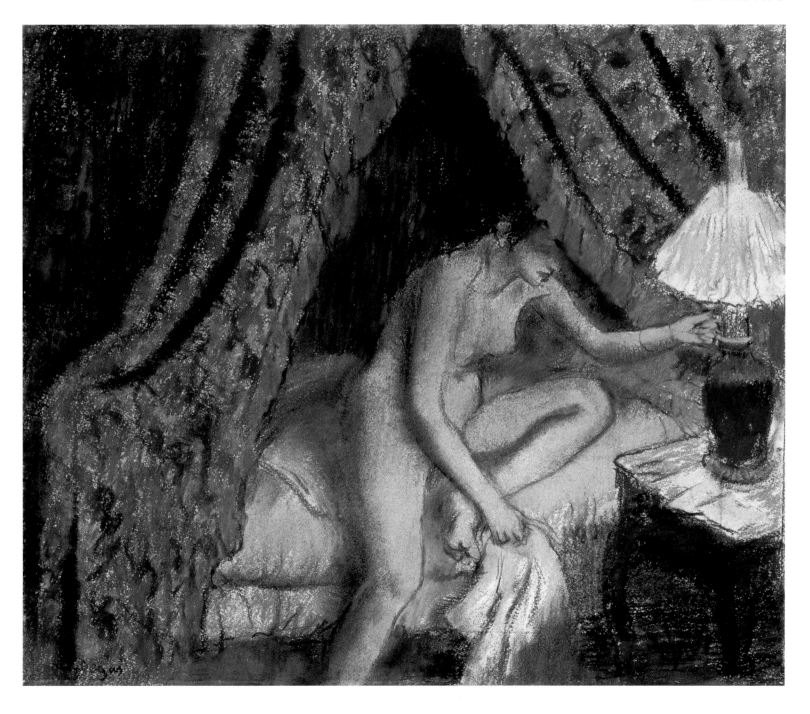

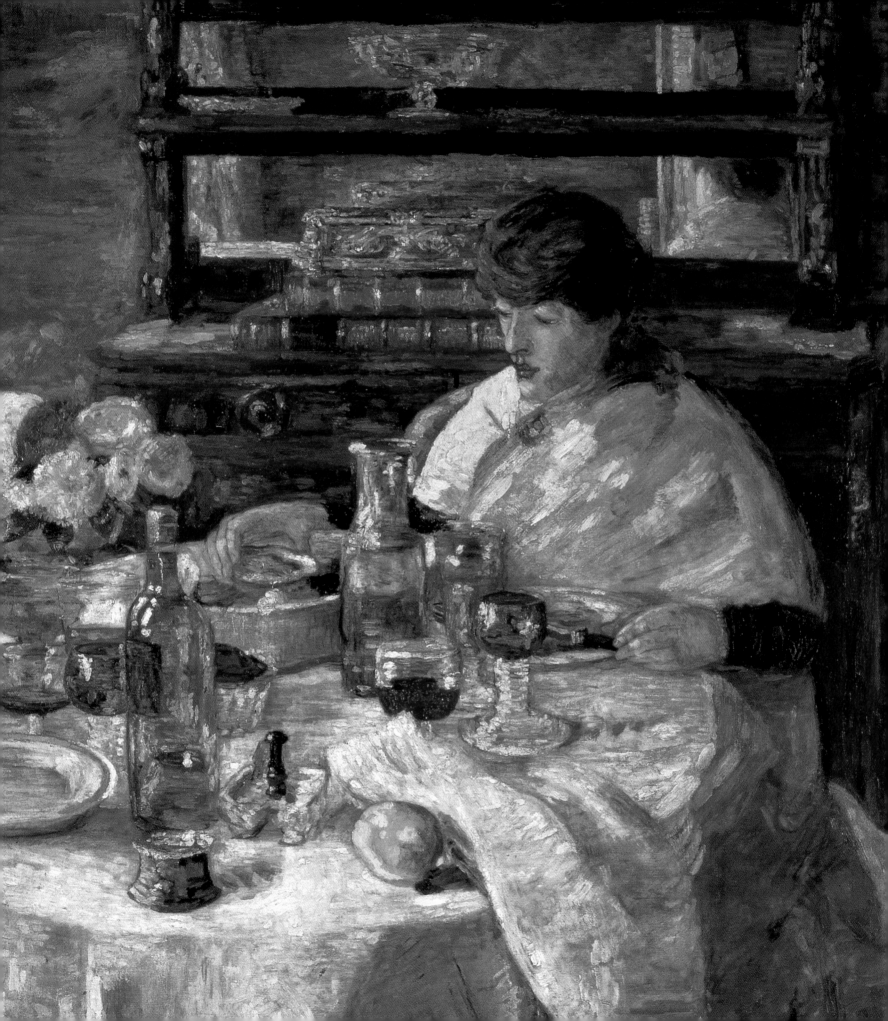

The Impressionists at Home

PAMELA TODD

with 174 illustrations, 125 in color

ACKNOWLEDGMENTS

Many people have helped me in the preparation and writing of this book. I acknowledge with thanks the facilities afforded me by the British Library, the University of London libraries, the National Gallery and the Courtauld Institute. I would like to take this opportunity specially to thank the Trustees of the London Library for their grant, and acknowledge the unfailingly courteous help and assistance of the many librarians in reference sections of London borough libraries who have rallied to my aid, as have the guides and custodians of those artists' houses and studios open to the public. I am grateful to them all. I am also grateful to the staff of Thames & Hudson; in particular I owe an important debt to my editor Christopher Dell, who has guided the book safely and expertly through the editorial process with great patience, panache and good humour. I should also like to thank Maggi Smith for an intelligent and beautiful design and Alice Gillespie for her knowledgeable help and assistance as my picture researcher. This book is a product of my own curiosity about the domestic day-to-day lives of a lively group of artists and their families. It has grown up out of conversations and speculations with many friends and I thank them all, particularly Hilary and Russell Hanslip for their hospitality in the South of France and for accompanying me around some of the sites and homes I have included here; Frances and Richard Warlters; Professor Lynda Nead and Kenneth Mahood. Finally, as ever, I thank my family, and particularly my children, Chloe, Florence and Freddie, who prompted many of the questions I've felt moved to ask about motherhood, childcare, domesticity and working mothers, and who, in their own way, provided me with answers.

First published in 2005 in hardcover in the United States of America by Thames & Hudson Inc., 500 Fifth Avenue, New York, New York 10110

thamesandhudsonusa.com

Library of Congress Catalog Card Number 2005900166

ISBN-13: 978-0-500-51239-5
ISBN-10: 0-500-51239-6

Printed and bound in Singapore by C. S. Graphics

p. 1: EDGAR DEGAS
Retiring, c. 1883

p. 2: JAMES ENSOR
The Oyster Eater (detail), c. 1908

Contents

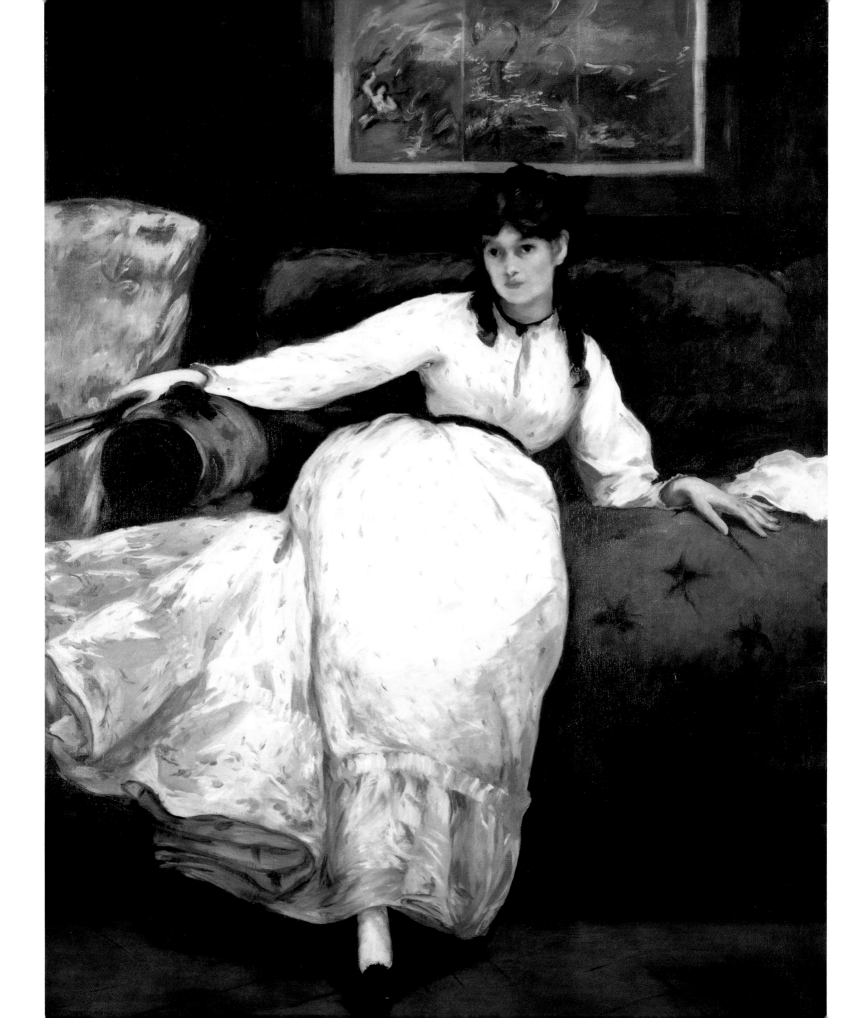

Introduction

'I believe the man who will go down to posterity is the man who paints his own time and the scenes of every-day life around him.'
– Childe Hassam, 1892

EDOUARD MANET
Repose, 1870

While the Impressionists are most often associated with out-of-doors painting, their interiors tell us a great deal about how they lived as well as the tastes of the day. The fashionably dressed woman caught here in an apparently informal pose is Berthe Morisot, but Manet is also careful to capture the fine surroundings.

The Impressionists were born into a world on the cusp of change. Their lives coincided with a period of modern marvels, a new age of leisure, travel and social mobility. They lived or studied in a Paris transformed by Baron Haussmann's bold vision into a modern, airy city, crowned by the thrusting symbol of the Eiffel Tower with its electrically powered elevators and graceful geometry. Some artists set up home in small country villages clipped by encroaching industry or invaded by throngs of Sunday trippers; others sought sun and sanctuary in the South of France. Though best known for their *plein-air* paintings of sunlit spaces and convivial Sunday afternoons beside the Seine, they often turned inward for inspiration, pressing friends, family and servants into service as models and producing striking paintings, set within their immediate surroundings, which reveal their intimate daily domestic arrangements to us better than any camera. Denis Rouart in his preface to Berthe Morisot's collected correspondence reveals how his grandmother peopled her paintings with 'her daughter, her nieces, her maid, or the daughter of the concierge or of the corner grocer – all caught in their most habitual postures', and filled them with the objects 'she used every day,' those within reach of her hands. 'The setting is that in which she lived', he wrote.

It may seem perverse to pack a book concerned with the exponents of one of the greatest outdoor artistic experiments of all time with images of interiors. Unless, of course, the focus is on how the artists lived, rather than how or where they painted. Suddenly Impressionist interiors offer an extraordinary vantage point. They can operate as windows, or doors, swinging open to provide glimpses of people and places, fashion and furniture, the simple pleasures and daily domestic pastimes of a particular group of fascinating individuals at a pivotal point of social and technological change. How and where and with whom the Impressionists lived are central questions this book poses and explores. Family and domestic life occupy the centre ground but the range is wide enough to accommodate the changing role of women, models and mistresses, new methods of birth control, fresh ideas about home decoration, music, diet, the servant question and the importance of a child's education.

The new age ushered in revolutionary new ways of heating, lighting and moving around which in turn impacted on and transformed the interior and private life. The cultural observer Walter Benjamin noted that by the end of the nineteenth century the house had assumed a new role as an 'expression of personality'. With some of the most expressive personalities of their time among their number, the Impressionists' homes amply exemplified this trend. For, as well as being important observers of social change, the Impressionists were of course active participants in the modern world, enjoying the new leisure pursuits, becoming proud owners of automobiles and telephones, installing central heating and running water in their homes, and enthusiastically embracing the wide variety of new commodities and services – from fountain pens to wireless radios, safety razors to refrigerators, sewing machines to Kodak pocket cameras, electric light bulbs to newly patented vacuum cleaners – which flooded onto the market around the turn of the century. (The exception, perhaps, was Degas, who despite championing the new art of photography, disapproved as he grew older and crankier of newfangled contraptions such as

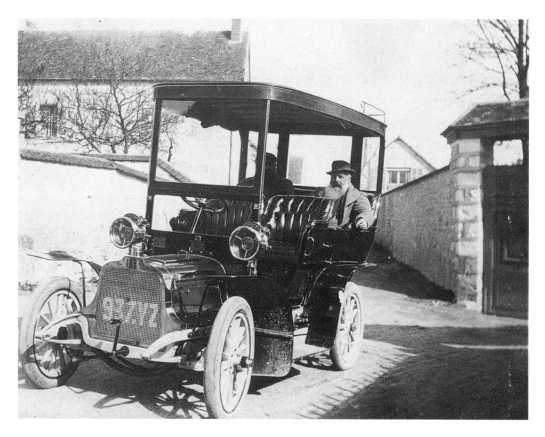

Claude Monet and his son-in-law Theodore Butler awaiting the arrival of the chauffeur, early 1900s

Monet never learned to drive himself but was an enthusiastic passenger and, at the first hint of good weather, the family would pack picnic baskets, bottles and flasks into the boot of their Panhard-Levassor and set out for a sedate jaunt through the gently undulating countryside.

aeroplanes or even bicycles and thought the telephone 'ridiculous'.) Monet, in particular, was an inveterate gadget guru who owned a state-of-the-art hand-cranked ice cream machine and adored his motor car, a swanky Panhard-Levassor, which he acquired in 1901.

Many Impressionists lived unconventional lives and thumbed their noses at the essentially mercenary character of bourgeois marriage in nineteenth-century France. In their paintings they chart the flux between public and private, male and female, master and servant, parent and child, family and individual, and show how the boundaries were shifting, blurring altogether in some cases, overlapping in others. Collectively, the ideal home was seen as a critical institution vital to the health of the nation. Individually, the desire for a personalized domestic space was driven by an increasing social mobility and aspiration, fuelled by the burgeoning consumer age the Impressionists inhabited and, when they were able, enthusiastically embraced.

Mostly of an age – Camille Pissarro, Edgar Degas, Edouard Manet, Claude Monet, Berthe Morisot, Pierre-Auguste Renoir, Frédéric Bazille, Paul Cézanne and Alfred Sisley were all born between 1830 and 1841; Mary Cassatt and Gustave Caillebotte just a few years later – they entertained one another in their homes and often travelled together, sharing expenses, experiences, insights, triumphs and despairs. Manet and Morisot came from similar *haut bourgeois* backgrounds. Their fathers were respected members of their professions and their mothers pillars of society, entertaining regularly and presiding over fashionable salons which attracted musicians, art critics, intellectuals and artists and set the example of cultural refinement expected of women of more modest means.

Renoir, the son of a tailor, lived much of his life on the edge of bourgeois respectability, cultivating and catering to middle-class patrons, yet refusing to give up his working-class habits, haunts and companions. After a long string of model-mistresses, he finally married Aline Charigot, the mother of his illegitimate son, when he was in his late forties, but he kept his family secret for years from genteel friends like Berthe Morisot.

Monet, Pissarro and Cézanne came from solid middle-class families who disapproved of their sons' artistic ambitions and irregular lifestyles and sought to control their behaviour by cutting off the oxygen of their allowances. Many of the artists – especially in the early days – suffered periods of extreme poverty and lived on a stream of credit which had a dismaying tendency to dry up. Monet bartered a painting for a pair of boots. Pissarro paid his doctor with pictures. Once, in Arles, Vincent van Gogh lived for four days on forty-three cups of coffee and stale crusts of bread, while covering canvas after canvas with glorious explosions of vivid colour. They often found themselves without money to eat, let alone paint, and were frequently hounded by creditors and indebted to the better-off members of the group – the dandyish Manet, the original nucleus of the movement, the urbane Degas, and the tall, bearded Bazille – for moral and financial support.

'Art is a business of hungry bellies, empty purses and miserable wretches', Pissarro wrote despairingly in 1878 to Eugène Murer, a pastry cook who occasionally bought his paintings; and Alfred Sisley

The Pissarro family

The Impressionists suffered mixed fortunes throughout their careers, and most came to rely heavily on their families for emotional and practical support. Pissarro, despite occasional clashes with his wife, Julie, was a dedicated father to his children.

fretted about what would be left over from the 200 francs his dealer Paul Durand-Ruel had sent him after he had given something to his butcher and his grocer. 'To one I have paid nothing for six months and to the other nothing for a year,' he wrote, adding: 'I am completely in pieces.'

Even somebody from a better off background, such as Cézanne, found it hard to make ends meet on a meagre allowance from a father who disapproved both of his son's lifestyle and his art. Ever scornful of Paul's artistic ambitions, Louis-Auguste Cézanne was fond of reminding his son that 'with money you can eat, with genius, you die.'

EDOUARD MANET
Madame Manet and Léon (The Reading), c. 1865–73

The problematic dating for this picture suggests that Manet returned to the work years later, possibly adding the figure of Léon, who would have been twenty-one in 1873. The suggestion is that the artist intended to keep up the appearance, encouraged by the Manet family, that Suzanne and Léon were sister and brother and not, as they probably were, mother and son.

The Impressionists forged deep friendships which nonetheless had their stormy moments. They fell out, they corresponded, they criticized and admired and collected each other's art. None lived ordinary lives. Monet, Cézanne, Renoir and Pissarro all had children outside marriage, though they did go on to marry the mothers of their children. Debate continues to rage over the vexed question of Manet's 'stepson', Léon Koëlla. Manet was just a teenager when he began an affair with his pretty, plump, blonde piano teacher, Suzanne Leenhoff, two years his senior. Three years into their affair, she returned from a short trip to Holland with an infant whom she presented as her younger brother, but whom she called Léon Edouard Koëlla. Was Manet Léon's father? We may never know. Some biographers have argued so, while others have suggested that Manet's own father, Auguste, fathered Suzanne's son. Manet did not

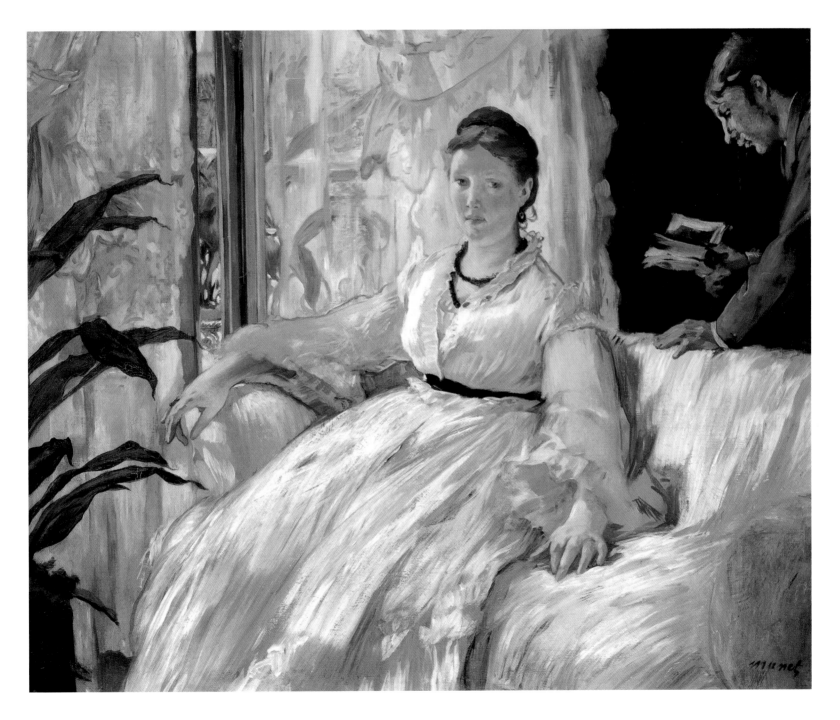

marry Suzanne until his father was dead – by which time Léon was eleven – and he never acknowledged the boy as his son in his lifetime though Léon lived with the couple and appears in many of Manet's paintings of intimate interiors – sometimes centrally, more often in the margins – and the artist made generous provision in his will for the boy, who was at his bedside when he died. Manet's mother, an important and influential society hostess, was apparently devoted to Suzanne and pleased and proud when she would consent to play the piano at her Tuesday evening salons. Whatever Léon's status, it was not discussed or challenged in the polite society in which the Manets moved.

Degas – the bachelor in the group – is often described as 'reclusive' though close friends like Gustave Geffroy, who encountered him at the centre of artistic and social events, recalled him as 'cheerful and news-hungry', and the English artist Walter Sickert spoke of his 'bear-like sense of fun' and his 'brilliant and sparkling' company. 'I want people to believe me wicked,' Degas told his niece. In fact he could be exceedingly sociable. He loved to dine out in the homes of friends and fed and entertained Renoir, Berthe Morisot, Mallarmé, the English painter William Rothenstein and others in return at his apartment in the rue Victor Massé. There Degas occupied two apartments, one above the other, at

EDGAR DEGAS
Self-Portrait with Zoé Closier, 1890

In spite of Degas's stormy relationship with his long-suffering housekeeper, Zoé Closier, she was sufficiently part of his life for him to incorporate her into this photographical self portrait. We have no record of what she made of such experiments.

number 37, an old provincial-style house, together with a long attic studio. The walls of the lower flat, where Degas slept and had a dressing room, were adorned with his beloved French masters, while upstairs, in discreetly appointed rooms furnished with faded Louis-Philippe furniture inherited from his parents and the oriental rugs he loved to collect, he kept his own works and those of his friends. His practical housekeeper, Zoé Closier, summed up the three-tier arrangement simply as 'coucher au second, manger au troisième, travailler au quatrième.'

It was a source of some regret to Degas that he had never married, though he was glad to avoid the 'marital shifts and scandals' of his peers. Yet marriage, especially for men and women of his class, like much besides in this period, was changing. Social mobility meant that it was no longer determined by economics and contract but was often founded on more elusive emotional ties. Many Impressionist painters shook off the parental stranglehold to marry for individual choice, romantic attraction and love; and some, like Monet and a number of American Impressionists, married more than once.

Gustave Caillebotte, a new recruit, wealthy and with considerable artistic talents of his own, chose to rebel against his stifling bourgeois upbringing by not marrying at all. Instead – after his mother had died

GUSTAVE CAILLEBOTTE
Billiards, c. 1875

Billiards was a popular pastime for the upper classes who installed tables in special billiard rooms which, rather like an indoor swimming pool might today, confirmed their wealth and status.

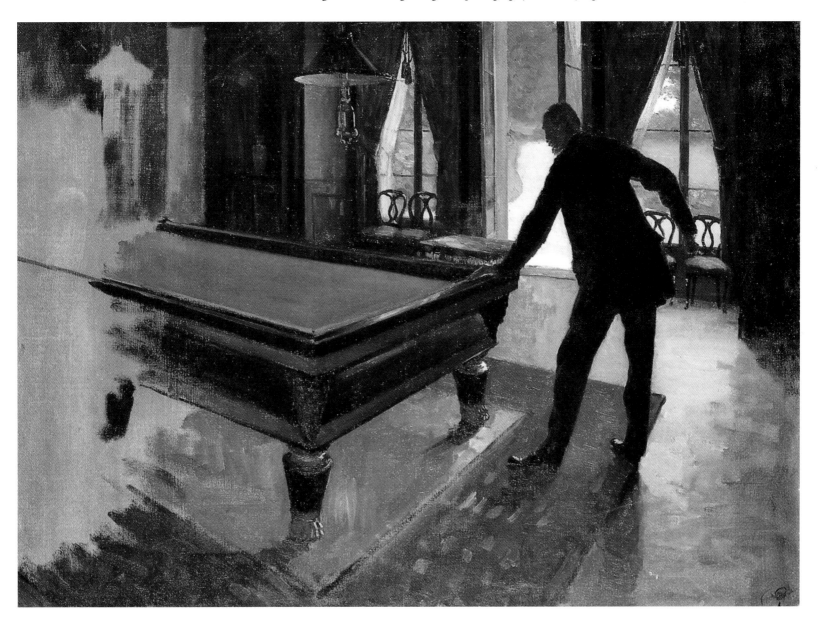

– he shared his substantial house at Petit Gennevilliers, just across the Seine from Argenteuil, with Charlotte Berthier, a woman thirteen years his junior and of a significantly lower class than he, who may have been an actress, and who already had a six-year-old daughter when they met. Caillebotte became god-father to little Jenny and made lavish provision for her and her mother in his will. His talents, generosity and organizational abilities greatly strengthened the cause of Impressionism and he was warmly welcomed. Renoir invited him to be godfather to his first child, Monet asked him to witness his marriage to Alice Hoschedé in July 1892. He became the regular recipient of baskets of plums from Giverny and shared a passion for gardening with Monet, along with a keen interest in sailing. His household boasted three servants – a cook, Marie Alexandre, her teenage daughter, Angèle, and Charlotte's maid Marie Guémeneur – together with two sailors (and a boy, Guillaume) who devoted themselves to the care and maintenance of his boats. A man of the leisure class who knew how to use his leisure, he died, tragically young, at forty-five, probably from a stroke though some obituaries speak of 'a long illness.' Pissarro attributed his death to 'brain paralysis' in a letter to his son Lucien and spoke of Caillebotte as 'one we can mourn, he was good and generous and, what makes things even worse, a painter of talent.'

Mary Cassatt, a talented artist from a wealthy Philadelphia family and one of the two important women in the group, never married but forged for herself a very full life and career in a number of homes in Paris and the French countryside and made the intimate, private spaces of the home her special study. Berthe Morisot, hailed by some contemporary critics as the 'most Impressionist' of the group, did marry – at the comparatively late age of thirty-three – Manet's younger brother Eugène, then in his early forties. She was, she explained to her brother Tiburce in a letter dated January 1875, 'facing the realities of life after living for quite a long time in chimeras that did not give me much happiness...' The suggestion that runs like a bright seam through art historical gossip and her own correspondence is that a hopeless infatuation with the married Manet was the mirage she waited on. So it came as a relief to her family when she accepted his younger brother, informing Tiburce that she had 'found an honest and excellent man who I think loves me sincerely.'

The difficulties of juggling a career and children were familiar to female artists like Berthe Morisot and the American Impressionist Mary Fairchild MacMonnies, who stood out against the tide of opinion which decreed that a well-bred women should confine her sphere of activities to organizing the household, finding and supervising servants, bearing and raising children, while socializing within a tightly proscribed circle and showing some not too threatening talent in the decorative arts. The background against which they battled to assert their right to work is encapsulated by the hostile comments of a writer of the period who stated that: 'Any woman who consents to become a mother has no moral right to engage in any employment which will unfit her for that function.'

In a period when men were expected to make their way in the public arena of business, finance or government administration, while women spent their time in the privacy of the home, many male Impressionist painters bucked the trend by choosing to spend more time than the average professional man at home. At this time there existed a cult of domesticity, which elevated wives and mothers (often at the expense of working girls, models and mistresses) and located the home as a sanctuary and refuge from a turbulent outside world. In their imaging of the intimate life of the family, Impressionist painters made the home stand for both the individual experience and a microcosm of society. Their paintings of interiors operate as a lamp to illuminate the age.

Some Impressionist households, like Monet's at Giverny, were, despite their unconventionality, run along extraordinarily conventional lines. Making and maintaining a middle-class home required work, and the work was primarily that of women. Some of the drudgery of housework had been eliminated by servants and, eventually, by labour-saving devices such as washing machines, but there were plenty of other demands on a woman's time. The role of Monet's second wife, Alice Hoschedé, extended beyond wife and mother to housekeeper, doctor, educator, social secretary, counsellor and travel companion. She planned the menus, juggled the family budget and, along with her husband, had views on the decor and the layout of the garden.

GUSTAVE CAILLEBOTTE
Young Man at his Window, 1875

The Impressionists moved frequently between the city and the countryside. Here, Caillebotte's younger brother René (who died later the same year at the age of twenty-six) stands at a window in the family apartment at 77 rue de Miromesnil which overlooked Haussmann's new residential quarter, gazing out upon the starkly empty street below.

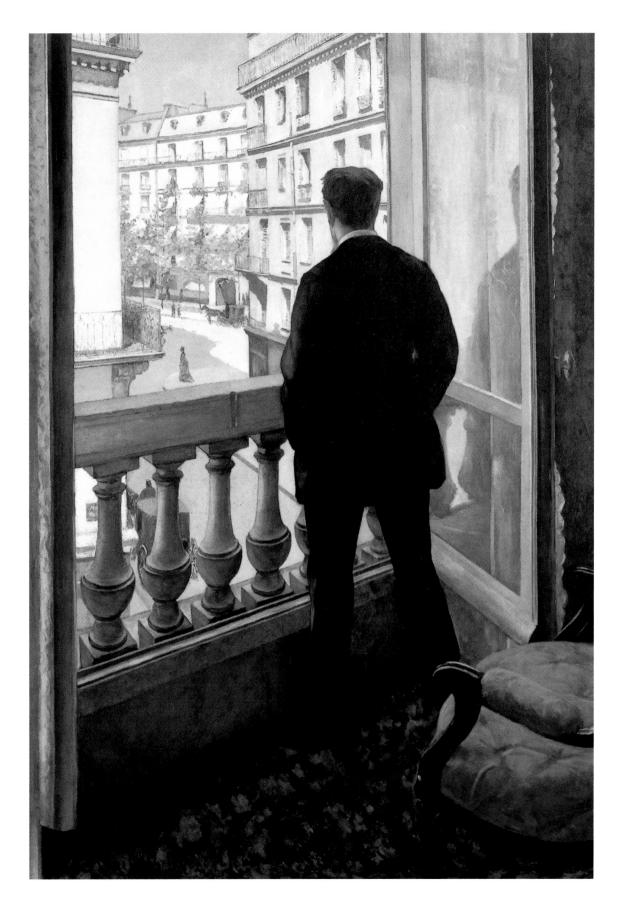

The period covered by Impressionism saw a new social mobility. Women were just beginning to move a little more freely in society, sparking the debate about whether such freedoms would lead to a neglect in their domestic duties. How the Impressionists, and particularly the women, utilized these freedoms in their lives and imaged them in their art are explored, along with ideas about leisure and repose, etiquette and entertaining, the changing notions and prevailing ideas about behaviour, manners, childcare and decoration. Constant shifts in fashion absorbed a great deal of female leisure time. The dress code of the day – corsets, tiny bonnets, French heels – prevented women from engaging in any vigorous work, just as the patent leather shoes, spats and cylindrical top hats worn by the middle-class men Degas depicts in some of his paintings conspired against the idea of them engaging in manual work. Clothes were another badge of class. You were what you wore and Paris was the fashion capital of the world.

American Impressionists like Childe Hassam and William Merritt Chase reveal a keen eye for women's fashions in their paintings while Degas offers a startling new interpretation of the ambiguous realm of desire in his depictions of milliners' shops. Chase and Hassam were part of an immensely gregarious crowd of American artists who were drawn to Paris and its art schools and from there went on to form colonies in Brittany (at Concarneau and Pont-Aven, where Gauguin had found inspiration), and, even more decisively for the cause of American Impressionism, in Normandy, at Giverny, where they clustered around Monet before returning to pursue their careers in New York and the coastal towns of New England. Commercial success was slow to come at first. They suffered from comparison with French painters and the conservatism of their countrymen. Important Impressionists like Theodore Robinson and John Twachtman frequently earned less than a thousand dollars a year and did not gain proper recognition until after their deaths. Within ten years, however, the *New York Telegraph* was praising them for the 'full maturity of their rich Impressionism' and artists like William Merritt Chase, Willard Metcalf and J. Alden Weir, who had stayed true to Impressionism, found the 'fat years' had at last arrived.

The different chapters of this book will take us into the various areas of all their lives, affording a unique opportunity to observe the French Impressionists, and their American and other European counterparts, at work and play, and to engage with them through the prism of their paintings. In their scenes from everyday life we will trace the outlines of their own lives and explore their attitude to some of the pressing issues of the day: for Degas's pictures of young women ironing, Cassatt's many paintings of women taking tea and making conversation, Pissarro's country maid washing crockery in a bowl balanced on a table outside a kitchen door, Chase's images of his children let loose in his studio, Renoir's nursing mothers and Bonnard's bathers all have much to tell us much about their responses to intimacy, class, social position, changing habits and customs and family life.

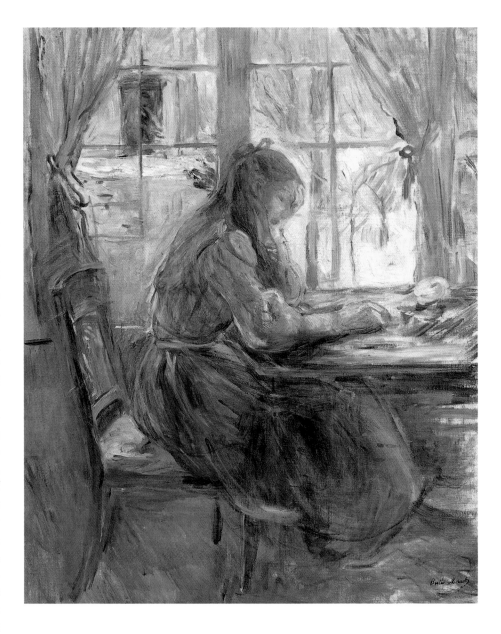

BERTHE MORISOT
Young Girl Writing, 1891

Berthe Morisot's daughter Julie was one of her favourite models and an enthusiastic diarist whose reminiscences were published under the title *Growing Up with the Impressionists*.

CHILDE HASSAM
The Room of Flowers, 1894

Hassam's famous painting captures perfectly the taste of an American *bourgeoise* (in this case the poetess Celia Thaxter) at the end of the nineteenth century - flowers, books, paintings, a rocking chair and even Beethoven's death-mask above the sideboard, create an image of a leisured, cultural life.

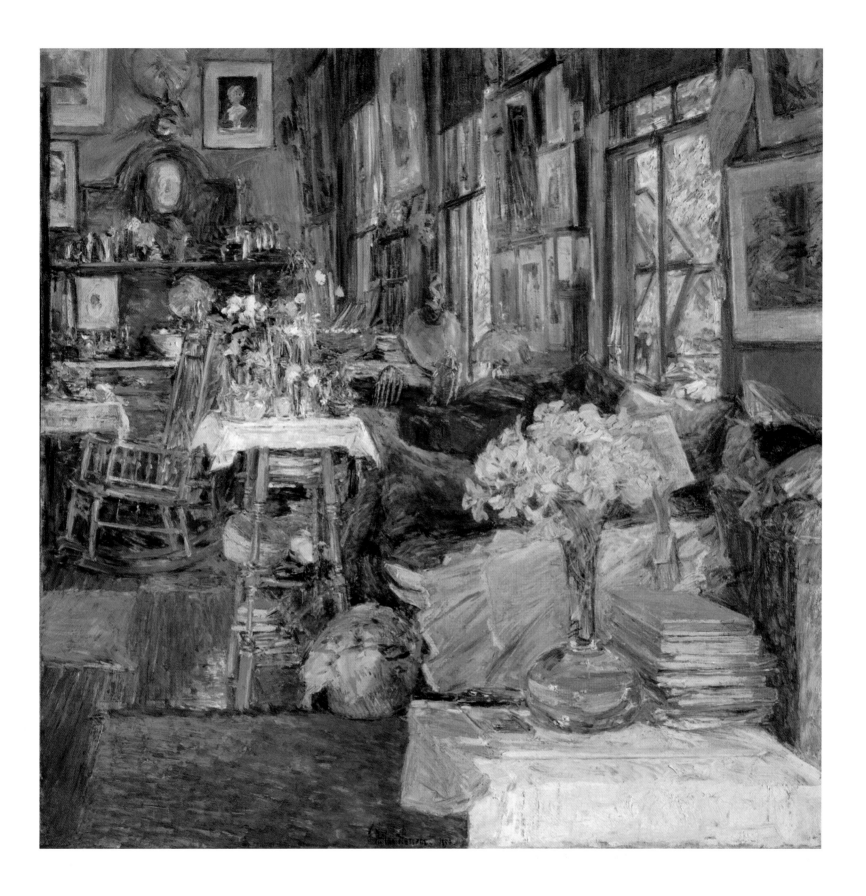

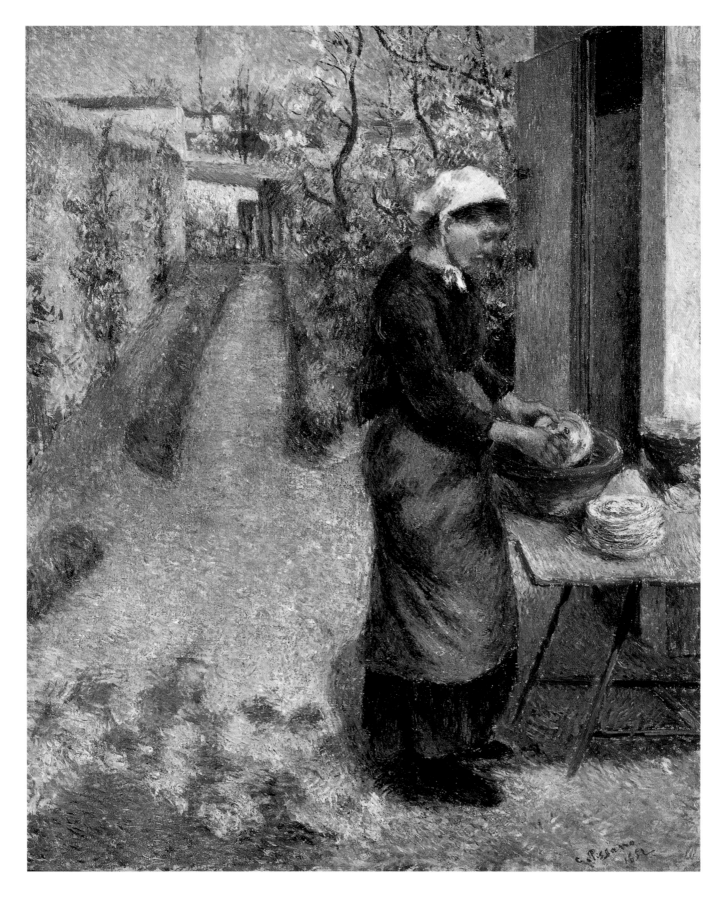

PIERRE BONNARD
The Table, 1925

An array of fruits, plates and baskets seems in danger of sliding off Bonnard's precipitously steep table, behind which the figure of Bonnard's wife Marthe can be seen absorbed in the business of preparing food for the dog.

CAMILLE PISSARRO
Young Woman Washing Dishes, *c.* 1882

A dedicated Socialist, Pissarro often depicted workers, even in his own home. Here a young country maid washes the breakfast things at a table set up just outside the kitchen door.

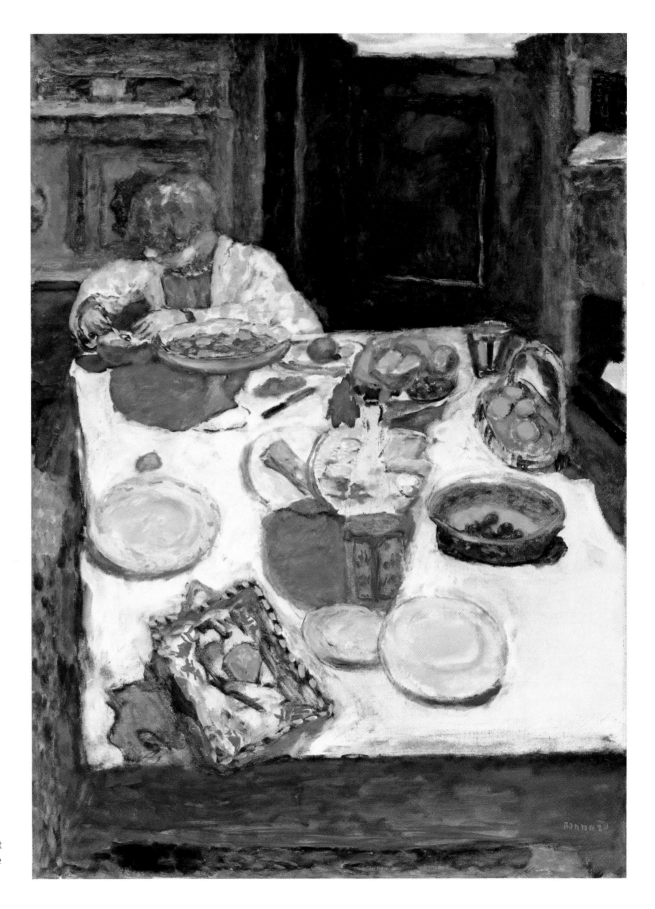

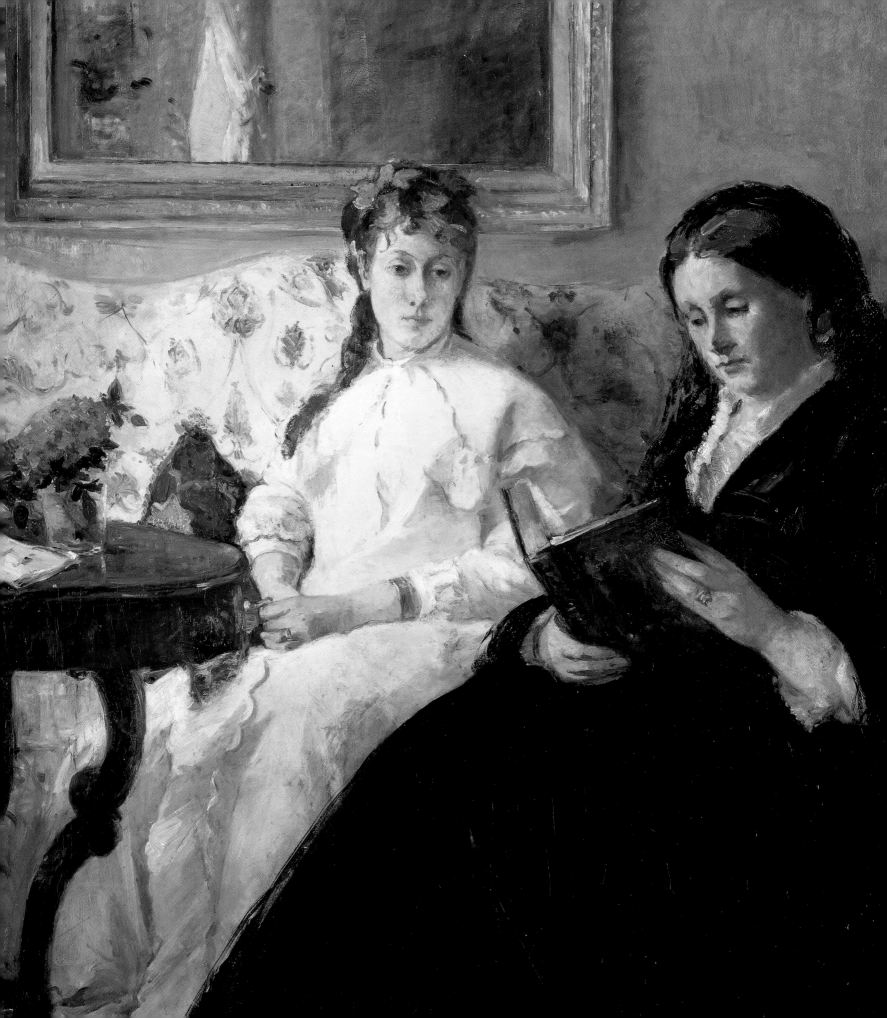

A Place to Meet

ENTERTAINING AND ETIQUETTE, DIVERSIONS AND DECOR

'There are few hours in life more agreeable than the hour dedicated to the ceremony known as afternoon tea.'
– Henry James, *Portrait of a Lady*, 1881

BERTHE MORISOT
Mother and Sister of the Artist (detail), 1870

Berthe's sister (and one-time painting companion) Edma, who had returned home to await the birth of her first child, is seen here being read to by her mother, though she appears lost in private reverie. This is the portrait Manet 'corrected' for his friend before it was sent off to the Salon, to her annoyance.

The degree to which Impressionist painters participated in the heady round of dinners, social calls and cultural spectacles on offer in the capital depended to a large extent on their income, their social standing and their gender. Berthe Morisot and her sisters Yves and Edma led privileged, sheltered lives in the narrow confines of Passy's select society, exchanging visits with other women of their class, taking part in the complicated social ritual of afternoon tea when they would be 'at home' to their visitors, and issuing or accepting invitations to elaborate evening entertainments, often involving music, card games and supper, in the lavishly decorated salon of their home or those of friends. Pierre-Auguste Renoir was an exact contemporary of Berthe Morisot but, as the son of a tailor, inhabited a very different Paris, preferring the street to the family's 'pocket handkerchief' apartment on the rue d'Argenteuil, where the dining room was so tiny that the extended leaves of the table almost touched the walls. The Morisots, by contrast, lived in a large square white house, with wrought-iron balconies on the rue Franklin, close to the park and the Trocadéro Palace. The parquet-floored rooms were spacious with delicate gilded mouldings and looked out across a verdant garden towards the Left Bank. Berthe's exceedingly sociable mother, Cornélie Morisot, hosted 'friendly and unpretentious' dinners of never less than eight guests on Tuesday evenings, regularly inviting artists like Henri Fantin-Latour, Puvis de Chavannes and Camille Corot, who could advise her talented daughters. Marguerite Renoir held open house on Saturday evenings, preparing a huge *pot-au-feu* for any friends and family who cared to call by. Guests never needed to let her know in advance if they could come and it was all very casual compared to the Morisot household, though Cornélie's son, Tiburce, insisted his mother – 'a born hostess' – 'received her visitors simply, without the slightest ostentation.' Cornélie's efforts afforded the young Berthe a rare opportunity to mix with other painters for, along with other female artists including Mary Cassatt, she was denied a chance to participate in the lively artistic debates which went on in the smokey atmosphere of the Café Guerbois and the Café de la Nouvelle-Athènes. Renoir, of course, was free to go anywhere, including backstage at the ballet, opera or theatre, and wander at will through streets and parks, harbours and railroads – sites accessible to the unmarried Berthe only when she was accompanied by a chaperone, if at all. Fortunately for Berthe, her parents recognized and encouraged her talent for painting and sought Corot's advice in finding a suitable teacher, and Berthe's father even had a studio built in the garden for his daughters. Renoir's early artistic skills had to develop on the job while working as an apprentice, from the age of twelve to seventeen, to a firm of porcelain makers.

One woman who was confidently making her way in Paris was Mary Cassatt. Fiercely independent, and secure in her social position, she, perhaps more than any other Impressionist painter, made the home and its social rituals her subject. Her paintings of women talking together or taking tea – often posed by friends or family members – seem, despite their specificity of place and personalities, somehow universal, and richly redolent of intimacy and warm friendship. Female friends like the painter Emily Sartain and the wealthy young heiress Louisine Elder (who would go on to marry the 'sugar king' H. O. Havemeyer and together with her husband build one of the most important collections of Impressionist

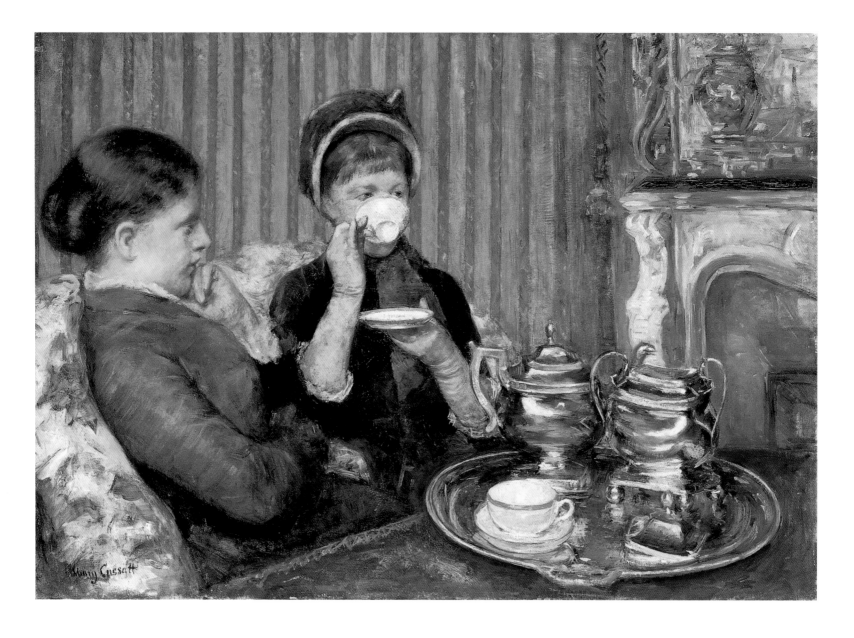

art) remembered her at as generous hostess, drawing great crowds of fascinating people to her 'delightful luncheons' and evening 'at homes'. 'I have seen her entertain a huge house party until two in the morning and be ready for another busy day after only a few hours' rest,' Louisine Havemeyer wrote admiringly in her *Memoirs*. Mary Cassatt impressed by her energy and her originality of opinion and taste, though she was careful that this should operate within a sphere of respectability.

A first-hand account of taking tea with Mary Cassatt has come down to us from May Alcott, as keen and breathless an observer of modern manners as her more famous sister Louisa, author of *Little Women*. May attended the tea party at Mary Cassatt's studio apartment at 19 rue Laval along with other American female friends in 1876 (the year before the thirty-two-year-old Cassatt met Edgar Degas) and her account is interesting not least for the amount of incidental detail she provides about the decoration and Cassatt's costume:

'….[we ate] fluffy cream cakes and chocolate with French cakes, while sitting on carved chairs, on Turkish rugs, with superb tapestries as a background, and fine pictures on the walls looking down

MARY CASSATT
Tea, 1879–80

It was customary for guests not to remove their hats or gloves during the ritual of afternoon tea, since visits were meant to be brief. A cup of tea, a slice of cake and a polite exchange of news about friends and family was the order of the day. The elegant tea service in the foreground had been made for Mary Cassatt's grandmother in 1813.

from their splendid frames. Statues and articles of vertu filled the corners, the whole being lighted by a great antique hanging lamp. We sipped *chocolat* from superior china, served on an India waiter, upon an embroidered cloth of heavy material. Miss Cassatt was charming as usual in two shades of brown satin and rep, being very lively and a woman of real genius, she will be a first-class light as soon as her pictures get a little circulated and known, for they are handled in a masterly way, with a touch of strength one seldom finds coming from a woman's fingers...'

Coming as she did from a wealthy Philadelphia family, Mary Cassatt was perfectly familiar with the world of strict social etiquette observed in the novels of Henry James and Edith Wharton. Yet the evidence of letters and first-hand accounts suggest that her afternoon gatherings were altogether more vibrant and lively. The conversation on offer was not trivial small talk, but deep intellectual discussion more in keeping with the French salon tradition, although the constraint contained in paintings like *Tea*, *Afternoon Tea Party* and *The Cup of Chocolate* would seem to suggest that the complicated demands of convention were still followed.

These rules were set down in etiquette manuals, which instructed young women paying calls not to fidget, steal the hostess's thunder or accept a second cup of tea (the beverage was considered to be a powerful stimulant). They were urged to pay special attention to their clothes, for reputation was crucial and arbiters of taste believed that one could tell a woman's character immediately from the way she dressed.

MARY CASSATT
Lydia and her Mother at Tea, 1882

Mary Cassatt was close to her sister Lydia and her death, from Bright's disease, towards the end of the year this etching was made, cast the artist into deep gloom. 'She has not had the heart to touch her painting for six months,' observed her sister-in-law, Lois.

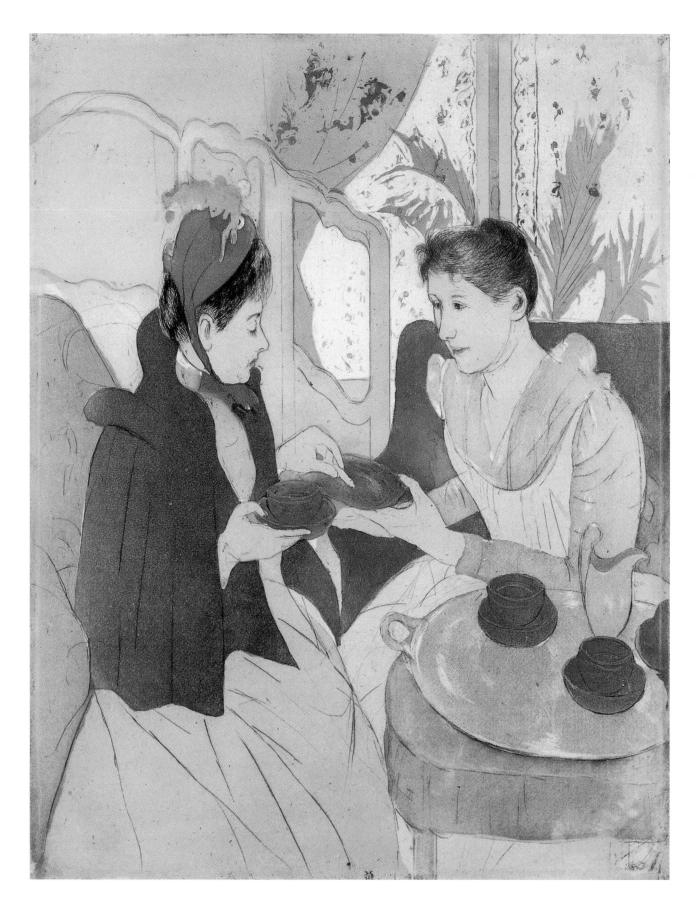

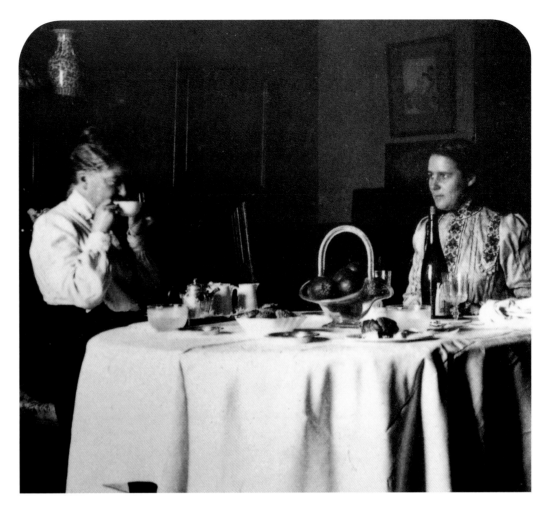

Mary Cassatt's visiting card, c. 1872

Mary Cassatt at home

The *carte de visite*, which shows Mary Cassatt at the age of twenty-eight, was an essential accessory of any well-to-do woman in Paris. The photograph on the right shows an older Mary Cassatt taking tea at her home in Beaufresne, with one of her Japanese woodblock prints seen on the wall behind her.

MARY CASSATT
Afternoon Tea Party, 1890–91

One of a set of ten colour prints with drypoint and aquatint shown in a joint exhibition of works by Mary Cassatt and her friend Camille Pissarro, who praised her work in a letter to his son Lucien, calling it 'admirable': 'the matt tone, subtle but delicate without stains or smudges; adorable blues, fresh rose…The result is admirable as beautiful as Japanese work.'

Unsurprisingly, these calls could become an alarming ordeal for some, though it is unlikely that they held any terrors for Mary Cassatt. Instead she found the complicated and self-perpetuating social round of calling cards, returning visits and hosting at homes extremely time-consuming and distracting. Unwilling to allow calls to interfere with her work, she often turned visitors away, instructing her servant to tell the caller, in the accepted code of the time, that she was not at home. 'I have a right', she declared, 'to refuse anyone, for I work from eight to ten hours a day.'

After living alone for some years, Mary Cassatt was joined in Paris in 1877 by her parents and her older sister Lydia, who had come to receive treatment for a chronic illness. Robert Cassatt, a recently retired businessman, and his wife Katherine were a wealthy, cultured couple, keen to avail themselves of the rich entertainments on offer in the bustling capital. Together with their daughters they established themselves in a large well-appointed apartment on the avenue Trudaine – a respectable address, yet in the heart of the artists' quarter, not far from Mary Cassatt's studio on the Place Pigalle – where they welcomed their daughter's artist friends, some of whom they found bohemian but others, such as Berthe Morisot, Edgar Degas and Gustave Caillebotte, they recognized as coming from the same respectable and relatively wealthy background as themselves.

At this time Caillebotte was living in somewhat suffocating bourgeois splendour in his mother's lavish, if gloomy, apartment at 77, rue de Miromesnil (the site of his famous *Floor Scrapers*), propping up a number of impoverished Impressionists with generous loans and gifts of money. One Wednesday, some time in 1877, he dashed off a letter to Camille Pissarro, inviting him to have dinner at rue de

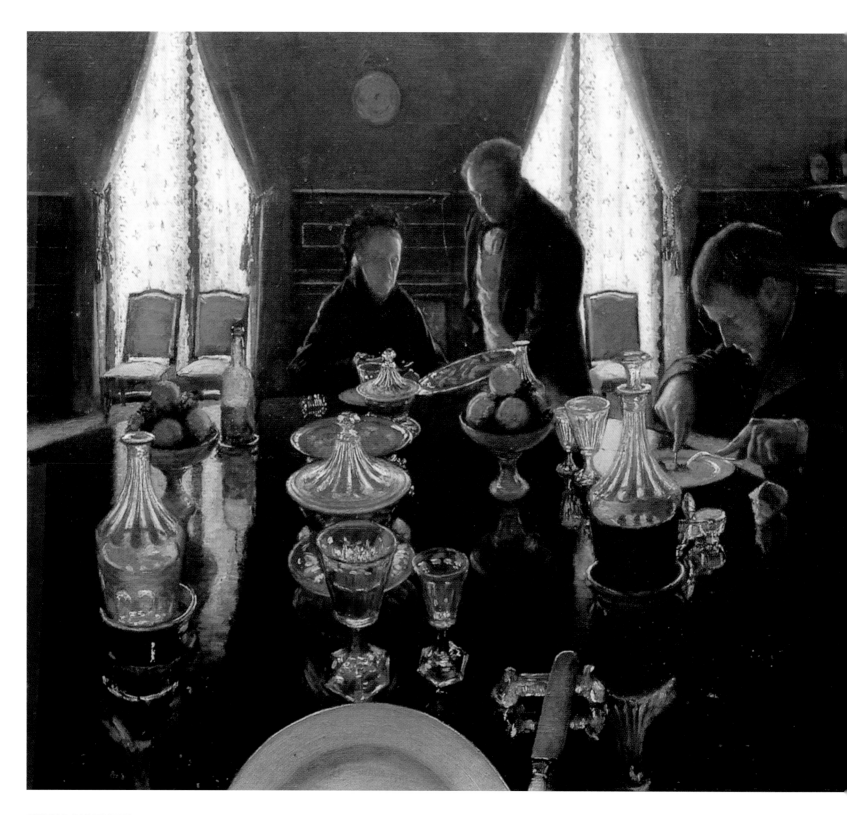

GUSTAVE CAILLEBOTTE
The Luncheon, 1876

Caillebotte shows his mother, his brother René, and the family butler,
in the opulent dining room of the rue Miromesnil family home.

Miromesnil. 'I am returning from London and would like to discuss certain matters with you relative to a possible exhibition,' he explained, 'Degas, Monet, Renoir, Sisley and Manet will be there. *I count absolutely on you.*'

What a stimulating occasion that must have been as seven of the most important painters of their age hammered out the details of what we now know as the third – and certainly the most coherent and focused – Impressionist exhibition. No visual record of the momentous dinner exists, though it is possible to imagine the artists – the dapper Degas; a younger Monet, his hair a mass of curls; Renoir, whip thin and nervy with wiry hair, a thin black moustache and snatch of beard on his pointed chin; the genial Sisley, solid and relaxed with curly reddish-brown beard and pale blue eyes; the patriarchal figure of Pissarro and the urbane Manet – grouped around the shiny circular table familiar to us from Caillebotte's painting *The Luncheon*. The importance of the occasion is demonstrated by the fact that Pissarro kept the undated note all his life and it is probably safe to assume that the gathering was a great deal livelier than the strained family dinner Caillebotte represented in his painting of 1876. In that picture the sense of emotional distance is heightened by the exaggerated distortion of the table – described as being 'twelve metres long' by one critic – and the crystal glassware arranged in a line leading straight up to his rather forbidding mother, Céleste. But on our Monday evening in 1877, as Caillebotte and the others tried – in vain, sadly – to persuade Manet to desert the Salon and join forces with the Impressionists, the table was secondary. Not even the massed ranks of Mme Caillebotte's imposing white porcelain dinner service (a four-hundred-and-fifty-piece set decorated with red and gold filigree) could steal the show as Caillebotte flattered, cajoled and smoothed out the differences between the

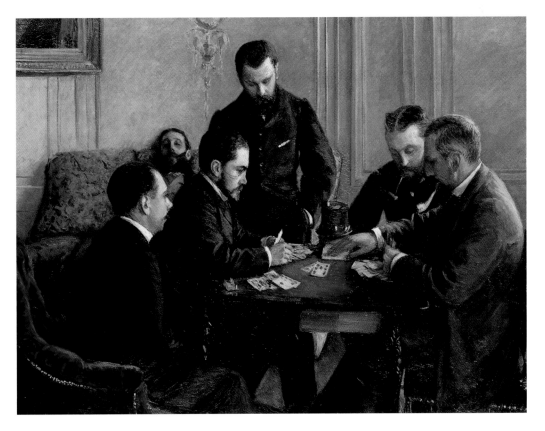

GUSTAVE CAILLEBOTTE
The Bezique Game, 1881

The artist's brother Martial and friends playing cards
in an apartment on the boulevard Haussmann, Paris.

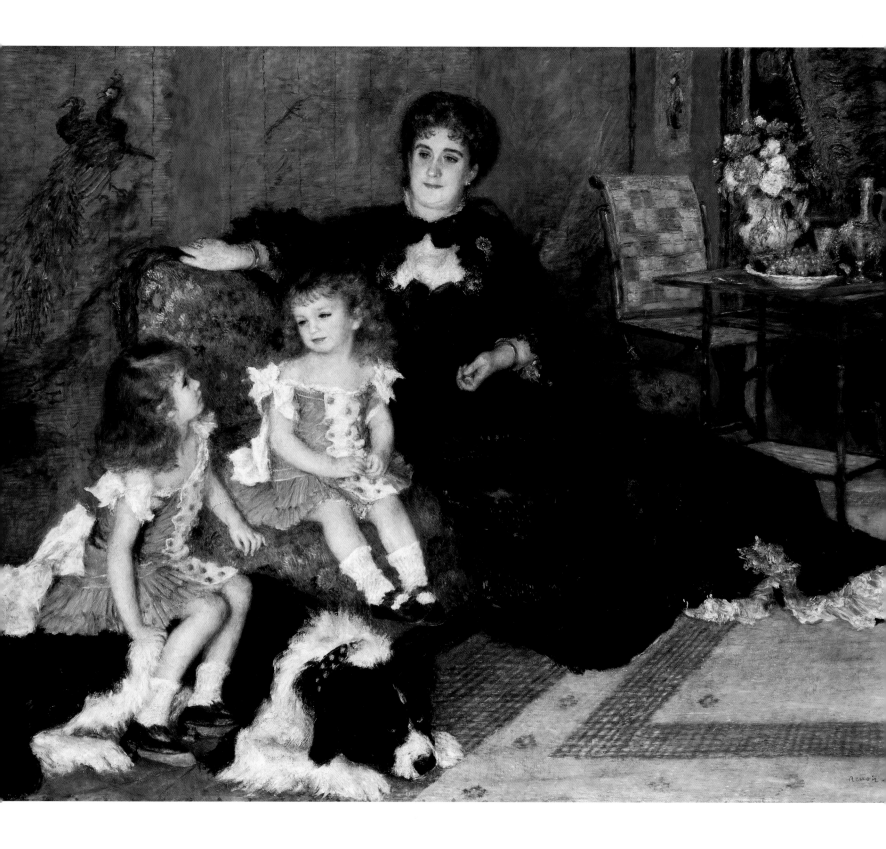

Socialist politics of Pissarro and the frankly bourgeois lifestyles of the others. It was Caillebotte who created the bridge across which Cézanne – too shy to attend the dinner but destined to be one of the stars of the exhibition – could pass, and who enabled Berthe Morisot to exhibit a record twelve pictures. Berthe Morisot was not present at the dinner, of course: it would have been unthinkable to compromise the reputation of a married woman by inviting her to dine alone with seven men in a private house, even though these men were her colleagues, her peers.

The appropriate venue for the Impressionist painters to come together in mixed groups was at soirées held in each others' homes or the homes of patrons like Ernest Hoschedé or Georges Charpentier. Renoir fell on his feet when the influential Charpentiers adopted him as their protégé. Georges published the brightest and best young authors, including Emile Zola, Guy de Maupassant, Alphonse Daudet and the Goncourt brothers. At shimmering parties in Marguerite Charpentier's stunning drawing room Renoir could mix with cutting-edge writers, statesmen like Léon Gambetta and Jules Ferry and fashionable actresses like Jeanne Samary and Yvette Guilbert, the café-concert singer immortalized by Degas and Toulouse-Lautrec.

Madame Charpentier's salon was a particularly grand affair, but there were plenty of others, hosted by socially ambitious upper- and middle-class women like the mothers of Berthe Morisot and Edouard Manet and 'the delightful Madame Stevens', the wife of the Belgian artist Alfred Stevens, who would choose a particular day of the week for their regular evening receptions and set out to attract great conversationalists from the world of politics, literature and, of course, art. Manet's mother loved entertaining and held twice-weekly soirées to which she invited her three son's friends on Thursdays and her own female friends on Tuesday evenings. Charles Baudelaire was a regular Thursday evening guest in the early years, along with Antonin Proust, Zola, Zacharie Astruc, the critic Jules Champfleury and artists like Fantin-Latour, Félix Bracquemond and Degas. Later the circle extended to include politicians like Georges Clemenceau and poets like Stéphane Mallarmé. There were also musical evenings at which Manet's wife Suzanne would sing, accompanying herself on the piano, 'like an angel' according to Madame Meurice, who left an account of a magical evening spent listening to Suzanne, the celebrated Catalan guitarist Jaime Bosch (who dedicated one of his solo pieces to Manet) and the 'Cherubin-Astruc', who performed a duet with a family friend.

Music featured prominently in the lives and art of a number of Impressionist painters. It was one of the pleasures that the English artist Alfred Sisley shared with Frédéric Bazille. They regularly attended concerts at the Conservatoire and Bazille often organized musical evenings in his studio in the rue de la Condamine. Manet loved Haydn, Bracquemond Beethoven, Fantin-Latour's 'god' was Schumann and Renoir admired Mozart. Monet became particularly fond of the opera. Wagner – around whom debate raged at this time – was much admired by Sisley, Bazille, Cézanne, Baudelaire and Renoir.

Edouard Manet's wife Suzanne was a gifted classical pianist and many of their friends were musical. The Claus sisters, for example, often played at Madame Manet's musical evenings, which Degas would sometimes attend, despite his often prickly relationship with Manet. Their friendship never really recovered from the rift caused by Manet taking a scalpel to the canvas of a fine joint portrait of the Manets Degas had painted around 1868, which shows Manet leaning back against a sofa still covered by white dust sheets, lost in reverie as he listens to his wife playing the piano. Manet's utterly informal posture marked something of a landmark in the history of painting; his cavalier attitude towards the canvas almost cost him a friendship. According to Julie Manet, who recalled seeing the painting almost thirty years later hanging in Degas's salon, and who relayed the story: '[Manet], thinking his wife looked ugly, cut her off.' When Degas saw what had happened he was incensed and carried the canvas back to his studio where he attached another piece, intending to repaint Suzanne, though he never did. Meanwhile Manet – uxoriously compensating – painted his own portrait of Suzanne, following the same pose, but giving more gloss and definition to the setting – the salon of Manet's mother's apartment in Paris – and presumably more flattering attention to Suzanne's profile.

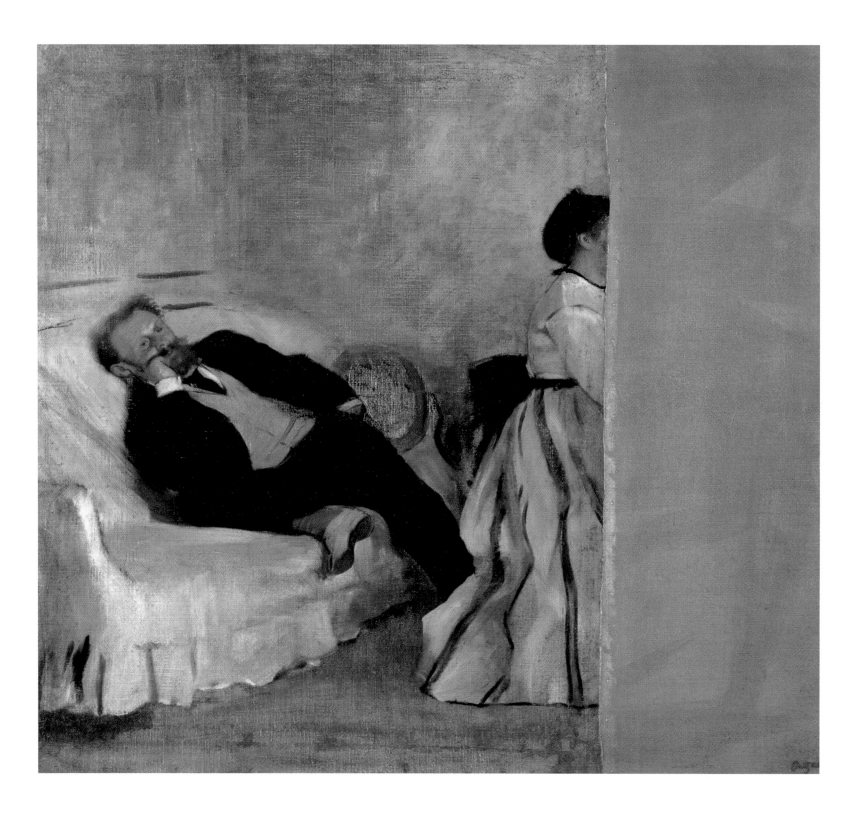

EDGAR DEGAS
Monsieur and Madame Manet, 1868–69

Degas was furious with his friend when he discovered that
Manet had taken a scalpel to the canvas of his joint portrait
of the couple.

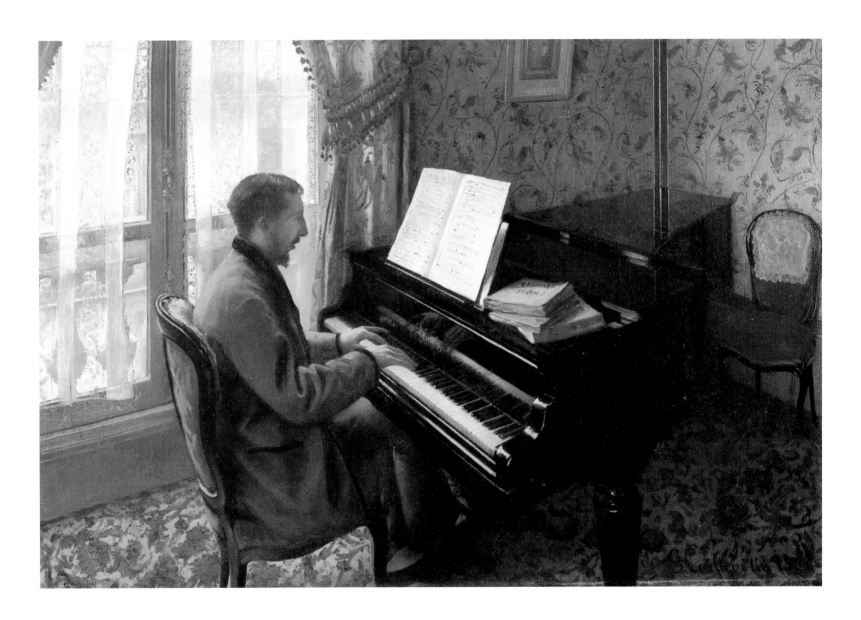

GUSTAVE CAILLEBOTTE
Young Man Playing the Piano, 1876

Since men were supposed to have less leisure time than
women, it is unusual to find a painting of a male pianist,
in this case Caillebotte's brother, Martial.

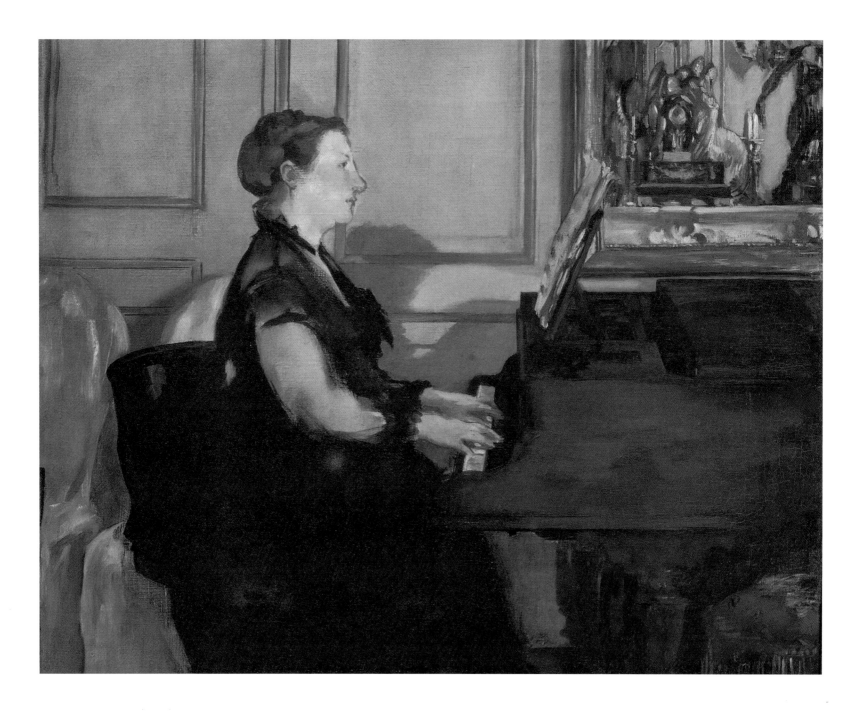

Relations, though strained, were cordial enough for Degas to attend one of Madame Manet's soirées three years later, when Cornélie Morisot watched him 'looking very sleepy' and wrote gloatingly to her daughter Berthe to report that 'the heat was stifling, everybody was cooped up in the one drawing room and the drinks were warm.' Perhaps the music had not been to Degas's taste, which ran towards Wagner or Gluck, though in sunnier moods he loved Neapolitan airs, and on one cheerful occasion is reported to have danced his model – naked but for a pair of slippers – around the studio while singing a snatch from an Italian opera.

Musicians and composers frequently moved in Impressionist circles and became close personal friends. Degas painted his friend the bassoonist Desiré Dihau in the pit at l'Opéra in 1870; the singer Jean-Baptiste Faure bought Monet's large, important *Railroad Bridge in Argenteuil* in 1874. The composer

EDOUARD MANET
Madame Manet at the Piano, 1867–70

The gold strip of panelling behind Suzanne's face intersects her features precisely along the line where Manet had sliced a strip off the right-hand side of Degas's portrait (see p. 30). This work was painted in the Paris home of Manet's mother in the rue de Saint-Pétersbourg, where Manet and Suzanne lived for several months.

Emmanuel Chabrier bought several works from Renoir and, along with François Cabaner – a vivid personality, who died young and in poverty – often dined with the artist and his family in Montmartre.

Berthe Morisot and Edouard Manet came from similar *haut-bourgeois* backgrounds and had even had paintings accepted by the same Salon juries of 1864 and 1865 (the year that Manet's *Olympia* almost caused a riot) but they were not formally introduced until, one afternoon in 1867 before a Rubens painting Berthe and her sister Edma were copying in the Louvre, their mutual friend Fantin-Latour was on hand to correct the oversight. When they first met, Berthe was twenty-six and single; the controversial and audacious Manet nine years older and married. Both sisters were smitten. Edma admitted that 'my infatuation for Manet is over' a year later on her marriage, warning her sister to burn the letter. For Berthe the infatuation may have lasted longer.

Contemporary photographs show Berthe Morisot as a slender serious beautiful woman in fashionable dress who often chose to stare directly at the camera. Her friend Mallarmé testified to her 'extraordinary charm...exquisite breeding...and...exceptional personal elegance.' The younger Valéry found her 'rare and reserved'. Manet bridged that reserve. It was not long before he invited Berthe to model for him (accompanied of course by her mother) in his studio in the rue Guyot. Berthe welcomed the invitation and was possibly flattered by it. Edma was drifting away from art towards marriage and Berthe, separated from her sister and the support she provided, suffered doubts about her own work. Manet's company was an important prop. His portraits of her are intimate, his letters affectionate and numerous. The Manet–Morisot social circles overlapped (Mme Morisot and Mme Manet senior had become great friends) and Berthe spent a great deal of time in Manet's company, posing for fourteen portraits – none of which showed her at work – some of which demanded many, many sittings, and art-historical gossip has speculated long and feverishly on the exact nature of their relationship. It is

BERTHE MORISOT
Julie Manet and Jeanne Gobillard Practising, 1893

A pencil sketch of Berthe Morisot's daughter on the violin and her cousin on piano. Close throughout their childhood, the girls lived on together in the rue Villejust house after Berthe Morisot's death, overseen in an avuncular way by Renoir and Mallarmé, who had been appointed guardian. Degas was instrumental in bringing Julie together with Ernest Rouart, one of the sons of Henri Rouart, his wealthy school friend and an occasional exhibitor with the Impressionists. Degas's efforts led to a double wedding, for Jeanne Gobillard married the poet Paul Valéry at the same ceremony in 1899.

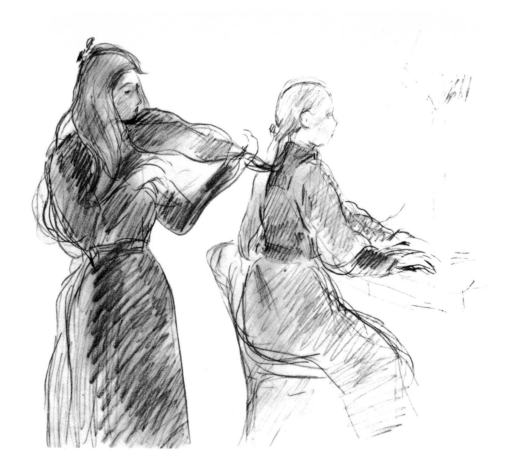

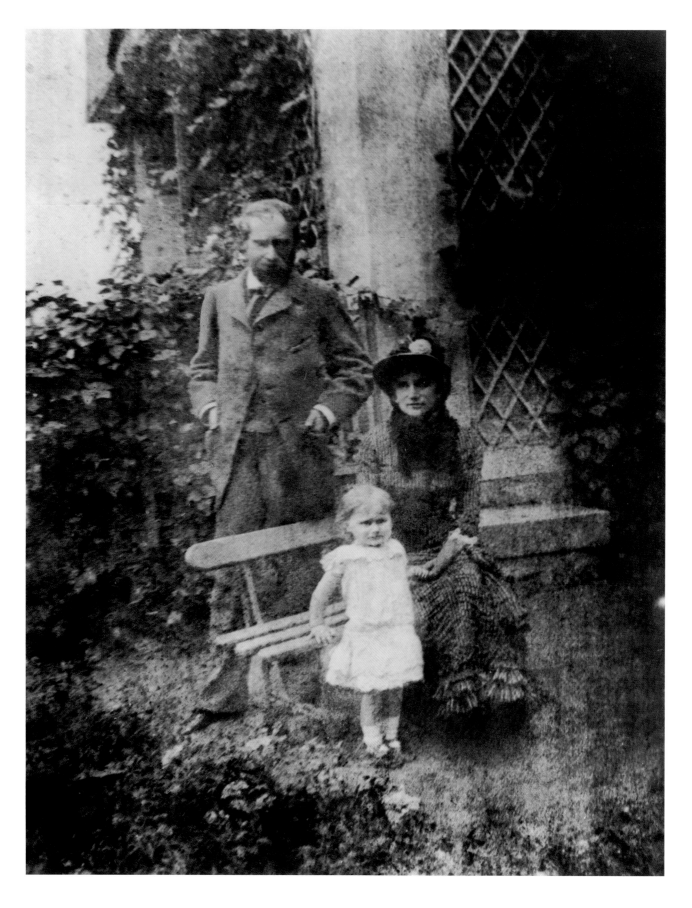

possible that they were extremely attracted to one another. It is possible that they were in love. Berthe referred to Manet's wife as 'the fat Suzanne' in a letter to her sister Edma and was jealous when Manet took the younger artist Eva Gonzalès on as a student. Berthe was never his student, however. She always considered herself his equal – and suffered agonies when he 'corrected' one of her paintings as it was going off to an exhibition.

Despite such insensitivities, close exposure to one of the most innovative artists of the age was enormously beneficial to Berthe Morisot and helped to direct her own artistic ambitions, which, especially after her sister Edma had married, took a battering from her mother. 'Yesterday my mother told me politely that she has no faith in my talent, and that she believed me incapable of ever doing anything worthwhile,' Berthe wrote to her sister in August 1871. Edma was living in Normandy with her conservative naval officer husband, Adolphe Pontillon. The picture she painted of marriage in her letters to her sister was hardly enviable: 'I am often with you, my dear Berthe,' she wrote wistfully. 'In my thoughts I follow you about in your studio, and wish that I could escape, were it only for a quarter of an hour, to breathe that air in which we lived for many long years.'

Berthe's own feelings flash like flares from her replies to her sister: 'Men,' she wrote, 'incline to believe that they fill all of one's life, but as for me, I think that no matter how much affection a woman has for her husband, it is not easy for her to break with a life of work.' Two years later she asserted: 'Work is the sole purpose of my existence, and...indefinitely prolonged idleness would be fatal to me from every point of view.' Her work, however, was not going well. She painted only a handful of pictures in the three years 1869–71 and was often depressed. Manet lent moral support during this difficult period, as did his brother Eugène, with whom Berthe became romantically involved, marrying him in 1874, a year in which she produced ten new paintings and exhibited for the first time with the Impressionists. The following year she produced eighteen. Her career was launched.

Together with her new husband she took an apartment on the avenue d'Eylau (now renamed the avenue Victor Hugo after another prominent Passy resident) and, in 1881, bought land on which to build an elegant town house in the rue Villejust, between the Etoile and the bois de Boulogne, which provided Parisians and lively throngs of Sunday visitors with varied recreational facilities, including running, cycling, ice-skating, horse riding, walking. There she gave dinner parties which friends remembered for their lively argument and serious discussion across a range of issues. Her *salon*, which the poet Henri de Régnier called 'a strange place of rare distinction...and...impeccable taste', was a high-ceilinged Empire-style room, which served as her studio and – once she had stashed her painting materials modestly behind a screen – the venue for her own Thursday evening gatherings to which she invited old friends like Mallarmé, Renoir, Caillebotte, Pissarro and Whistler. It was at her *jeudis* that Mallarmé and Degas discussed poetry and Puvis de Chavannes at last met Monet. She had a great gift for smoothing rough edges – even Degas's – according to Renoir, who claimed she 'acted like a special kind of magnet on people, attracting only the genuine.' Degas, despite his reclusive reputation, went out several times a week and, according to Paul Valéry, could be 'the soul of the evening; a constant, brilliant, unbearable guest.' Monet was less abrasive and often dined with Berthe and Eugène when up in Paris from Giverny, though her friendship with the slightly younger Mary Cassatt, which had begun so cordially, appeared to cool over time.

Towards the end of the century many women, including those of her own class, were relaxing the rules a little, but Berthe Morisot remained cast in her conventionally correct mode, an *haute-bourgeoise*, who joked with Mallarmé that one day 'Julie [her daughter] and I will dress as men and attend one of your Tuesdays', but never had the chance for she died suddenly of pulmonary congestion, aged just fifty-four. The death certificate described her as 'without any profession', despite the fact that the year before the French government had purchased her painting *Young Woman in a Ball Gown* for the national collection.

Henri de Toulouse-Lautrec was an original, both as an artist and as a man, and he loved to entertain. He came from one of the most distinguished families in France and was rich as well as talented, but a bone disease, exacerbated by a riding accident, caused the stunted growth which blighted his life.

Photograph of Eugène Manet, Berthe Morisot and their daughter Julie at Bougival, 1880

Berthe Morisot spent a part of each summer in and around Bougival for over twenty years, incorporating marriage and maternity into her art. Julie, whom she described as 'like a kitten, always happy; she is round as a ball; she has sparkling eyes and a large grinning mouth', was a favourite subject. The portrait is surprisingly formal.

HENRI DE TOULOUSE-LAUTREC
Portrait of the Comtesse A. de Toulouse-Lautrec
in the Salon at Malromé, 1887

Lautrec's aristocratic mother Adèle kept him supplied
with local delicacies from his native region – pâté de
fois gras, truffles, capons, grapes and wine from the
vineyards surrounding her château at Malromé.

He excited loyal friendships, but also attracted hangers-on. He was eccentric, colourful in his tastes and
once scandalized his cook, 'the good Léontine', who was shocked to find a young woman, completely
naked, seated at the dining table when she brought in the first course of a dinner she had prepared. This
was bold behaviour even for Montmartre.

Lautrec, born in the old Hôtel du Bosc in Albi, lived for most of his short adult life in Paris,
first with a family friend, Dr Henri Bourges, then for a while with his mother, the Comtesse Adèle
de Toulouse-Lautrec-Montfa, and finally on his own in rue Caulaincourt. By then he was twenty-seven
and relishing the prospect of living alone for the first time. 'I shall have the ineffable pleasure,' he wrote
to his grandmother, 'of keeping the household accounts and knowing the exact price of butter.
It's charming!'

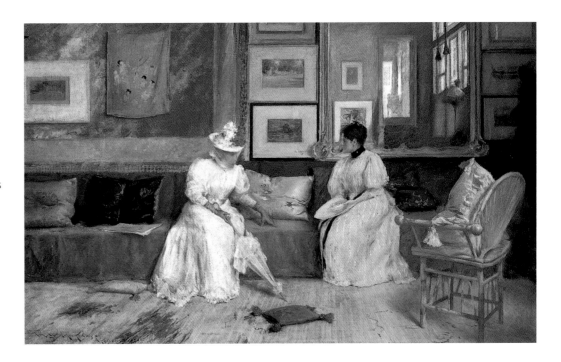

With all the enthusiasm of a child furnishing his first tree-house, he begged of his mother: 'If you could make me a present of six small-size tablecloths and some table napkins you would oblige me very much because I'm going to have to stock up...Some very ordinary table knives would also be a great help...'. 'I'm going to buy pots and pans, etc., etc.,' he went on, comparing the experience to 'getting married without a wife.'

He never did marry. Instead he died young, seen off by a combination of alcoholism and advanced syphilis, in 1901, aged thirty-six. In his short life he was immensely sociable, a gregarious, at times even tyrannical, host. The many visitors to his famously shambolic fourth-floor studio on the corner of rue Tourlaque and rue Caulaincourt were obliged to drink the cocktails he would concoct from apparently random bottles of many different liqueurs which stood on a long untidy table just inside the entrance. As the distinctions between work and play began to blur, his studio became more and more the centre of his social life, while the work went on at small tables in the many crowded clubs and cafés he frequented. He held open house on Friday evenings and according to the painter François Gauzi, the studio was mobbed by a crowd of people who weren't necessarily friends of Lautrec, but who came along to see the show, sometimes to sneer, always to drink his extraordinary 'American' cocktails. None of this bothered Lautrec, and the parties went on for several years.

Across the Atlantic the vertiginous social round was energetically pursued by those with enough money and sufficient leisure to follow the complicated conventions. The American Impressionist William Merritt Chase, who often used his family in his work and documented his home life through the frame of his pictures, provides a glimpse of the female world of afternoon visiting in *A Friendly Call*. In the painting we see his fashionably dressed wife, Alice (seated on the right), listening politely as her elegant visitor leans towards her in full conversational flow. Plump cushions are placed along a seat which ranges the length of a wall. No tea, or other refreshment, is in evidence and, perhaps sensing she is not going to be offered any, the caller has not pinned back her veil, or removed her hat. The large room – in fact Chase's summer studio on Eastern Long Island – is hung with paintings and textiles and mirrored back to the viewer, simultaneously celebrating the pleasures of domesticity while subtly alluding to the process of artistic production.

Interior Decoration

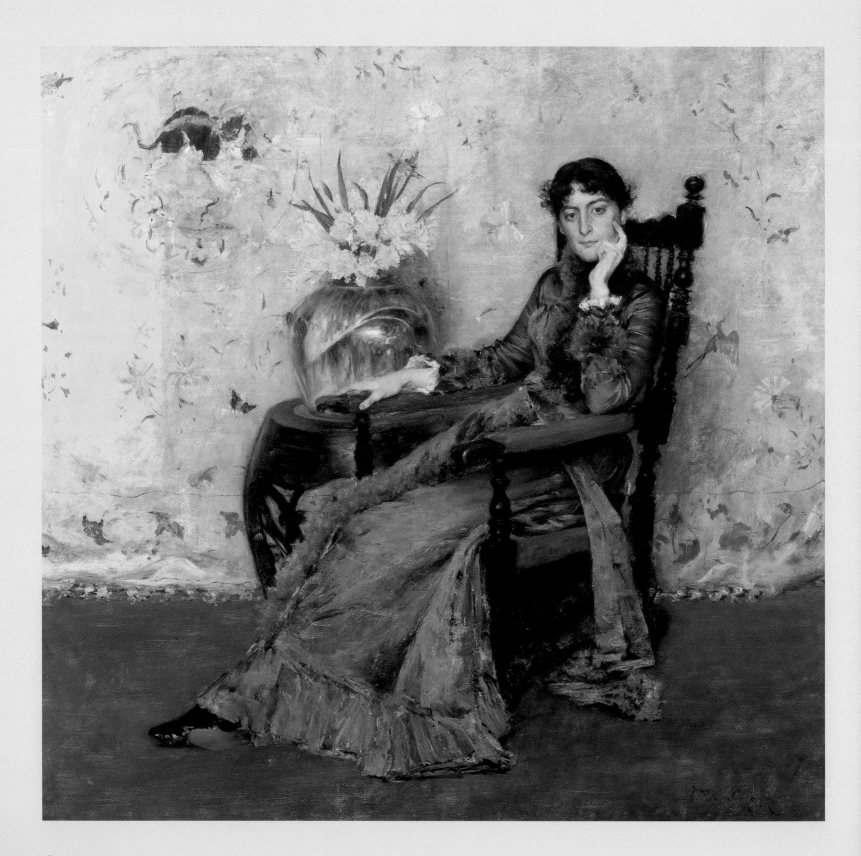

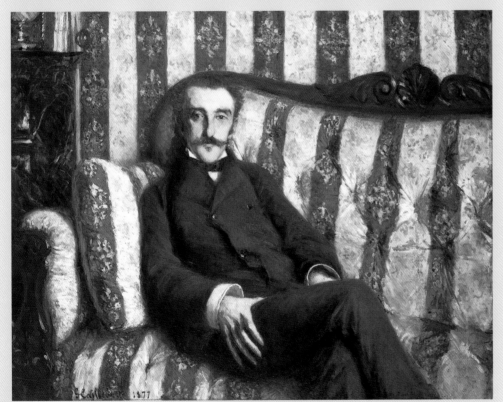

MARIANO FORTUNY
The Children of the Painter in the Japanese Room, c. 1874

GUSTAVE CAILLEBOTTE
Portrait of Monsieur R, 1877

By the mid-nineteenth century an increasingly affluent middle class led a growing interest in interior decoration – not just as one's own environment, but as a demonstration of taste. The Impressionists were not excluded from this, and were just as concerned to stamp their own personalities on their homes. 'Furnishing continues to preoccupy me,' Degas confessed to his sculptor-friend Bartholomé in 1895. Degas decorated his homes in a conventional style with ornate tables and chairs, gilt-framed paintings, rich carpets and fabrics. Georges Jeanniot recalled how, 'The first time I took my wife to Degas's home, rue Blanche, he approached her as she was inquisitively looking at his apartment and at a few beautiful old pieces of furniture, and murmured in her ear: "So! You thought that in an artist's place, it would be amusing, different, didn't you?...Don't you believe it dear Madame, you are in the home of a bourgeois."'

The period saw a boom in influential decorating manuals which appeared in Europe and the United States. Books like Clarence Cook's *The House Beautiful*, 1878, promoted an ideal of artistic decoration achieved through constant rejuvenation and redecoration of the home. Basic items of furniture a couple may have acquired at the time of their marriage which might have been expected to last a lifetime, were unceremoniously replaced if they fell out of fashion. Put simply, the home had become a stage for conspicuous display; possessions a way of defining oneself. Henry James's character Madame Merle, in *Portrait of a Lady*, sums it up in her exclamation: 'I've a great respect for *things*!' 'One's self – for other people – is one's expression of one's self,' she explains to Isabel Archer, 'and one's house, one's furniture, one's garments, the books one reads, the company one keeps – these things are all expressive.' The Impressionist painters understood this well, and consciously expressed their personalities through their surroundings – Chase's portrait of Dora Wheeler could almost have been made to illustrate Madame Merle's philosophy, with Wheeler sitting in front of a Japanese wall-hanging – the very height of chic, as we can also see in Mariano Fortuny's painting of 'the Japanese room'.

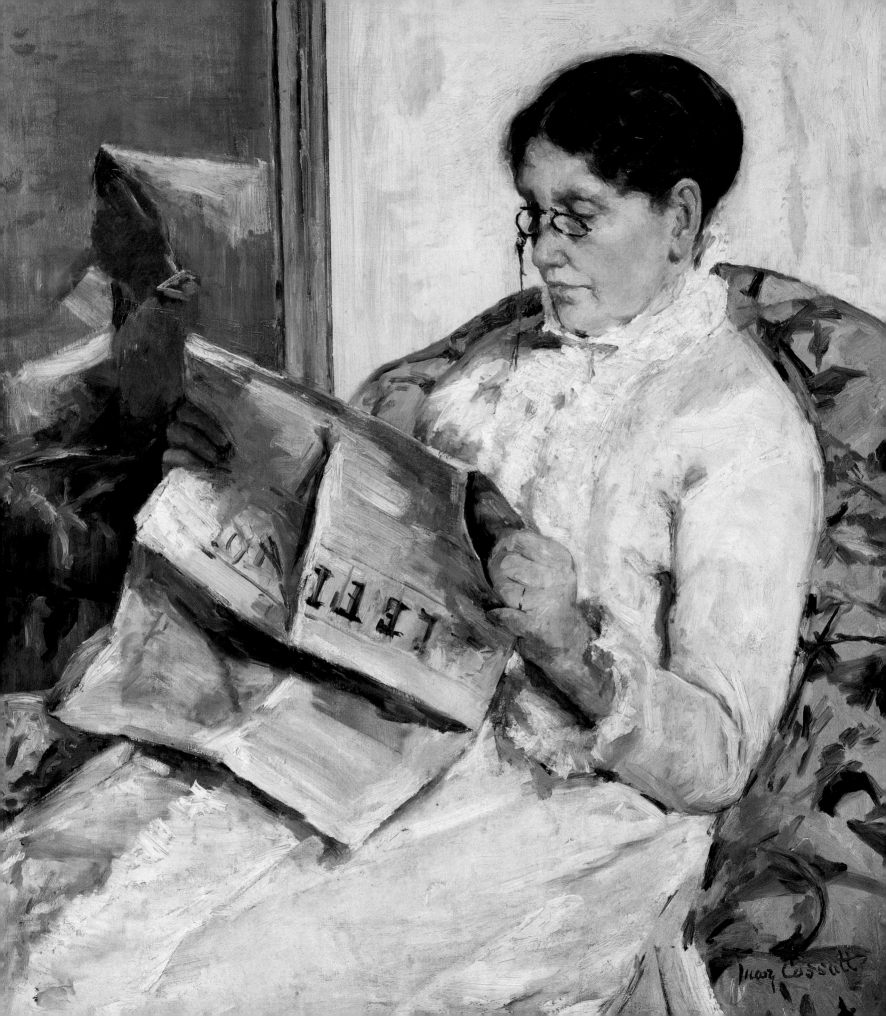

CHAPTER 2 # A Place to Escape
PASTIMES AND PASSIONS, UNIONS AND REUNIONS

'Mlle. Cassatt, who, I believe, is an American, paints French women, but manages somehow to introduce into her Parisian interiors an 'at home' feeling. She has succeeded in expressing, as none of our own painters have managed to do, the joyful peace, the tranquil friendliness of the domestic interior.'

– J. K. Huysmans, reviewing the sixth Impressionist exhibition in 1881

MARY CASSATT
Le Figaro (detail), 1877–78

Cassatt's mother relaxes in an armchair with a copy of the Parisian newspaper *Le Figaro* – highly unusual reading at a time when women were supposed to prefer romantic novels. The Impressionists were documenters of a time of great change, but often the real revolution is in the detail, and in their celebration of the everyday.

BERTHE MORISOT
Embroidery, 1889

A charming pencil sketch of the artist's ten-year-old daughter, Julie, and an older girl sitting together on a sofa as they both concentrate on embroidering a large piece of cloth.

Home, for many Impressionist painters, operated as a comfortable refuge from a turbulent and hostile outside world. A warm private space into which they could retreat and relax with their families, pulling up the drawbridge behind them. There they could be themselves and pursue their own interests and hobbies: reading, music, gardening, writing letters to friends. In the intimate spaces of their own homes they found inspiration and rich and rewarding subjects for serene paintings, which celebrate the virtues and pleasures of domesticity. Simple acts like sewing or reading were tenderly recorded in glowing canvases. Pissarro painted his wife Julie, sitting by the window to maximize the light, intent on a piece of mending. The American Impressionist Willard Leroy Metcalf depicted his wife Henriette and daughter Rosalind absorbed in their needlework, the little girl a bundle of concentration, mimicking the movements of her more practised mother as they sit in comfortable cushioned chairs, lapped by the light from the open window behind them. Berthe Morisot's pencil drawing of her daughter Julie and an older girl intent on embroidering a large piece of material demonstrates how sewing could be a shared female activity, recreational and quietly enjoyable, yet purposeful and suitably instructive. Indeed, the large number of Impressionist paintings showing wives, daughters and sisters engaged in the act of sewing is an indication of how regular an occupation this was for women. Until the arrival of the sewing machine every seam of every jacket and dress, every article of children's clothing and every stitch of all those petticoats and extravagant undergarments, whether made at home or by a dressmaker, had been sewn by hand. There is, however, a distinction – and once again it is one of class – to be made between the types of sewing the women are engaged upon. While the young girl Pissarro depicts in *Young Woman Sewing* is mending stockings, Mary Cassatt's *Lydia Seated at an Embroidery Frame* shows her sister intent upon a tapestry. The first activity is prompted by frugal necessity, the second is the leisure-pursuit of a refined upper-class woman.

While the ability to sew was a necessary requirement for women of the lower classes, it was just one more desirable accomplishment and proper pastime to add to piano playing and sketching for those of the privileged classes.

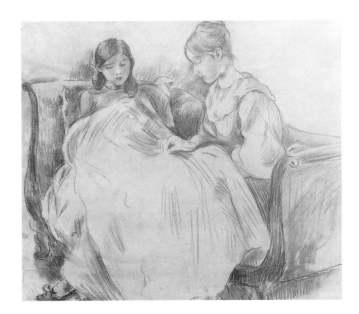

41

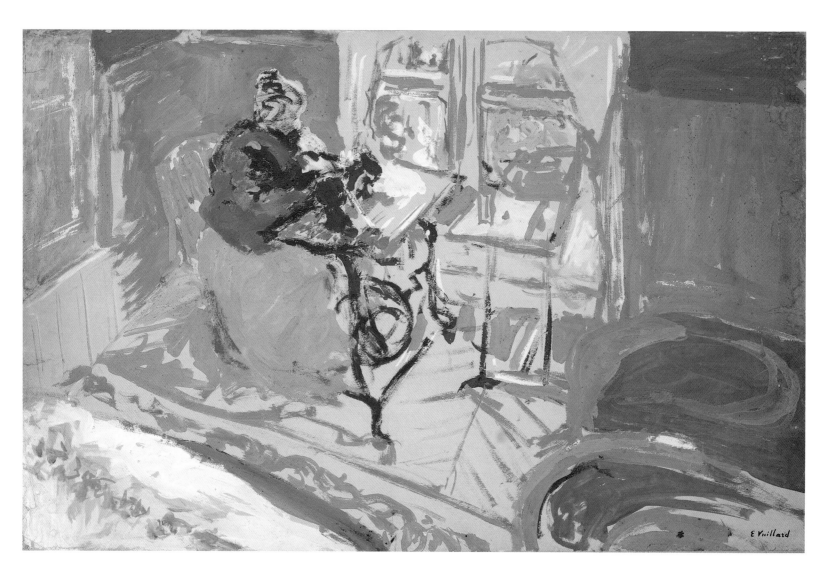

EDOUARD VUILLARD
Madame Vuillard at the Sewing Machine

Vuillard's mother (widowed when the artist was fifteen)
ran a corset-making workshop and appears in over
five hundred of the artist's paintings, often depicted
absorbed in her sewing. It was Madame Vuillard's
encouragement and thrifty economies which saw her
son through art school and he remained grateful to
his mother until her death in 1928.

Ladies of leisure like Lydia Cassatt prided themselves on their fine needlework skills, showing them off in complicated tapestries and embroideries which demonstrated not just their talents but proved their taste and showed the world they had the time and leisure to devote to long complicated projects. Young girls, like Julie Manet, would be taught first to knit – practical items like shawls and stockings, warm

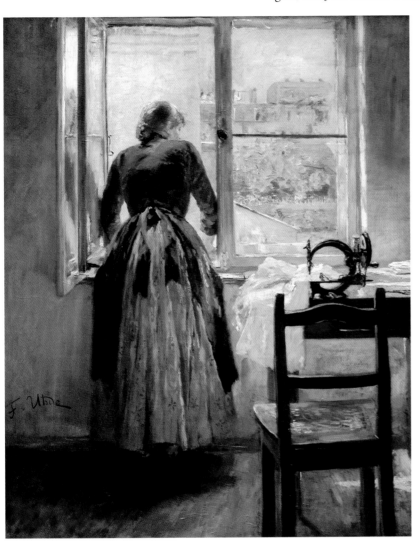

FRITZ VON UHDE
Young Woman at the Window, c. 1891

Impressionist paintings uncover and explore the subtle distinctions between chore and recreation. Sewing could be a hobby or a job, pleasure or necessity.

hats and mittens – and then progress to the more sophisticated skills of crochet or tatting decorative edges for handkerchiefs, petticoats and lace or muslin fichus. White on white embroidery was particularly popular at this time as a trimming to embellish delicate items like lingerie or babies' christening gowns.

The arrival of the sewing machine must have been a great relief for women, although its appearance does seem to have coincided with, or perhaps fuelled, an era of maximum clothing, creating even more work. In *Young Woman at the Window* by the German Impressionist Fritz von Uhde, the machine sits temporarily abandoned mid-stitch on the table, while the young aproned woman leans out of the window, her attention caught by some activity in the street below, or perhaps she is just taking a well-earned break.

Commercial manufacturers responded to the arrival of the domestic sewing machine by seeking to discourage and somehow discredit the whole idea of homemade clothes. They did this by subtly fostering through the pages of daily newspapers and fashion magazines the idea that the woman who sewed at home was somehow out of step with the modern world, and hopelessly old fashioned. Women were bombarded with advertisements for 'Ladies' costumes ready-made – all trimmed in the latest styles,' 'Paris ready-made dresses, very elegant' and, in the *New York Daily Tribune* of 1875, 'New styles just landed'. Parisian styles were the height of fashion and the term 'homemade' now became – in an inversion of traditional values – something reproachful, while 'factory-made' garnered praise.

The effort to keep up with the rhythm of ceaseless change was probably too much for one woman and her sewing machine anyway, especially once a new language of clothes had been created by modern pursuits – like cycling, which required a 'bicycle suit', with or without a divided skirt, together with a 'cyclist corset for all athletic purposes', bicycle shirt, stock, hose, hat, vest, gaiters, shoes, and even a bicycle handkerchief, available in twelve designs, for men or women.

The home had become a stage for conspicuous display; possessions a way of defining oneself. Women were encouraged to constantly renew and beautify their homes, to usher in the seasons with new chair coverings and curtains, and revitalize their homes with new linens and dresser runners, paper flowers, elaborate needlework, *objets d'art*. All of which entailed great effort and considerable expense and went against all the tenets of a thrifty housewife like Aline Charigot, who sat down on a wet evening in June 1893 to write from Paris to her husband, Renoir, who was painting in Dieppe. This letter – one of the few that survive between them – is a humdrum little note, full of domestic concerns. We learn that the leak in Renoir's studio roof has yet to be repaired. 'I don't know,' she wrote, 'if we will have enough money to last to the end of the month, because we must buy some more material. We haven't enough for the big curtains to hang at the side of the large window where most of the sun comes in....' She had found a cheap shop but was worried because she had already spent forty francs. They had been living together now for thirteen years, married for the last three and had an eight-year-old son and a baby on the way. They lived in Montmartre, renting a house in the grounds of an eighteenth-century folly

known pretentiously as Château des Brouillards, inhabited even then by the bohemian bourgeoisie. The rent was cheap and Renoir made the place his own by painting the rooms white and the doors Trianon grey. Some of the glass panes of the dining room were decorated with scenes from Classical mythology and from his attic studio he could see the hilltops of Meudon, Saint-Cloud and Argenteuil. Montmartre was quite unlike the rest of Paris: there were fields, vineyards, cows and fresh air. The house had its own small garden planted with plum trees and lilac where Renoir often painted, though he also had another studio on the rue Tourlaque at the foot of the hill. Friends would climb the hill to visit Renoir and Aline at Château des Brouillards, but Renoir would also go out – often alone – to cafés or restaurants like the Café Riche where Georges de Bellio, an important patron, had instituted a tradition of monthly Impressionist dinners.

A number of Impressionist paintings show solitary women alone at home, gazing searchingly out of windows, into fires, or off into the middle distance, apparently suspended at some aching moment of unarticulated longing. They seem static and resigned. In truth, the cult of domesticity could leave many women feeling marooned. Shopping was a distraction, an important and justifiable activity which eased the boredom and, as the century progressed, became both the work and the recreation of middle-class women. Now they found themselves pivotal players. Edmond de Goncourt, together with his brother Jules, a great collector of French art, discussed the psychology of accumulation in the preface to the catalogue of their 1880 collection, *La Maison d'un artiste*. He coined the term 'bricabracomania' to describe what he saw as a veritable disease of the period. For Goncourt it linked to the emptiness, the loneliness of the human heart in the new industrial society and its modern cities. Quite simply he believed that the men and women of this fast-paced modern age were plugging their *ennui* and anxiety with possessions, seeking to reassure themselves with their durability.

BERTHE MORISOT
The Artist's Sister at the Window, 1869

Her younger sister Edma was one of Berthe Morisot's favourite models in the late 1860s and early 1870s. This searching portrait was made in the Morisot family home shortly before the birth of Edma's first child – a daughter, Jeanne – and we sense that the long passive days of her pregnancy are beginning to sap the young woman's spirit.

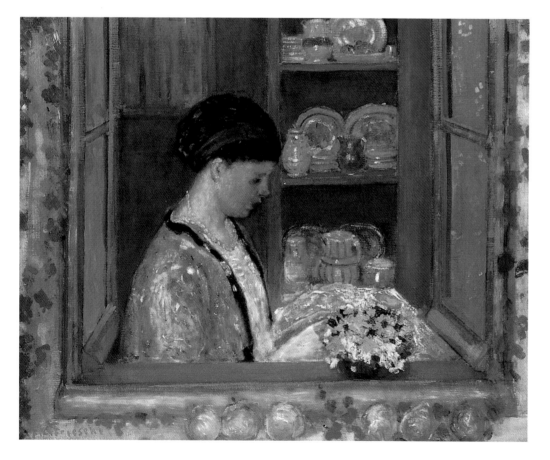

FREDERICK CARL FRIESEKE
Mrs Frieseke at the Kitchen Window, 1912

Frieseke sought inspiration in his domestic surroundings and the house he shared with his wife Sarah – just up the road from Monet's at Giverny – is easily recognizable as the backdrop to many of his paintings. It boasted charming latticework on the outside, while inside the colours sang: the living room was lemon yellow and the kitchen a deep blue, with a vivid blue door, shelving and wooden panelling, which contrasted with the green window frames.

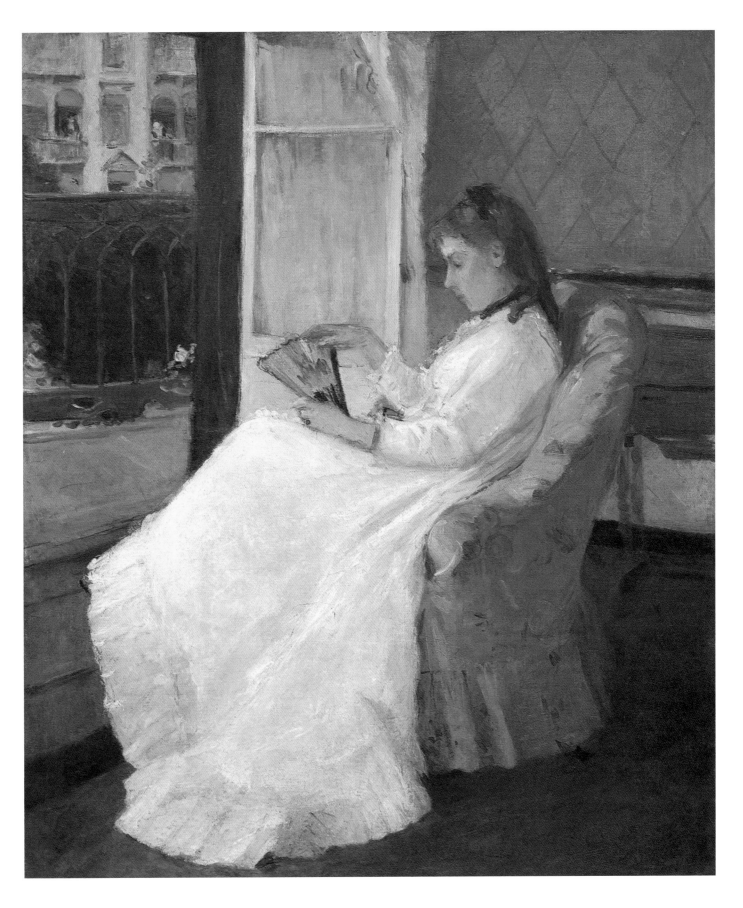

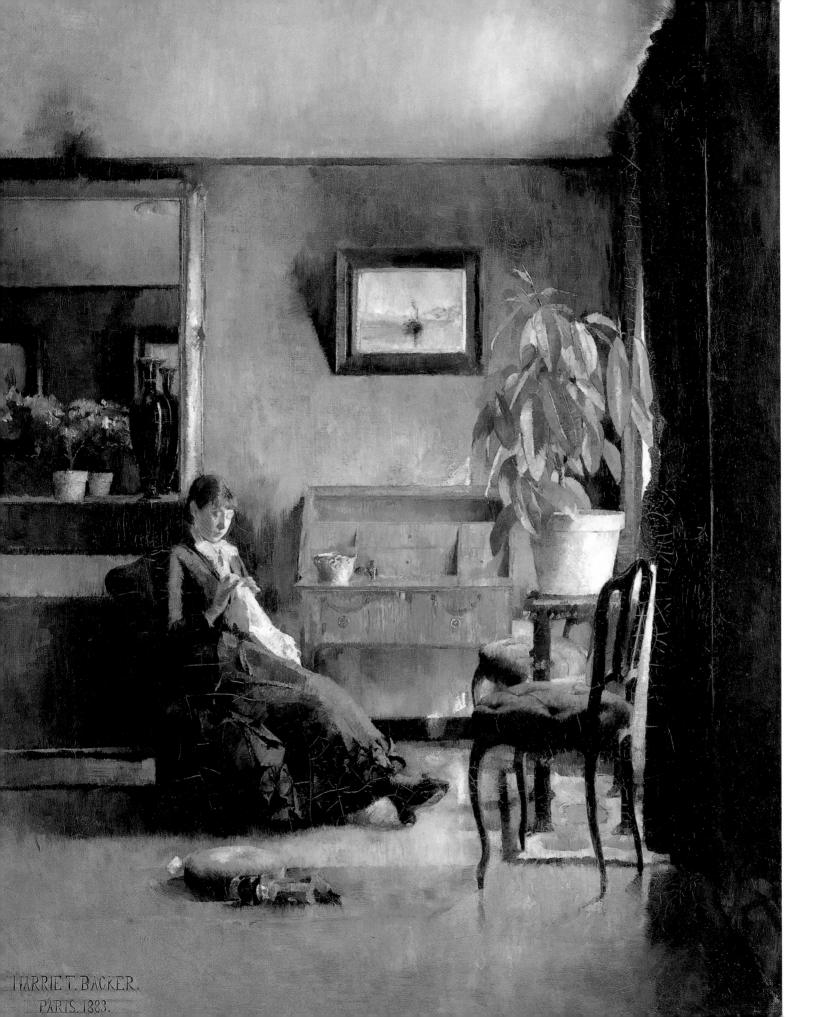

HARRIE T. BACKER.
PARIS. 1883.

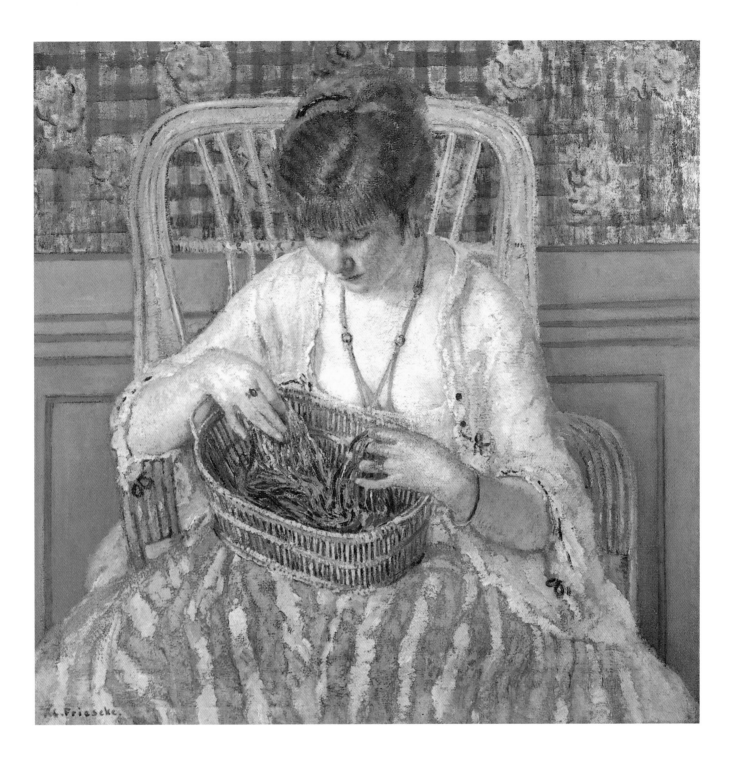

FREDERICK CARL FRIESEKE
Unravelling Silk, c. 1915

The American Midwesterner Frederick Carl Frieseke
was a great colourist. Although he always claimed to
be more of an admirer of Renoir than Monet, it is later
Impressionist painters like Vuillard and Bonnard he
most calls to mind.

HARRIET BACKER
Blue Interior, 1883

A tranquil young woman sits sewing in the lozenge
of light cast by the window. The room is neat and
ordered. Life is lived here at an unhurried pace.

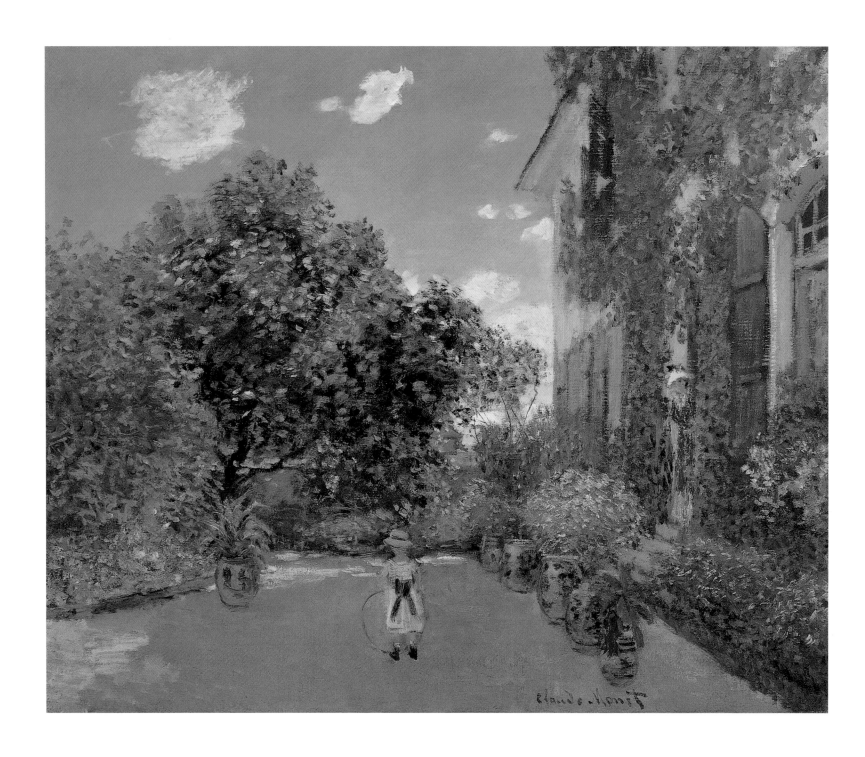

CLAUDE MONET
The Artist's House at Argenteuil, 1873

The profound happiness of Monet's settled, financially
stable years in Argenteuil radiates from the many
paintings he made during this period, often featuring
his family. Here he paints Jean in the garden with
Camille in the doorway.

The Impressionists were, of course, part of this circle of consumption, as both producers and enthusiastic consumers. For Claude Monet, whose early career had been marked by poverty and struggle, the small inheritance he came into on the death of his father in 1871 allowed him to move to Argenteuil with his new wife Camille Doncieux and give free rein to all his generous impulses. Their first Argenteuil house – the substantial Maison Aubry – had a beautiful garden and plenty of room for guests. The town boasted a good school for their four-year-old son Jean, a frequent rail service to Paris, and excellent shops offering almost everything the couple might need, including the best asparagus in France. After living so long on the margins of destitution, Monet could at last settle into the *petit bourgeois* life to which, despite his bohemian profession, he naturally inclined. His Argenteuil period proved extraordinarily prolific. Over six years he painted around 180 canvases, an average of thirty a year, or, as one commentator has calculated, one every twelve days. Camille and Jean appear in over forty of them.

It was an exceedingly sociable period in their lives. Alfred Sisley paid a visit, as did Pissarro; Renoir, who was fond of Camille and would play with Jean while she made the lunch or dinner, was so frequent a guest that a bed was kept permanently reserved for him. Manet's family had property just across the Seine at Gennevilliers and he and Monet and Renoir spent much of the summer of 1874 working side by side in the garden of a new and even more agreeable pink-painted house with green shutters which Manet had been instrumental in finding for the Monets. Manet was a good friend in other ways too. Despite Monet's prolific output, sales were not always brisk and he often turned to Manet for financial support. Besides, he regularly spent more than he earned and his situation was not helped by his extravagant lifestyle. At a time when a labourer might expect to earn an average wage of 2,500 francs, Monet made between 9,000 and 24,000 and employed a staff of three, two to help in the house and a gardener – although they were still claiming outstanding wages years after he had left the area.

Just across the Seine from Monet at Argenteuil, Gustave Caillebotte had set up home with his mistress, Charlotte Berthier, and her little daughter, Jenny, at Petit Gennevilliers, where, in a substantial red-roofed country house, attractively decked out with wooden balconies, and surrounded by a beautiful garden, he received his friends – fellow artists, boating partners, bezique and billiard players. It was a far cry from the stifling bourgeois splendour of his mother's rue de Miromesnil apartment, and more than likely that, in living with rather than marrying Charlotte, he was striking a blow at the very foundations of his respectable beginnings. His mother's death had liberated him. He had the money

EDOUARD MANET
The Monet Family in the Garden at Argenteuil, 1874

Camille and Jean rest in the shade beneath a tree while Monet, in a blue shirt and round hat, potters about tending the flowers in his borders.

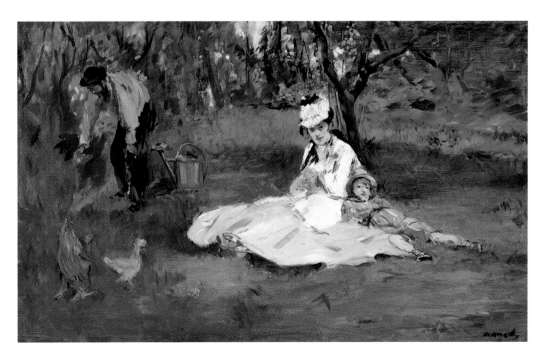

and the talent to suit himself and, at Petit Gennevilliers, lived a comfortable life, devoting much time to his garden and his twin passions – stamp collecting and sailing – at the expense, at times, of his painting though not his friendships.

Camille and Julie Pissarro were hardly ever in a position to splash out on luxuries although the year 1884 found them more comfortable than for a long time. With the aid of a loan from Monet, Pissarro had been able to scratch together the 31,000 francs he needed to buy the house he had been renting at Eragny-sur-Epte, where, on 22 August in that year the last of his six children, Paul Emile, was born. For once Julie seemed content. The house had a huge flower-filled garden and an old apple orchard making 'a kind of Garden of Eden, full of mystery, which,' he wrote to his son Lucien, studying in London, 'invited one to run wild, or to throw oneself down in the midst of wild grasses.' The younger children found the garden perfect for games and adventures. Julie had plenty of space to grow vegetables and fruit and kept rabbits in the backyard alongside the hen house and pigeon cot. The surrounding countryside was beautiful: hills covered with chestnut trees and the winding river Epte, just a field away from the house, curving through the valley of Eragny.

Pissarro's price had improved, too, and he could now expect to get about 900 francs for an oil, 200 for a watercolour and 150 for a pastel. However, it was hard to find buyers and harder still the following year when, after meeting Georges Seurat and Paul Signac, he began to change his style. Julie believed that her husband's 'dots' would bring them to the brink of ruin and, in truth, they did alienate some of the buyers the dealer Paul Durand-Ruel had found for Pissarro's earlier work. Once again Lucien was the conduit for complaint. 'Your mother believes that business deals can be carried off in style, but does she think I enjoy running in the rain and mud, from morning tonight, without a penny in my pocket, often economising on bus fare when I am weak with fatigue, counting every penny for lunch or dinner?' he wrote. Lucien diplomatically urged his mother to see things from Pissarro's point of view, reminding her that a 'discouraged man is incapable of working, and above all of working well.'

Despite his own setbacks Pissarro was still capable of responding wholeheartedly to the burning enthusiasm of others. Returning one day from Asnières where he and Lucien had visited Signac, they ran into Vincent van Gogh in the rue Lepic, close to the apartment he shared with his brother Theo. Vincent was dressed in a blue workman's smock and insisted on showing the kindly Pissarro his work there and then, oblivious to the comments and derision of passers-by.

The three conditions Monet needed to be met in order that he should be able to paint in 'tranquillity' – namely, the financial security 'to work all day', his family and a home – came together finally in Normandy. However it had not been plain sailing. When Monet first met Alice he was married to Camille and she was the wife of Ernest Hoschedé, one of his most devoted patrons and a director of one of those dazzling department stores that had become such a feature of Parisian life in the Impressionists' time. The Hoschedés had a lavish house in Paris and a large country estate but, in 1877, like a character in a Zola novel, Ernest's fortunes changed: he lost his Midas touch, became bankrupt and, near suicidal, temporarily abandoned his wife and six children. The following year the Monet and Hoschedé families joined forces, sharing a house in the village of Vétheuil. It was an improbable arrangement which became increasingly ambiguous after Camille's death in 1879 and the almost total absence of Ernest. In 1883, however, they decided to make a new start and Monet looked about for a house large enough for himself, Alice, and their combined family of eight children, ranging in age from five to nineteen. He found it, famously, in an old farmhouse at Giverny.

Photograph of Pissarro and his daughter Jeanne in his studio at Pont Neuf in Paris

Many of the Impressionists kept studios in Paris as well as at their homes outside Paris, even when they were relatively poor, as was often the case with Pissarro.

GUSTAVE CAILLEBOTTE
Dahlias, Garden at Petit Gennevilliers, 1893

Caillebotte installed the large greenhouse in front of his house shortly after taking up permanent residence in Petit Gennevilliers, and there experimented with propagating orchids, though it is his love of dahlias that is foregrounded in this painting, which also includes Charlotte and his dog.

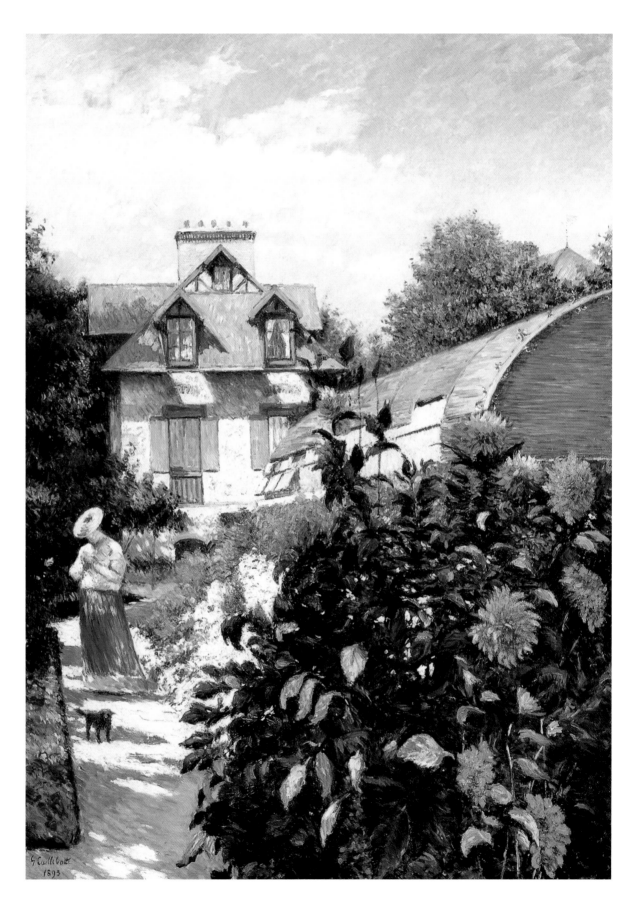

His art dealer, Paul Durand-Ruel, advanced him four-and-a-half thousand francs against future work to cover the initial settlement of rent and the costs of moving into the long, low house – a former cider farm – with ample gardens and walled apple orchards in the quiet Norman village, situated on the Seine, half-way between Paris and Rouen. The pink stucco Maison du Pressoir with its blue-green shutters had rooms enough for a family of ten, with the added plus of a large barn in the west part of the house, which provided Monet with the first of three eventual studios. Seven years would pass – during which Monet improved the house and re-landscaped the gardens – before he could finally purchase the property in 1890. Substantial sales in the seemingly insatiable American market had made him a rich man, although not all Impressionists painters reaped the same rewards. Pissarro complained in a letter to Lucien in 1891 that 'people want nothing but Monets, apparently he can't paint enough pictures to meet the demand...everything he does goes to America.' And Edmond de Goncourt observed sourly in his *Journal* that 'the Americans, who are in [the] process of acquiring taste, will, when they have acquired it, leave no art object for sale in Europe but will buy up everything.'

Prosperity enabled Monet to make Giverny bloom. He employed six gardeners, a chauffeur (to drive his Panhard-Levassor), a cook, a laundress and a maid. The house was very much Alice Hoschedé's province, though both Alice's and Monet's personalities are reflected in the choice of decoration.

The Monet and Hoschedé families, c. 1880

Monet is seen here standing at the left behind Alice, with his two and her six children under the lime trees at Giverny.

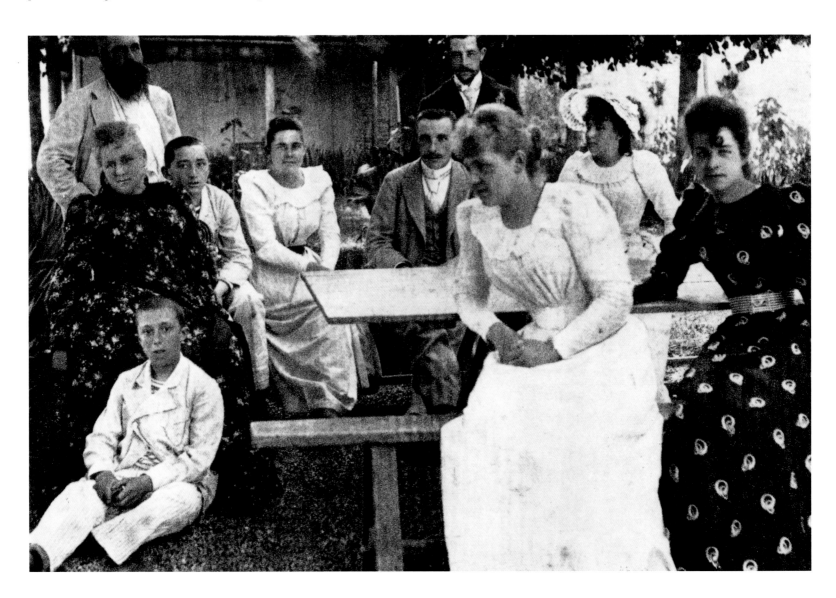

Monet's salon-studio at Giverny

Photograph of Monet in the salon-studio, Giverny, 1913

Monet's elongated house at Giverny had a good north-south aspect and a large room with excellent light provided the artist with the first of three studios, which also doubled as a drawing-room to which family and guests would repair after dinner for coffee, followed by brandy and liqueurs. Monet had brought little round glasses back from Norway and liked to drink his own home-made plum brandy from one of these.

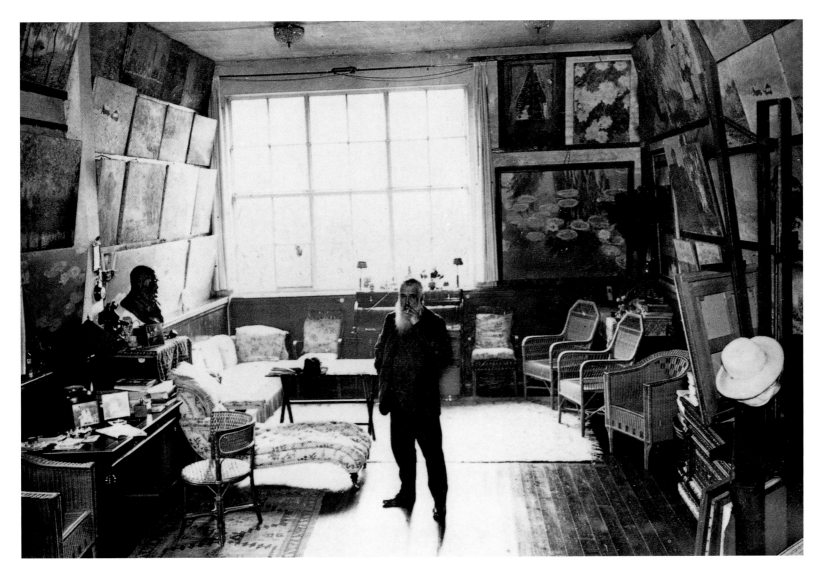

Their friend the painter Jacques-Émile Blanche, writing in 1893, described how 'Monet had lined his dining room walls with white damask cloth with Japanese designs on its silvery background.' This was about to change, however, for in October that year the room was repainted a sunny – if rather avant-garde – yellow to provide the perfect setting for Monet's collection of Japanese prints and a colour-coordinating blue and yellow dinner set, which Monet had designed himself, was introduced into service. Taken together with the mauve drawing room, this decorative scheme made a bold statement for the time. A small blue-painted panelled *salon* housed hundreds of books and, in 1897, the original studio was redecorated and refitted to become the family *salon*. Here Monet, surrounded by his own pictures hanging on the walls, would read aloud to the family.

Monet's hard-won privacy was threatened after 1885, however, when the first trickle of American artists, attracted to the rural charms of Giverny and drawn by the presence of the 'great master', swelled to flood proportions. Theodore Robinson was the first. The French artist Deconchy brought him over from Fontainebleau where he was painting and presented him to Monet, who was friendly and welcoming. As he was a little later when Willard Leroy Metcalf rang at the painter's gate with three student friends from the Académie Julian in tow. Monet invited them all to lunch and they spent an amiable afternoon painting in the garden with Blanche.

The sleepy little village of Giverny was hardly equipped for tourists, however. Metcalf and his friends had had to persuade the proprietress of the village café and grocery store, Angelina Baudy, to rent out her own room and to do a little cooking for them. Her cooking was impressive; her prices were absurdly low. Giverny was a find and they returned to Paris enthusing about the apple-blossom, the excellence of Madame Baudy's cuisine and the friendliness of the great father figure of French Impressionism. The flood gates were opened. At first Angelina and her husband Lucien responded to the influx of visitors by finding them rooms with local families but before long they decided to convert their house into the Hôtel Baudy, complete with an atelier in its gardens. Theodore Robinson's name is one of the first in the Hôtel Baudy register, swiftly followed by Louis Ritter, Henry Fitch Taylor, Theodore Wendel, John Leslie Breck and his brother Edward, along with their mother. Even enlarged, the Hôtel Baudy could scarcely cope with the demand. By 1887 there were so many Americans in Giverny during the spring and summer months that a tennis court for their use was constructed across the street from the Hôtel Baudy.

The dining room in the Hôtel Baudy, c. 1910

A studio in the Hôtel Baudy

The Hôtel Baudy grew out of the village café-cum-grocery and served an increasing number of artists making pilgrimages to Giverny. Here they drank neat spirits and played the piano or the banjo until late at night. The proprietor, Madame Baudy, worked hard to please her American guests by preparing Boston baked beans and stuffed spare ribs, squash and Philadelphia pepper pot.

GIVERNY. - Salle à Manger de l'Hôtel BAUDY

Phot. A Lavergne, Vernon

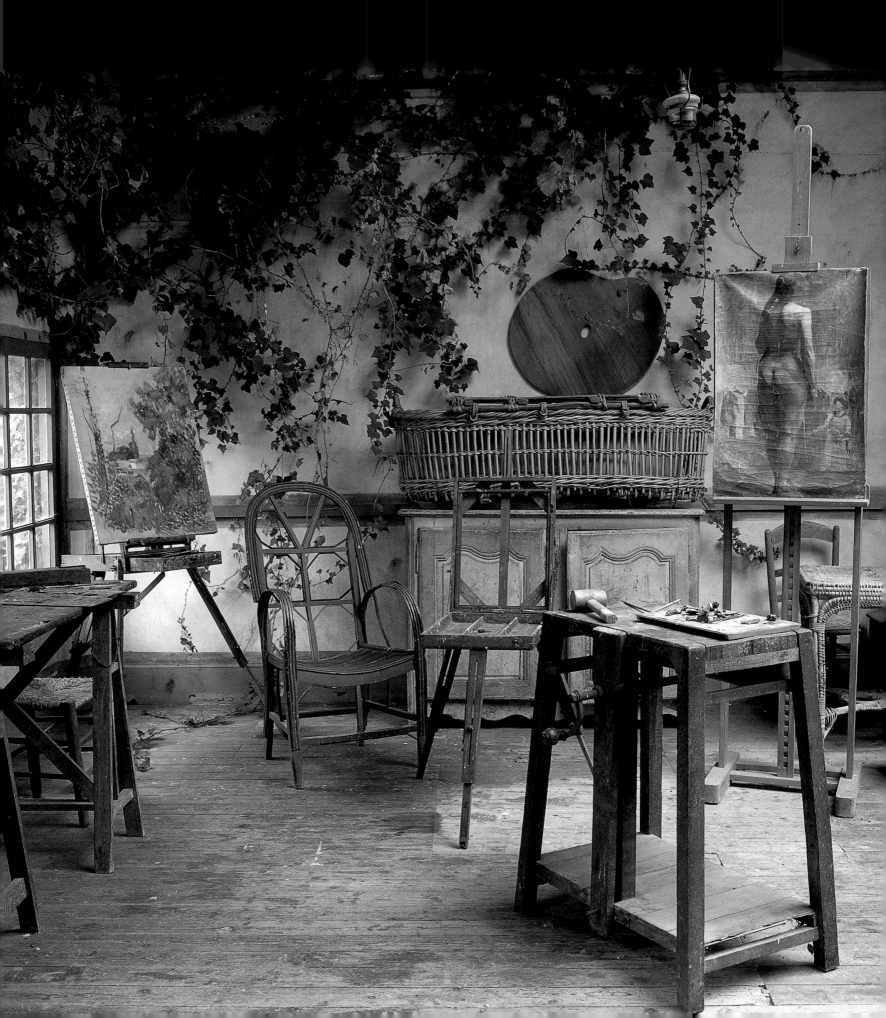

Monet's friendly interest in Robinson continued and the young American artist came to look on the older man as a mentor, though not in any formal sense. He was sure of a warm welcome in the Monet household, as was John Singer Sargent, who was a regular summer visitor for the four years between 1885–89 – the period during which he was most involved in the Impressionist aesthetic and when he began to buy and collect Monet's paintings. But there were just too many American artists arriving. The *salon* was becoming too crowded. Monet's rigorous routine was at risk. The drawbridge went up.

Especially after one young American overstepped the mark by proposing to one of Monet's stepdaughters. John Leslie Breck, who had stayed on in Giverny during much of the winter of 1887–88 and most of the following year, had become romantically attached to Blanche Hoschedé but Monet, who had at first befriended the Boston-born artist and invited him to paint with him, was energetically opposed to the match. Despite his own past history as an impoverished artist in love, despite Breck's obvious talents – his haystack series *Studies of an Autumn Day* pay particular homage to Monet – and his own profound influence on the painter, he was simply not prepared to countenance a struggling artist for a son-in-law and he did all he could to discourage the relationship. In 1891 a dejected Breck left Giverny for good, returning to the family farm in West Rutland, Massachusetts, where he continued to paint up to his early demise in 1899. Following his death, the American Impressionist artist, John Twachtman, credited Breck with having 'started the new school of painting in America.'

Blanche did finally marry in 1897 and this time Monet could not fault her choice, for she took for her husband his own son, and her stepbrother, Jean, but before that there were two other weddings at Giverny. For, where her sister had failed, Suzanne Hoschedé had succeeded, marrying one of the 'merry invaders' John Singer Sargent had brought to Giverny on 20 July 1892.

Theodore Earl Butler came from a distinguished family of American bankers and his friend Theodore Robinson was on hand to memorialize his marriage to Suzanne – a momentous event in the history of the American involvement with Giverny – in his painting *Wedding March*. Four days before the young couple's wedding, however, came another: Monet's own, to Alice Hoschedé, his companion these last dozen years. This sequence meant that Monet could take on the formal role of patriarch and lead his stepdaughter to the altar, though he found it all something of an upheaval: 'Excuse me,' he wrote to Paul Durand-Ruel in September 1892, 'for not having written for so long, but as you may have suspected, we have had a fair number of disruptions in our life which normally is so regular and peaceful.' His deep reservations about American artists, especially those seeking his stepdaughters' hands in marriage, had extended at first to Butler, but he came to like his new son-in-law very much and took great pleasure in his grandchildren, James (Jimmy) born in 1893 and Alice (Lili) the following year, not least because the growing family lived so close at Maison Baptiste, a cottage near Monet's estate.

The Butler house in Giverny became the centre of social activity for later generations of American artists and friends who rented or bought houses instead of lodging at the Hôtel Baudy. It was a heady, convivial atmosphere. Stanton Young, a first-class tennis player, set about organizing tournaments; Willard Metcalf accompanied Michel Monet and Jean-Pierre Hoschedé on their botanical trips, collecting birds' eggs; the local children made a point of including the American households in their carol singing round. Many artists rented rooms in the village, though some, like Lilla Cabot Perry and Mary and Frederick MacMonnies, bought their houses and lived in Giverny year round.

The quiet Norman village had become a colony for expatriate American Impressionists, a place where they could lead a bohemian life in an atmosphere sympathetic to their ideas and development as artists. Many of the first generation had moved back to America or – in the case of Breck and Robinson – suffered early deaths, but a new wave followed on, introduced and integrated into the group by the sociable Lilla Cabot Perry , who came from an aristocratic Boston family and, as a near neighbour of Monet's and fellow gardening enthusiast, maintained a long-standing friendship with the increasingly reclusive artist.

MacMonnies was a sculptor who became friendly, if not intimate, with Monet through dint of his long residency in the village. He and his wife rented various villas before finally converting and settling

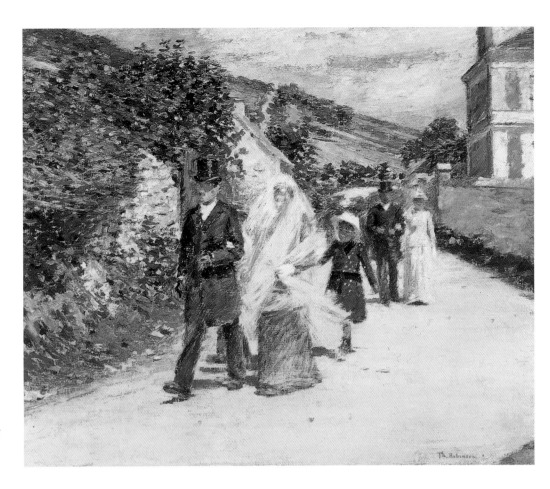

THEODORE ROBINSON
The Wedding March, 1892

The wedding of Monet's stepdaughter Suzanne
Hoschedé to the American painter Theodore Earl Butler
is captured on canvas by Theodore Robinson, hailed as
'the first American Impressionist.'

in Le Moutier, the village priory, known to their friends as 'the MacMonastery'. MacMonnies kept a studio in Paris but the bulk of his time was spent – pleasurably from the evidence of his wife's vivacious paintings – in the house at Giverny where he developed a formal terraced garden which, some argued, came to rival Monet's own. Here MacMonnies worked on his sculpture in a barn in the grounds, while Mary worked in a studio inside the house, which also doubled as their daughter Berthe's nursery.

Butler also captures the carefree domestic life of the Franco-American community at Giverny in paintings like his *Late Afternoon at the Butler House*, which, however, belies a tragedy at the heart of his family. For, following Lili's birth, Suzanne – Monet's favourite model among his stepchildren – became paralysed and died five years later in 1899, a shocking event which left Alice inconsolable and sent her into a deep and lasting depression. The story does not end there, however, for a year later, in October 1900, Butler married Suzanne's older sister Marthe, who had been attending her ailing sister and looking after the children. There was no painting this time to memorialize this second wedding, though photographs exist of the vast Monet-Hoschedé clan gathered on the steps before Giverny, joined by friends like Alfred Sisley's adult children, Jeanne and Pierre, and Alice's notebooks record the wedding feast in lingering detail. Butler, who had succeeded in marrying not just one but two of Monet's stepdaughters, found a new peace and deep contentment at Giverny during the first decade of the new century, though Alice's death in 1911 clouded the family's happiness and the First World War years were spent in America.

The war years were long and lonely for the widowed Monet, who could hear the shells exploding as he worked in his garden at Giverny and watch the wounded passing on stretchers along the Chemin du Roy. He was relieved when Blanche, who had continued to paint, returned to Giverny after Jean's premature death to become his devoted companion and housekeeper. His old friend Clemenceau – now once again Prime Minister of France – called her Monet's *ange bleu* when he dropped in to Giverny on his regular tours

of the front lines, though Monet was less grateful. Occasionally, in a rare moment of self-realization, he would murmur: 'How kind she is, and how maddening I must be to everyone' but he failed – despite his great wealth and unforgivably in the view of some – to leave any financial provision for Blanche after his death. Before that, however, came Monet's last great project: his vast waterlily landscapes which Clemenceau had persuaded him to revive. A massive studio was constructed specially in 1916 – costing more than the original purchase price of the whole property – and Monet worked on, despite his failing eyesight, until the end of his life painting the water motifs which had consumed and fascinated him for decades. Monet outlived many of his old friends, but made new ones like Pierre Bonnard, who became a frequent visitor to Giverny, and was with Monet just a fortnight before he died in 1926.

MARY FAIRCHILD MacMONNIES
Baby Berthe in Highchair with Toys, 1897–98

Cleverly combining motherhood with her career as an artist, Mary MacMonnies paints her plump daughter Berthe soberly surveying a selection of wooden toys set out before her.

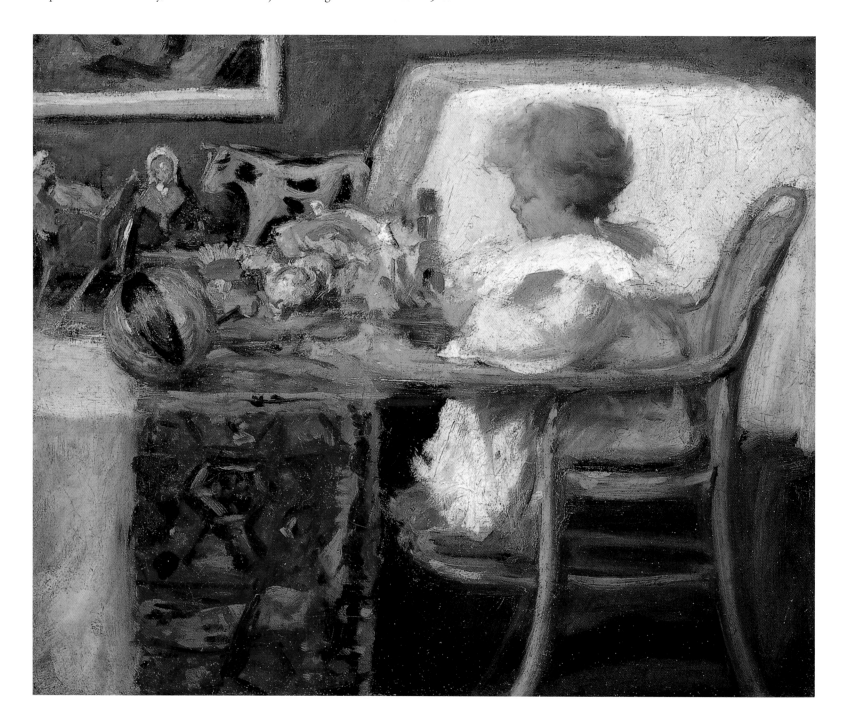

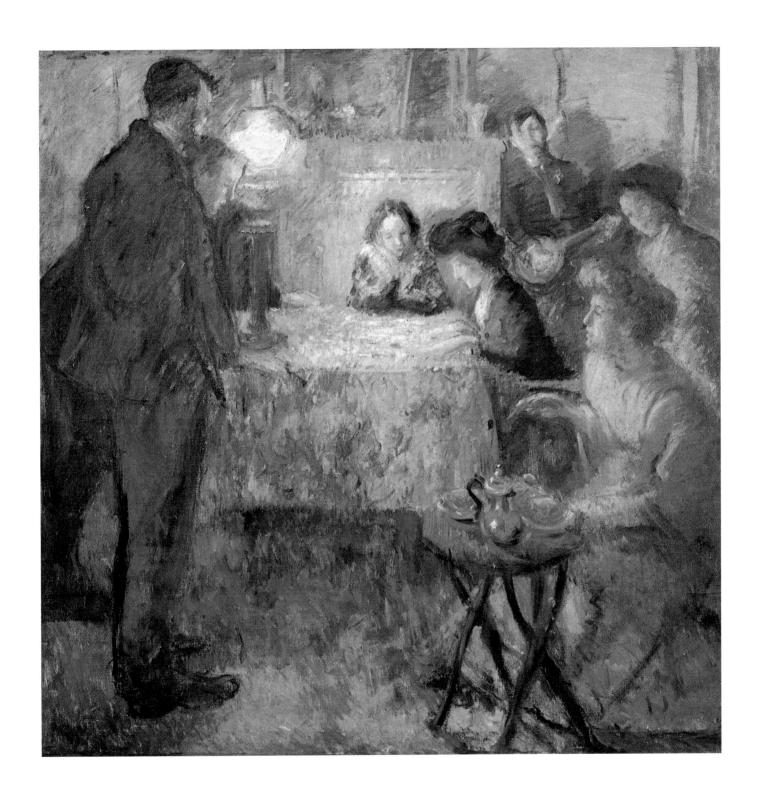

THEODORE EARL BUTLER
Late Afternoon at the Butler House, Giverny, c. 1907

An animated group gather round the warmly lit table
at tea time in Marthe and Theodore Earl Butler's house
at Giverny.

Reading

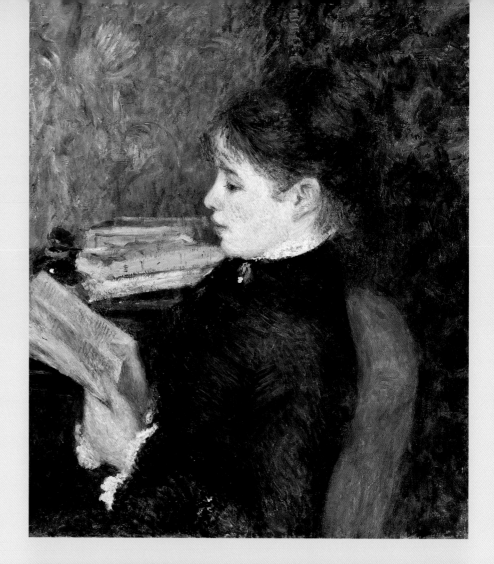

Reading was an activity often depicted by the Impressionists. Renoir paints the indispensable Gabrielle languorously leafing through an illustrated magazine; Manet tucks the studious Léon into the only dark area in the top right-hand corner of an otherwise luminous painting showing his wife Suzanne seated on a white sofa (see p. 11); Gustave Caillebotte portrays companionable silence in his double portrait of a young woman – possibly his mistress Charlotte Berthier – reading a newspaper while a young bearded man in the background (who has been identified as his friend Richard Gallo, editor of *Le Constitutionnel*) reclines on a vast sofa, engrossed in a book.

The Impressionists moved in the same circles as the leading writers of the day and signalled their interests and allegiances through their art – Manet's painting of *Nana,* the eponymous heroine of Zola's novel is the obvious example, while Degas's painting *Interior* of about 1868–69, also known as *The Rape* has been associated with a scene from another Zola novel, *Thérèse Raquin*. Like Zola, they found their subjects in the everyday life of the people.

We know something of their reading habits. In 1869 Degas wrote to Manet, asking to borrow two books by Baudelaire, an important author and seminal figure, whose rallying cry to portray modern life in a modern style spoke directly to the Impressionists, though Renoir – according to Ambroise Vollard – heartily disliked Baudelaire's *Les Fleurs du Mal*, detested Victor Hugo and couldn't bear Zola's novels. His penchant was for the novels of Dumas *père* and the seventeenth-century translation by Galland of the *Thousand and One Nights*. When Flaubert published *Madame Bovary* (which, like *Nana* was promptly pirated in America with each going on to sell nearly a million copies) it was immediately condemned as scandalously brutal by the same conservative critics who scorned the innovative art of the Impressionists. Deemed entirely unsuitable for young middle-class women we cheer when we hear that Berthe Morisot recommended the book to her sister Edma, who praised it as a great work of art, calling it 'astonishingly fresh and modern'.

PIERRE-AUGUSTE RENOIR
The Reader, 1877

GUSTAVE CAILLEBOTTE
Interior, Woman Reading, 1880

JAMES McNEILL WHISTLER
Pink Note: The Novelette, 1883–84

Monet liked to read aloud to his family in the big *salon* (formerly his original studio) at Giverny. He built up a substantial library which included the work of Aristophanes, Tacitus, Balzac, Tolstoy and Ibsen, though Alice – a great reader herself – encouraged his eclectic reading of the Goncourt brothers, Maupassant, Flaubert, Zola and friends like Octave Mirbeau and Stéphane Mallarmé. We know that Monet read John Ruskin's newly translated *Stones of Venice* before a visit to the city in 1908 and that the twenty-six volume *La Flore des serres et des jardins d'Europe* was a favourite gardening title, along with a number of horticultural magazines to which he subscribed.

Cézanne, who wrote poems in his youth, prized his copy of Baudelaire's *Les Fleurs du Mal* and returned again and again to Virgil's *Ecologues*. In later life, when he found it difficult to sleep, his wife Hortense would often read aloud to him, sometimes for hours at a time, amply illustrating the quality of patience Cézanne captures so succinctly in his many portraits of her. Degas, too, wrote a number of sonnets, though Daniel Halévy, in his book *My Friend Degas*, summons a sombre picture of the elderly painter, recalling how he advised the younger man not to read at all. '"You only do it out of laziness to avoid thinking. A man should be able to spend hours by his hearth, watching the fire burn, thinking over cherished thoughts – one must have one's own personal thoughts." I tell it badly,' Halévy wrote, 'but he spoke very emphatically with something of the fury of a blind man who can't read.'

Popular American authors included Mark Twain, James Fenimore Cooper and Nathaniel Hawthorne, and the act of reading was a favourite subject for American Impressionists like John Singer Sargent, James McNeill Whistler, Frank Benson and Mary Cassatt, though there is a crucial difference of intellectual tone between, say, Whistler's *Pink Note: The Novelette* and Mary Cassatt's *Le Figaro* (see p. 40). Young women were steered towards authors like Louisa May Alcott, whose heroines were considered robust and sensible, and away from French novels, which were deemed risqué. When a woman sat down to read it was often perceived as a frivolous pastime, but for a man it was viewed as an intellectual pursuit. For this reason, when Mary Cassatt painted her mother reading *Le Figaro*, a serious political paper, she was making a strong statement about equality and modernity. The following year Cassatt's father wrote proudly to his son Alexander that Mary drew respect 'among artists and literary people,' not only as a painter, 'but also for literary taste & knowledge & which moreover she deserves for she is uncommonly well read especially in French literature.'

JOHN SINGER SARGENT
The Breakfast Table, 1884

PAUL CÉZANNE
Portrait of the Artist's Father Reading L'Evenement,
1866

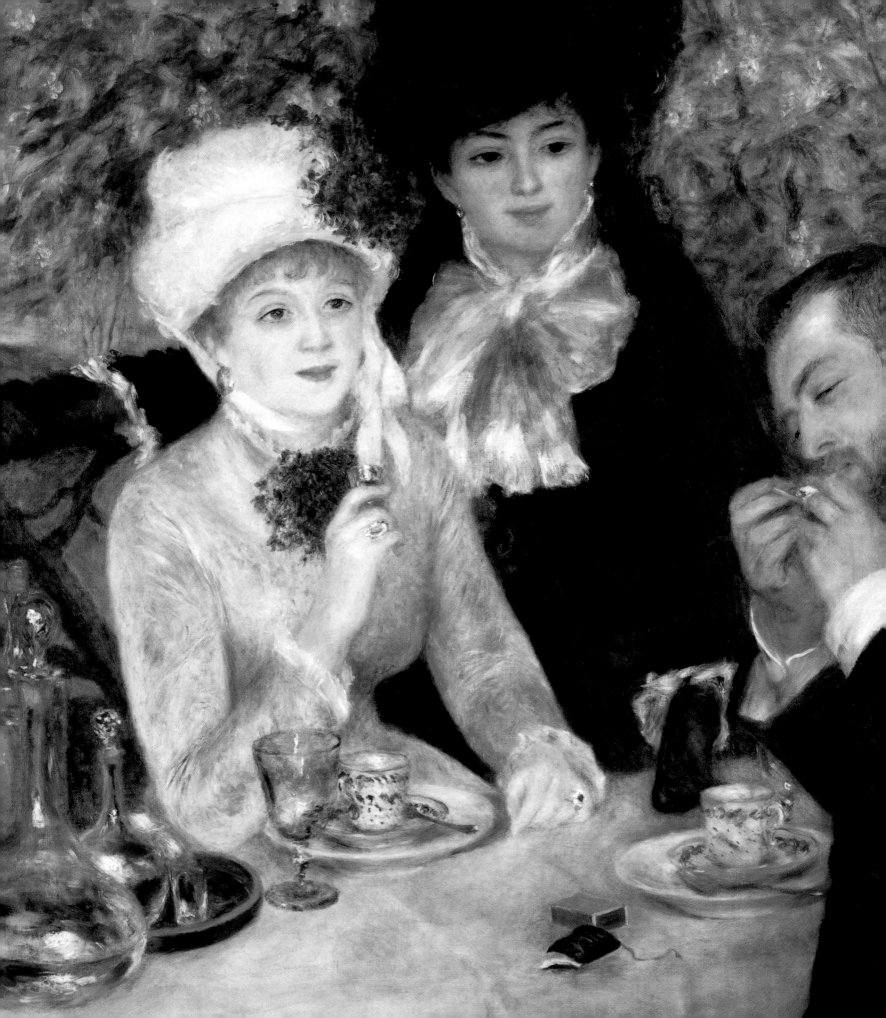

A Place to Eat
FEASTS AND FRUGALITY, KITCHENS AND CONNOISSEURS

PIERRE-AUGUSTE RENOIR
After Lunch (detail), 1879

Contentment exudes from the male diner, who lights a cigar in the company of two pretty women, who include the actress Ellen Andrée on the left.

Food – even when it was absent – played an important part in the lives of the Impressionists. Monet was a great *bon viveur* and lavish host. As his fortunes improved, so did his table and Alice Hoschedé's bound books of menus testify to some splendid dinners. Cézanne's mother's fennel soups and brandade of cod – 'ambrosia of the gods' – contributed to Renoir's decision to move to the South of France. Manet's love of asparagus found form in a still life, bought by the banker and amateur art historian Charles Ephrussi for 800 francs, though Ephrussi apparently overpaid Manet, who immediately dashed off another painting of a single stalk, which he sent along with a note: 'Your bunch was one short.' Berthe Morisot included some daring foreign dishes in her repertoire, including Mexican saffron rice and chicken with dates, while Degas was rumoured always to serve the same dinner – *rillettes de pays,* chicken, salad and preserves – to his guests. When Henri de Toulouse-Lautrec, heir to one of the

EDOUARD MANET
The Asparagus, 1880

The Bundle of Asparagus, c. 1880

Manet's bundle of stippled cream asparagus immortalizes the gastronomy of the Paris region. The single stalk is typical of the little still lifes that Manet liked to send to friends as expressions of fondness. He painted a bunch of violets for Berthe Morisot in 1872 and three apples for Méry Laurent in 1882.

oldest French families, was born in Albi on 24 November 1864, the baptismal feast lasted a week. 'The Toulouse stomach' was famous for miles around and vast quantities of food were prepared in the great kitchens of his parents' house, the old Hôtel du Bosc, and consumed by family and guests who came from all over the Midi to feast on deer and pheasant, salmon and trout, jellied eel, pâté de fois gras, and rare cheeses sent from Paris.

Renoir was forty when he met his future wife in – significantly – a restaurant: the tiny Crémerie de Camille, opposite his studio in the rue St-Georges, which, in addition to selling cream, milk, butter and eggs, provided simple meals for a few regulars who could buy their wine from the dealer next door. With the good-natured proprietress clucking over him, Renoir would sit down to a bowl of broth and a slice of boiled beef and beans, or a veal or mutton stew, followed by a piece of cheese (brie, which he called 'the King of cheeses', was his favourite), in the company of local workmen, house-painters and young seam-stresses, including, one day in February, the nineteen-year-old Aline Charigot, who lived nearby with her mother, Mélanie. Like Pissarro's wife, Julie Vellay, Aline was a country girl from Burgundy, who,

PIERRE-AUGUSTE RENOIR
Breakfast at Berneval, 1898

Renoir found the chalet Aline rented at Berneval, on the coast near Dieppe, cramped and uncomfortable and indicates this in the way he wedges his teenage son, Pierre, into the foreground of this painting. The trio of figures is completed by Gabrielle and Jean, now almost four but still sporting his long curls.

Auguste Renoir and friends at dinner,
Les Collettes, Cagnes, c. 1905

A true Frenchman, food was always important to Renoir, who greatly enjoyed the specialities of the Riviera.

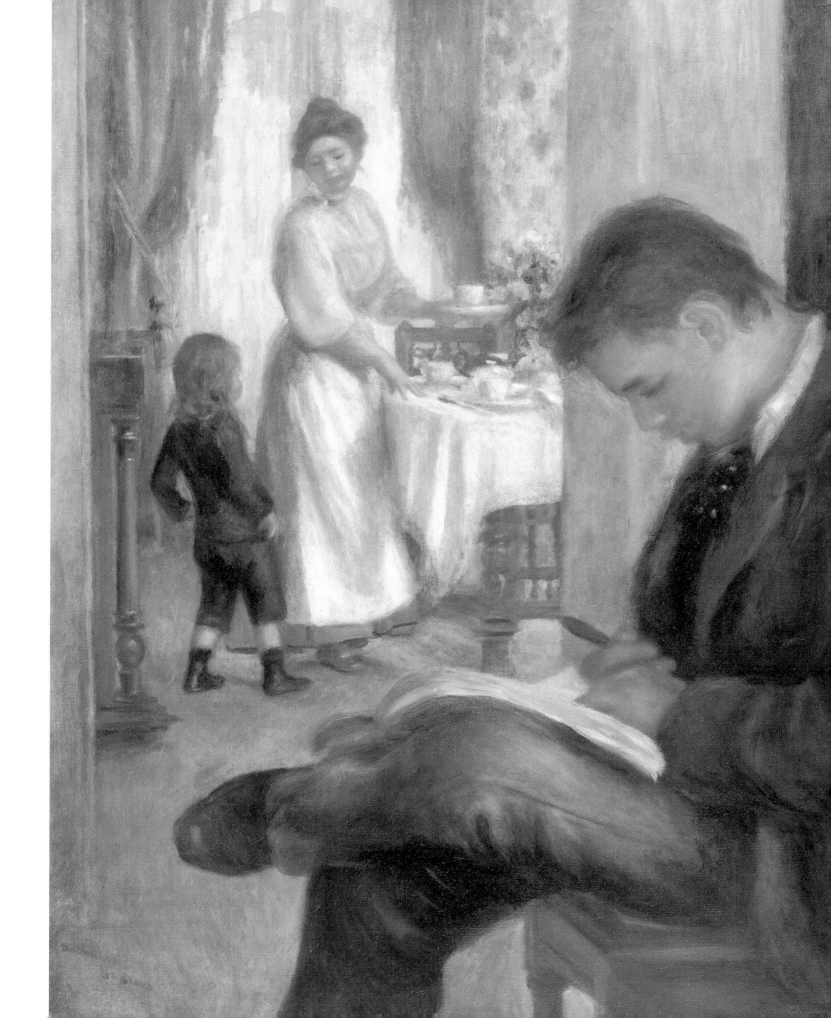

according to Renoir 'walked on the grass without hurting it.' Always quick to spot a pretty face, Renoir asked her to sit for him and she soon became his favourite model. We see her, a slender, pouting young woman, playing with her little dog in the group featured in *The Luncheon of the Boating Party* and smiling out over the shoulder of her dance partner in *Dance in the Country.*

At first they lived together, unmarried, in the rue Houdon with Mélanie Charigot, who was a fantastic cook – whipping up 'soufflés, blanquette of veal and caramel custard' – but later moved to Montmartre and, later still, they married. Aline could work wonders in the kitchen. A simple, practical woman whose one concern was Renoir's well-being, she knew how to stew a rabbit with garlic and olives, transform even the most unpromising chicken, and prepare a sumptuous *bouillabaisse* for guests. Even when they were relatively poor, she had help. She could always call upon Madame Mathieu who was both laundress and cook to the family, but in 1894, pregnant with her second child, she decided to invite her young country cousin Gabrielle Renard to Paris to help with the children and the housework. Gabrielle was fifteen years old, convent educated and, like many young teenage girls, making her way to the capital from the countryside for the first time. She proved more than capable, however. According to Jean Renoir, who wrote a vivid memoir entitled *Renoir, My Father*, she knew how to sew and iron and she could 'guess the year of a wine, catch trout with her bare hands without being caught by the local policeman, look after the cows, help bleed the pig, gather greens for the rabbits and collect the manure dropped by the horses when they returned from the fields'. She also had a skin which 'took the light' which meant that very soon her duties also included posing for Renoir.

When Gabrielle first joined the Renoirs they were living in Montmartre. Jean Renoir recalled how the women in the district never 'stood around chatting idly.' They were 'always busy, bursting into a neighbour's kitchen unannounced to ask for a sprig of chervil, or to bring over a sample of the wine their husbands had freshly bottled.' Living in Montmartre was like being in the country at this time: the steep, twisting streets and narrow rustic lanes had escaped Baron Haussmann's heavy hand and the district was dotted with bucolic windmills, thriving market gardens and picturesque taverns. There was even a working farm and each morning Gabrielle would collect fresh milk from the small farm house, gathering snails from the hawthorn bushes on the northern side of Montmartre between the Moulin de la Galette and the rue Caulaincourt on her way back. Both Aline and Gabrielle put themselves out to please the painter. Renoir loved herrings – grilled on a charcoal fire and served with a memorable mustard sauce – and Aline would place her order with a local woman, Joséphine, a fishmonger, who left early for Les Halles market each morning and returned to sell her wares in the streets of Montmartre.

For fruit and vegetables or brioche from the pastry shop, Aline or Gabrielle would have to venture down the hill to rue Lepic, or further to rue des Abbesses, where, on special occasions, they might order a vol-au-vent or a pâté at Bourbonneux or perhaps some smoked eel from Chatriot's. Their life was informed by small rituals. On Good Friday Aline would prepare her famous fennel-infused *bouillabaisse*, using small crayfish and scorpion fish, ordered direct from Marseilles and collected from the Gare de Lyon by Gabrielle. And, on Saturday nights, for their open house, Aline, continuing the family tradition, cooked a huge *pot-au-feu* on a charcoal-burning kitchen stove. 'If no one showed up,' Jean recalled, 'we were obliged to eat boiled meat for the rest of the week.' That didn't happen often, however, for among their circle of artistic, bohemian or intellectual friends, who regularly trekked up the hill to the house on the rue de Girardon, were Ambroise Vollard, Georges Rivière and the musicians Emmanuel Chabrier and François Cabaner.

Aline was growing plump and often found herself too short of breath to do the cooking personally, though she made sure that she supervised all the preparations from her kitchen chair – shelling peas with baby Jean on her lap – and made up menus to include all Renoir's favourite foods: spit-roasted meats, chestnuts and potatoes cooked on the open fire, red beans with bacon, cooked in the regional ways he liked best. The kitchen was generally a hive of activity for there was much to do. Large loaves of bread were cooked alongside a piece of pork or vast fruit tarts with greengages, cherries, plums or apples. Most of the food preparation took place on a sturdy central wooden kitchen table, which was kept

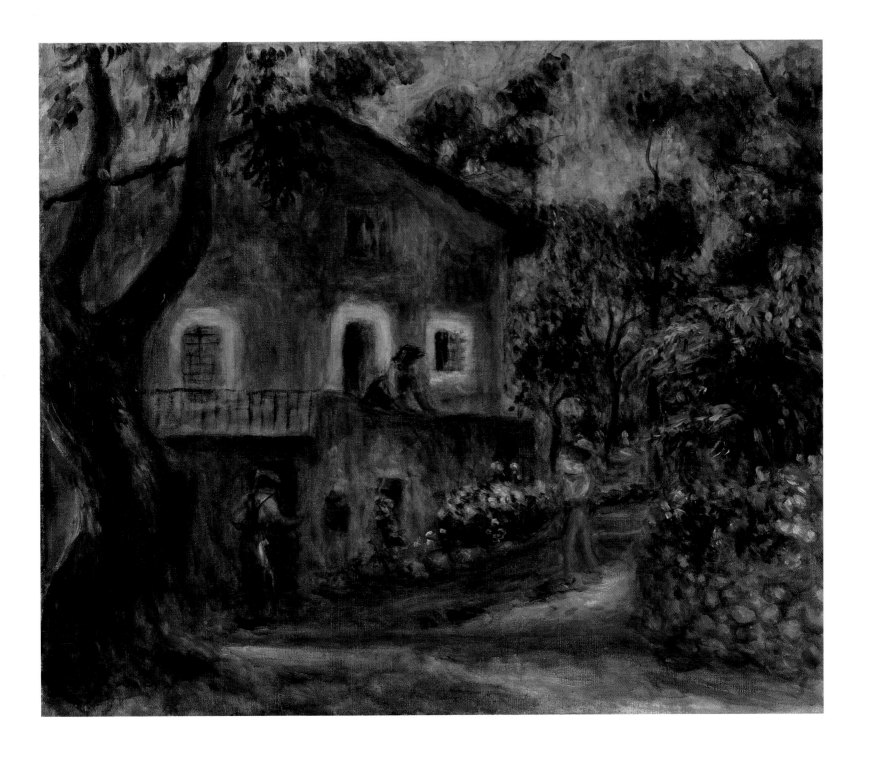

PIERRE-AUGUSTE RENOIR
The House at Les Collettes, Cagnes, 1912

Rather than paint his own house, Renoir preferred to
depict this farmhouse on the estate at Les Collettes,
which he saw as a symbol of a continuing rural tradition.

well-scrubbed, though a smaller marble-topped table was used for rolling pastry. Food was kept in a cool pantry off the kitchen, away from the heat of the range. Linen and cutlery were stored on the deep shelves and in the drawers of dressers fitted into alcoves in the dining room – like those seen in Monet's *The Luncheon* (see p. 80) and in photographs of his own yellow dining room at Giverny – with bulkier items such as bread bins and large storage jars placed in the deep cupboards or on an open shelf underneath.

The Renoirs spent their summers in a house by a stream in Aline's home village of Essoyes in the Champagne district. Jean Renoir recalls the quiet domesticity of the evenings: 'In the corner the food was cooking on the open fire, in another corner the house girl was heating irons. In the middle, hanging on a hook above the fire, the soup simmered in a huge cast-iron pot.' Eventually in 1898 Renoir bought a house on the outskirts of the village, decorating it simply with country antiques and hanging his own unframed canvases on the walls. Aline made curtains of bright coloured calico bought from the local market and over time Renoir added a studio at the rear of the garden and a billiard room, illustrating just how far he had come up in the world. By 1903 Renoir's arthritis had driven them south for the sun and they began spending the winters at Cagnes-sur-Mer, taking Gabrielle along with them, of course, for Aline, now in her forties and a lot less lighter on her feet, had a new baby – Claude, always known as Coco – and was finding the amount of effort involved in maintaining a home and looking after small children overwhelming and physically exhausting.

Since they found themselves spending more and more time in the South of France, Renoir bought a piece of land and, in 1907, built himself a large comfortable house, Les Collettes, overlooking the sea where he could receive his many friends. The house had a large, formal dining room fitted with French windows, and all the modern conveniences of electricity, running water, a telephone and central heating. 'Old Louise' presided over the kitchen which boasted a brand new wood-burning stove. For their first Christmas she followed the traditional turkey with thirteen Provençal desserts – catering it would seem principally to the sweet tooth of the mistress of the house, for Renoir's appetite, along with his health, had diminished. Getting around was becoming difficult. The house was built on a hill and, in 1911, Renoir bought a Renault 14-20 CV and employed an Italian chauffeur called Bistolfi to drive him up and down to Cagnes and facilitate trips to his doctors at Nice and Cannes. Despite his not inconsiderable problems, he wrote optimistically to Rivière: 'It doesn't seem as if misfortune could ever reach you in this wonderful region. We live a completely sheltered existence.'

Despite his irregular and bohemian youth, Monet came from good middle-class stock and it was to this bourgeois style of life that he returned at Giverny, becoming a great gourmet, as particular about his food as he was his paints. Along with Renoir, Monet was one of the most convivial of the Impressionist painters and certainly the one with the most robust appetite. He spent the last forty-three years of his life at Giverny, where his strict routine was governed by the light and his fondness for meals. He would rise at five to decide – after a quick inspection of the sky – whether or not the day was suitable for painting. If it was, and whatever the season, he would take a cold bath and sit down, at five-thirty, to a hearty hot breakfast of eggs, bacon and grilled tripe sausages, followed by cheese – often Dutch Gouda or the English Stilton he had developed a taste for on his trips to England – with toast and orange marmalade, all washed down with tea. His stepdaughter Blanche, who was also a painter, often kept him company at this meal and together they would set off, Blanche trundling a wheelbarrow filled with painting equipment, to whichever site in the garden, or down by the lily pond, Monet had decided to paint that day. At eleven-thirty the family was summoned to lunch by two rings of an outside bell. The table could comfortably seat fourteen, with room for a further six places to accommodate Monet's frequent guests; or they might lunch outside on the wide wooden terrace from which Monet's lovely garden, sloping away down to the river, could be admired in all its glory. Monet adored black pepper and would dress the salads himself at the table. Endives from his own vegetable garden, laden with garlic and croutons or dandelion leaves with strips of bacon, were favourites. Lunch was a substantial and gregarious meal which often ended with fruit 'as beautiful as flowers' placed on the table.

Monet in the dining room at Giverny, *c.* 1900

The dining room at Giverny

Two views of the yellow dining room at Giverny, showing Monet's collection of Japanese woodcuts. Here Monet presided over some memorable meals, including the celebratory lunch held each year on his birthday on the 14 November, when it was customary to serve woodcock and a large fish – either pike or turbot.

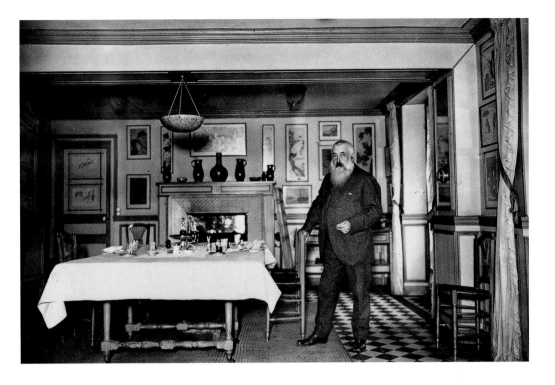

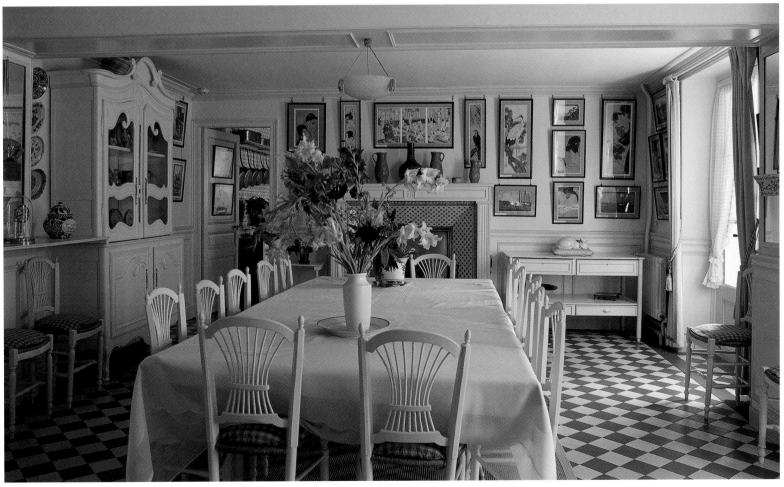

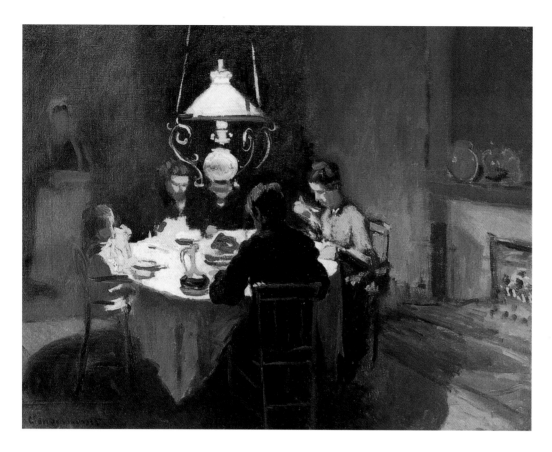

CLAUDE MONET
Lunch at the Sisleys, 1868–69 or 1872

The warm tones and glow from the overhead lamp all conspire to draw the viewer into the congenial circle grouped around the table.

After a stroll around the garden, sipping a glass of the homemade plum brandy, Monet would return to work until it was time for tea, taken on the lawn. He preferred not to entertain in the evenings, as he liked to be in bed by nine-thirty, after a dinner which could hardly be described as frugal.

The house was practically self-supporting. The Monets kept turkeys and chickens, good-quality birds like the Bresse hen; the children were willing fishermen and the river was well stocked with fresh fish, including eel; and a team of six gardeners maintained the vegetable garden and the luxuriant flower garden which unfolded in a rippling sea of colour beyond the windows of the yellow-dining room. The large light and airy blue-and-white-tiled kitchen was constantly being modernized to keep up with new developments. Out went the open fireplace, with its cumbersome variety of spits and hanging hooks, and in came a handsome Briffaut stove over which the famous Marguerite reigned, surrounded by a formidable array of gleaming copper pans and fish kettles, concocting soups and casseroles, soufflés and stews, steaming the tiny vegetables brought in from the kitchen garden and whipping up egg whites for an apple meringue. Of all the many cooks Alice employed at Giverny over the years, Marguerite was undoubtedly the best. She became so precious to her employers that when she was about to marry, Monet immediately employed her husband Paul as a butler rather than risk losing her.

Many of the improvements the Monets made to the kitchen were designed to provide a better working environment for Marguerite. The coal-burning, cast-iron range was easier to clean and the separate ovens for roasting and baking, with dampers to adjust the temperature, were a considerable improvement on the blasting oppressive heat of an open fireplace. Many middle-class homes were installing similar ranges, together with other innovatory marvels, like the refrigerator (an improvement on insulated ice chests, lined with zinc or slate, or the old meat safes) and mincing machines (the fore-runners of the modern food processor, though their many complicated parts had to be cleaned carefully).

Monet was gregarious and kept in touch with his fellow Impressionists, extending warm invitations to them to visit him at Giverny. On 23 November 1894 he told Gustave Geffroy that he hoped 'Cézanne will come here again and join our party, but he is so strange, so afraid of meeting someone new, that I am afraid he will let us down...How unlucky that man has been not to find enough support in life! He is a true artist who has come to doubt too much, and he needs to be encouraged.'

Despite Monet's fears, Cézanne did arrive, though he proved as strange and 'intensely emotional' to Geffroy as Monet had implied he might. During a tour of the garden, he threw himself on his knees before the sculptor Auguste Rodin, 'to thank a celebrated man for having shaken his hand' and became even more agitated when Monet invited Renoir, Sisley and a few others to dinner to welcome him. During the dessert, as Monet was making a sincere and innocent speech, on behalf of the others, assuring Cézanne of their affectionate admiration, he burst into tears and, stuttering, cried, 'You, as well, Monet! You, too, are making a fool of me.' Then, jumping up from the table, he bolted back to Aix, leaving unfinished canvases behind in his room at the Hôtel Baudy which Monet had to arrange to be sent on after him.

The Kitchen at Giverny

The tidy kitchen at Giverny, with its blue Rouen tiles and bright copper pans, fish kettles, casseroles and sieves, was a model of order. The cook was assisted by two kitchen maids who would prepare the vegetables, delivered very early each morning from the kitchen garden, at the long table, while pans simmered on the range.

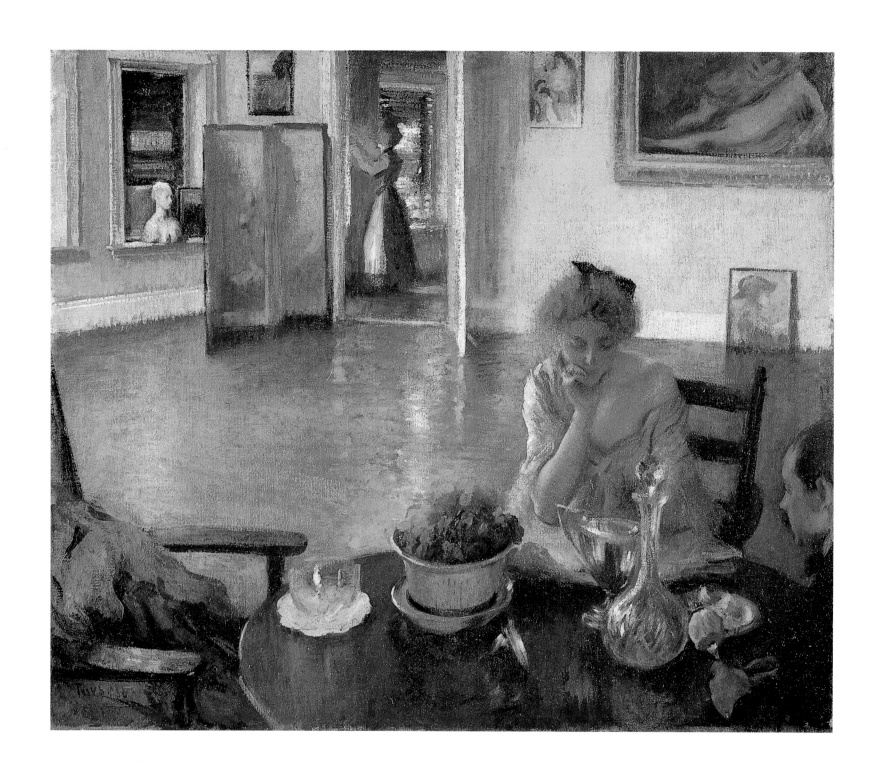

EDMUND C. TARBELL
The Breakfast Room, c. 1903

This picture sets up an interesting counterpoint
between the couple enjoying a leisurely breakfast
and the maid, just glimpsed through the doorway,
going about her chores as if invisible.

It has been suggested that the American Impressionists – painters like William Merritt Chase, Edmund C. Tarbell, Childe Hassam and J. Alden Weir, who had formed friendly ties with Mary Cassatt and Claude Monet in the 1890s – portrayed a fairly narrow, upper-middle-class slice of society, most often their families, presenting a view of the daily life of the few, rather than the many. The charge is that while French Impressionists explored the social and sexual change unfolding around them, American artists isolated themselves from the sordid business of urbanization and retreated into a leisurely, nostalgic world, discreetly staffed by servants, glimpsed through open doors in the distance. Yet their pictures were never sentimental and paintings like Tarbell's *The Breakfast Room* and William MacGregor Paxton's *The Breakfast* tackle intensely modern issues, hinting, as they seem to do, at complex tensions and vast emotional distances between men and women. The former shows a couple at a table in large opulent room hung with pictures. The floor is glossy with wax. A trim servant in a neat white apron, framed by the door, is purposefully engaged, perhaps putting away some linen. Her orderly industry is contrasted with the picturesque dishevelment of her mistress (a paid model called Mary Sullivan), who is depicted idly reading a newspaper, while the man squeezed into the right hand corner of the picture appears engrossed in the orange impaled upon his fork, which he is peeling. The couple studiously ignore each other. The tension in the room is palpable. A Boston journalist called it 'one of the best modern interiors ever painted.'

As leisure time increased for the privileged classes in America so too did expectations. Bigger homes and increased standards of living led to a new emphasis on cleanliness, involving new demands on a woman's time and energy. Hiring and training servants was just one of many tasks that fell to middle-class women and finding the right sort of girl was becoming difficult in a radically democratized America. As early as 1869 Harriet Beecher Stowe and her sister Catherine were asking where the 'race of strong, hardy, cheerful girls, that used to grow up in country places, and made the bright, neat, New-England kitchens of old times' had gone. Their response to this dearth was to bring out a self-help manual entitled *The American Woman's Home*. 'The first business of the housekeeper in America,' they exhorted in the chapter entitled 'The Care of Servants', 'is that of a teacher. She can have a good table only by having practical knowledge, and act in imparting it. If she understands her business, practically and experimentally, her eye detects at once the weak spot; it requires only a little tact, some patience, some clearness in giving directions, and all comes right.'

Edouard Vuillard and Pierre Bonnard were later Impressionist painters who found inspiration in the domestic routines which unfolded around them. Vuillard's fascination with pattern is anchored in his early years when his mother would spread overlapping samples of material across the dining room table as she worked. Bonnard wanted to 'show what one sees on first entering a room, what the eye takes in at once glance. One sees everything, and at the same time nothing.' Carl Schmitz-Pleis and Henri Le Sidaner's slightly later paintings also have something to say about the quiet pleasures of an ordered life.

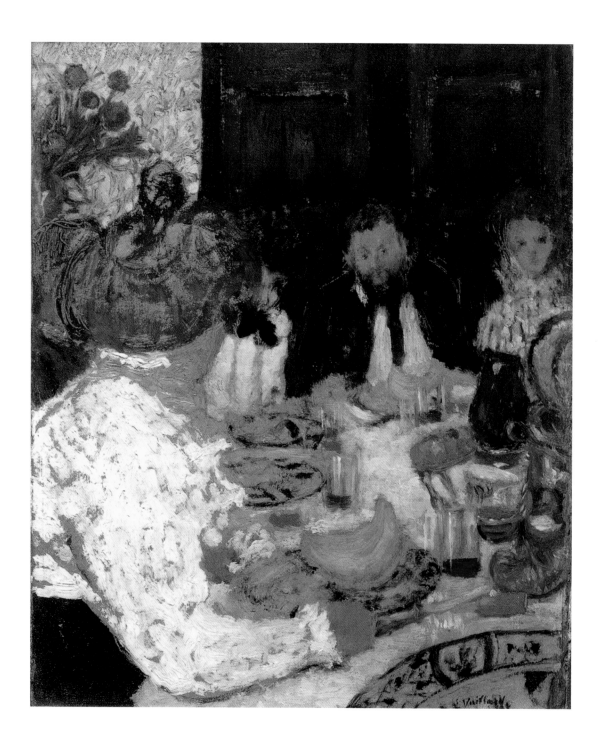

EDOUARD VUILLARD
The Luncheon, c. 1897

Vuillard often depicted the ritual of a family meal
around a circular table, staged in the various
apartments in Paris he lived in with his mother and
sister, Marie. The table would often double as a space
upon which to spread out needlework tasks associated
with his mother's corset-making business, with which
Marie helped.

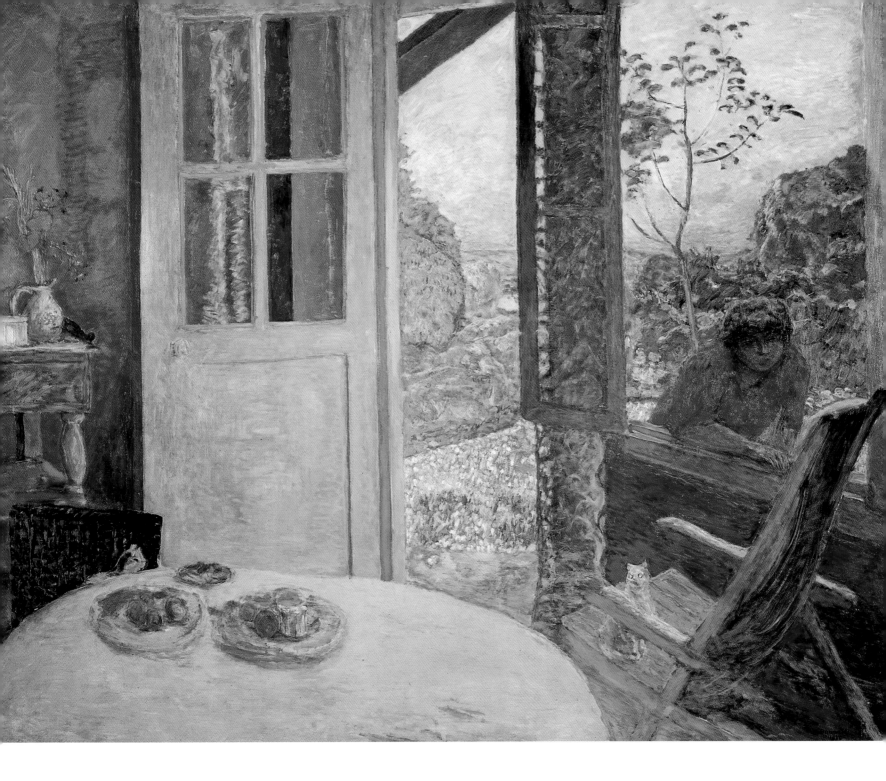

PIERRE BONNARD
Dining Room in the Country, 1913

Bonnard's mistress Marthe leans in through the open
dining room window of their house in Vernonnet, the
next village to Giverny along the Seine, and an easy
walk for Monet and Bonnard who began to exchange
visits before the First World War. In the foreground a
table is spread with a translucent milky white cloth
and behind her the garden explodes in a riot of colour.

CARL SCHMITZ-PLEIS
At the Coffee Table (detail), 1926

A shapely shouldered young woman sits in a wicker chair with her back to us reading a note at a simply laid table.

HENRI LE SIDANER
The Table in the Country, 1918

The urban sophistication and restraint of the image on the left contrasts with this abundantly laid table set in the garden of a house in the country. The wine – local, no doubt – has already been poured into the glasses. Water jugs and steaming dishes full of sturdy country fare await the arrival of the diners.

The Impressionist Appetite

France is the home of *haute cuisine*, of clever complicated cooking, painstakingly produced with much culinary dazzle. *Fin-de-siècle* appetites ran towards rich foods, sensuous sauces and heavy desserts. The Impressionists, though governed to some extent by their fluctuating fortunes, generally ate well both at home and in public places. In Paris, students and struggling artists in the Latin Quarter could eat a 'simple meal' of soup, a plate of meat and vegetables, salad, cheese, dessert, half a bottle of red wine and bread for a couple of francs at modest restaurants like the Dix-Huit Marmites and Renoir's favourite Chez Camille. In January 1873, when the cheapest seat at the opera cost a few francs, the most expensive fifteen, a meal of Ostend oysters, onion soup, a main course and dessert, at the Restaurant Barrate in Les Halles, set Gérard de Nerval back seven francs, including a bottle of claret.

There is some evidence to suggest that Berthe Morisot may have suffered from an eating disorder as a young woman – photographs from the period show her alternately plump and worryingly thin and in March 1870 her mother wrote to her sister: 'I do not think that Berthe has eaten half a pound of bread since you left; it disgusts her to swallow anything. I have meat juice made for her every day. Oh, well!' – but this appears to have righted itself and, as a married woman and popular hostess, she was well known for the quality of her table.

Renoir, as we have seen, loved his food and ate well at home and when he went away, writing to Ambroise Vollard from 'my little Hôtel de la Paix' in Aix-les-Bains on 3 May 1900, where he felt 'very coddled,' to report teasingly: 'They make me little gourmet meals that that glutton Vollard would be very happy to taste...' Degas, meanwhile, despite his famous crustiness, his intolerance of bores and his own eccentricity and whims, dined out frequently at the homes of friends and returned the invitations.

Berthe Morisot recalled being admirably entertained by Sisley, his wife and daughter over lunch in 1883, after which they all set off in charabancs to Moret and the forest of Fontainebleau; Pissarro and his wife Julie often feted friends round the oval table in their dining-room, which was hung with paintings by Cézanne, Monet, Delacroix, Degas and Van Gogh and crowded with drawings and watercolours by Manet, Cassatt, Sisley, Signac and Seurat.

Seurat was a great friend of Pissarro. Shy, secretive and obstinate, Degas called him 'the notary' because he

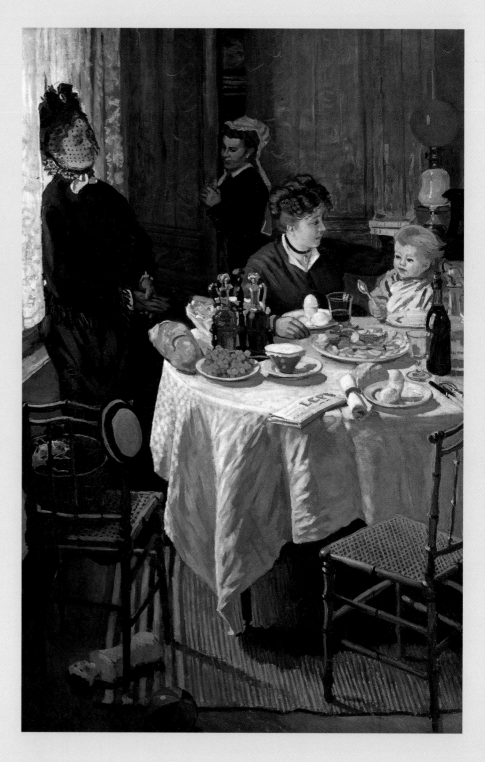

CLAUDE MONET
The Luncheon, 1868

CLAUDE MONET
The Jar of Peaches, 1866

The Self-Freezing Ice Cream
Machine, c. 1907

GUSTAVE CAILLEBOTTE
Still Life with Oysters, 1880–82

was always immaculately dressed in blues and blacks. His obsessive routine left little time for socializing. He ate a rapid lunch at the restaurant nearest to his studio and took his evening meal at home. Cézanne, like Seurat not the most sociable of the Impressionists, was nevertheless a kind host, instructing his housekeeper Madame Brémond to produce a dish of chicken with olives and tiny mushrooms which the young writer Léo Larguier pronounced 'excellent' the day he nervously came to Sunday lunch at rue Boulegon. Told to come early so that they could 'talk art a bit', he committed the terrible *faux pas* of arriving while the painter was still in his night shirt. Shown into the dining room, he was relieved to find the table already laid for two. 'Despite his fortune,' he wrote, 'he possessed only what was required by a single man of his age living alone, who takes a modest meal between two sessions of work and who, after his lunch, doesn't tarry to smoke oriental cigarettes while sipping Turkish coffee. There were a few cane-bottomed chairs, a round table of polished walnut, a buffet decorated with a litre beaker and a plate of fruit.'

The Impressionist with the most impressive appetite, however, was Monet, who lived well and made sure that his kitchen garden was bursting with good things with which to to supply his table at Giverny – romaine lettuce, tiny sweet peas, spinach, radishes, fresh fruit from the orchard. Monet was not himself a cook, though he was a keen collector of recipes, unembarrassed about asking friends and restauranteurs to yield up their secrets. Cézanne contributed the recipe Alice always used for *bouillabaisse*, Millet's was followed when making bread rolls. Their *tarte Tatin* came straight from the Tatin sisters and Monet even persuaded the proprietor of the Restaurant Marguéry in Paris, to share his famous recipe for *sole Marguéry,* so that he could try it at home. He liked to plan menus and be involved with the masterminding of meals. We know, from the surviving recipe books, that Monet dined sumptuously on tempting dishes such as *truffes à la serviette, entrecote marchande de vin* and *'vert-vert'*, a delicious sponge cake, studded with pistachios and covered in fondant icing coloured green with a spinach purée. When Alice's daughter Marthe married the American Impressionist painter Theodore Earl Butler, the ceremony was followed by a sumptuous six-course lunch at Giverny, which included *hors d'oeuvres*, followed by turbot in a Hollandaise or prawn sauce; roast venison and turkey; *lardons* fried in marrowbone; crayfish; *pâté de fois gras*; salad; praline and ice cream.

CHAPTER 4 # A Place to Work
HOMEMAKING AND HOUSEWORK, DOMESTICITY AND DEBT

'How it would simplify the burdens of the American housekeeper to have washing and ironing day expunged from her calendar! How much more neatly and compactly could the whole domestic system be arranged! If all the money that each separate family spends on the outfit and accommodations for washing and ironing, on fuel, soap, starch, and the other requirements, were united in a fund to create a laundry for every dozen families, or two good women could do in first rate style what now is very indifferently done by the disturbance and disarrangement of all other domestic processes in these families. Whoever sets neighborhood-laundries on foot will do much to solve the American housekeeper's hardest problem...'

– Catherine E. Beecher and Harriet Beecher Stowe putting the case for sensible cooperatives in *The American Woman's Home*, 1869

CAMILLE PISSARRO
The Little Country Maid (detail), 1882

The dining room of the Pissarro's house at Eragny-sur-Epte was hung with paintings by Cézanne, Monet, Delacroix, Degas and Van Gogh and drawings and watercolours by Manet, Sisley, Seurat, Signac and Mary Cassatt. A child sits at the oval table while the maid, who has pulled back the chairs, sweeps crumbs from the floor.

As painters of modern life, the Impressionists found a rich source of subject matter in the homely business of humble tasks. Sweeping a floor, putting away linen, serving at table, pegging out washing are all celebrated and recorded. Before the advent of many of the labour-saving devices we now take for granted (some of which the Impressionists would eventually enjoy) housework was extremely labour-intensive and often performed in fairly primitive surroundings. The day would start early with a routine of laying fires at five or six in the morning, cleaning and lighting the kitchen range, preparing breakfast and then dusting, making beds, washing floors. Stone-flagged floors had to be scrubbed by hand and wooden kitchen tables and draining-boards scoured with a mixture of lime and sand. Water and coal had to be humped up stairs and ashes and slops back down again. It was back-breaking work and depended on the additional aid of servants, employed to a greater or lesser extent in every Impressionist home. Some, like Pissarro, had only one live-in domestic, though they might supplement her services with dayworkers, such as a seamstress, a laundress, cooks and serving maids when the need arose. Others, like Monet at his grandest, could boast a staff of five, plus live-in gardeners and a chauffeur, while the Sisleys made do with the occasional assistance of Madame Antoine, a local cleaning lady, who recalled that the house at Moret-sur-Loing was never warm.

We know a fair amount about certain individual servants in Impressionist households – Gabrielle Renard, for example, Aline Charigot's cousin, who worked for twenty years for the Renoirs, and Zoé Closier, Degas's housekeeper, whose name is frequently preceded in accounts by the single word 'redoubtable' – but many who appear in their paintings are unidentified, nameless young girls performing simple chores with quiet patience. It is surely striking, however, that they appear not as shadowy figures, background ciphers in supporting roles, but centrally placed, the celebrated subject and point of the picture, painted with tenderness and, especially in the case of Pissarro and Morisot, quiet respect. Perhaps it is unsurprising that Pissarro – a lifelong and passionate Socialist who defied his bourgeois family by marrying his mother's maid – should seek, in his portraits of country girls, to stress their humanity and dignity. And yet their industry and quiet concentration is extraordinarily touching. A door swings open and we are afforded an intimate glimpse of the house at Eragny he shared with Julie and their five children.

Pissarro's country maids are representative of an army of young French women who went into domestic service in the mid- to late nineteenth century. Some saw it as an apprenticeship for marriage to a small businessman or prosperous artisan; others were attracted by the lure of the 'perks' a canny girl could collect. All were drawn to the cities by the higher wages and the obvious attractions Paris had to offer. The quality of board and lodging varied enormously, however, and some unfortunate girls were expected to work fifteen to eighteen hours a day, six-and-a-half days a week, retiring at night to small, barely furnished attic rooms, similar to those rented by the Impressionists when they were young and unknown, which were freezing in the winter and stifling in the summer when the sun fell full on the glass.

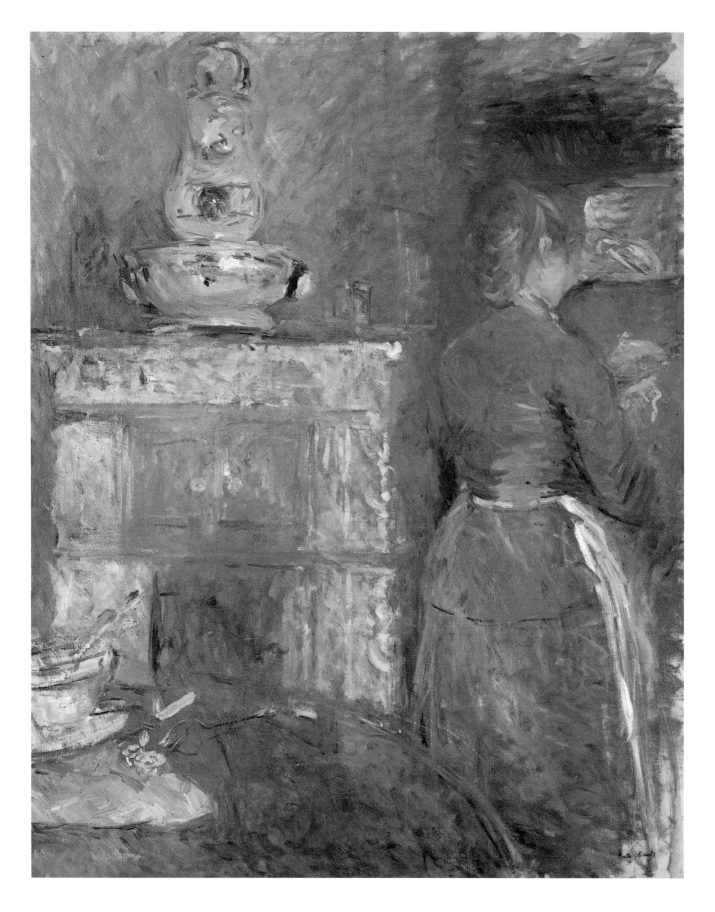

BERTHE MORISOT
In the Dining Room, 1880

Berthe Morisot paints her maid with her back to us in this decisively modern and thoroughly Impressionist painting. She captures the play of light on the dining room table with deft loose brushwork, which transforms the clutter of stacked plates, cutlery and bread into something faceted and jewel-like.

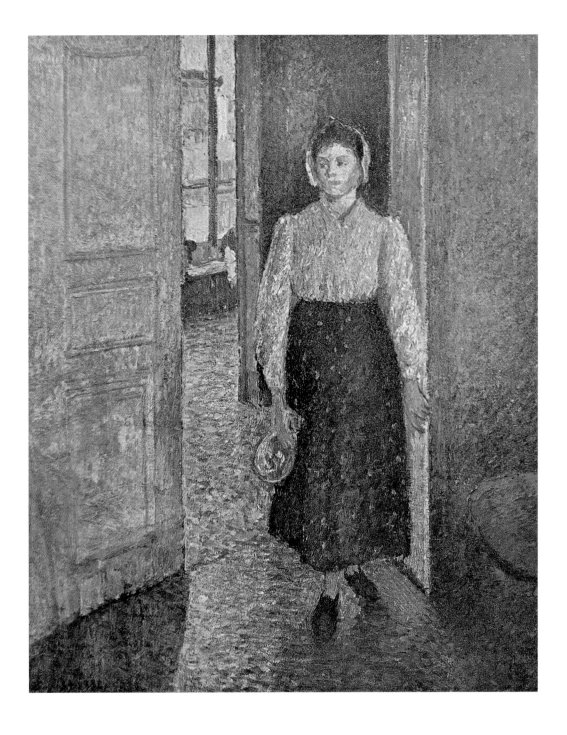

CAMILLE PISSARRO
The Young Maid, 1896

Pissarro's sturdy little maid stands in the doorway holding a carafe. Second only to agriculture in providing work for women, it has been calculated that up to a third of all French women worked as domestic servants at some point in their lives during the period covered by Impressionism.

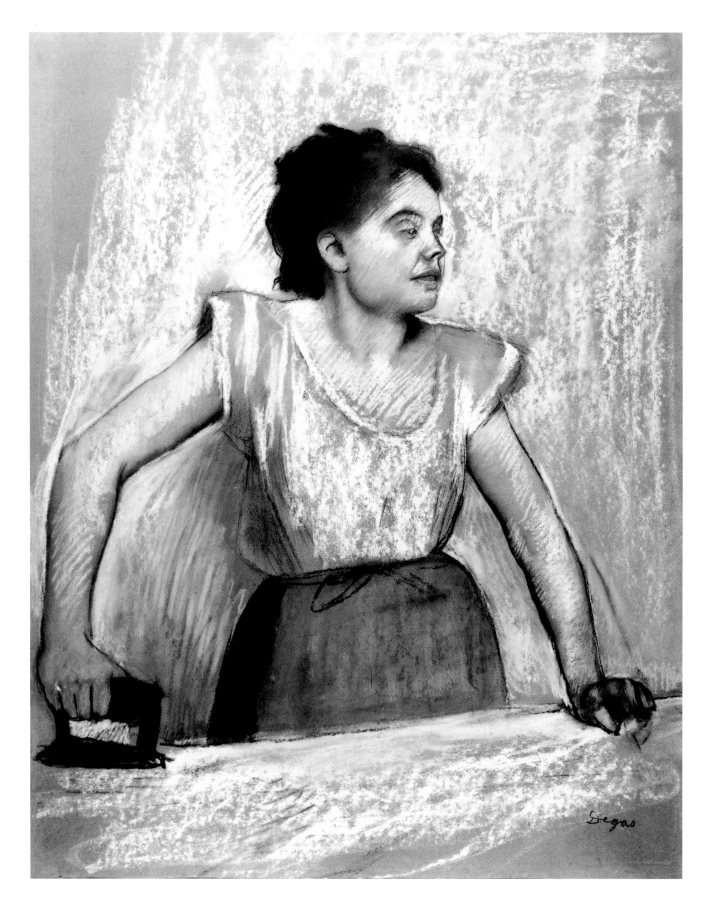

EDGAR DEGAS
Woman Ironing, 1869

CAMILLE PISSARRO
Woman washing the Linen, c. 1878–79

Both Degas and Pissarro were fascinated by the laundry process. Pissarro made numerous sketches of ample women getting to grips with the arduous chore of washing linen out of doors. Julie Pissarro would tackle her huge weekly wash with the aid of a laundress who was said to receive as much of a drubbing from her mistress as the dirty clothes and sheets did: her children knew to stay out of their mother's way on laundry day.

Julie Vellay had been part of this wave of young country women breaking on the shores of Paris. In the early 1860s she had travelled from her home in Grancey-sur-Ource, near Dijon, where her mother farmed a two-acre small-holding, to work as a maid to Rachel Pissarro, the matriarch of a large wealthy Jewish family. Julie was pretty and lively in those days, with long eyelashes, thick brown hair and broad cheekbones. Pissarro – rebelling against what he called 'the bondage of bourgeois life' – was smitten. Though she had little formal education, her strong, direct manner appealed to the artist and they began an affair. In 1862 she became pregnant, then miscarried, but on 20 February 1863 gave birth to a son, Lucien. Much to the annoyance of Pissarro's parents, Julie moved with her child into the small studio on the rue Neuve-Breda on the southern fringe of Montmartre which Pissarro was sharing with the Danish painter, David Jacobsen, and found work as a florist.

His family might have forgiven him for sleeping with a servant, for to have a mistress at the age of thirty-three was hardly shocking at the time. What put Pissarro beyond the pale, however, was his decision to live with Julie – a servant and a Roman Catholic to boot – to have not just one but two illegitimate children with her, and then to commit the cardinal sin of actually marrying her. Frédéric and Rachel Pissarro had hoped their son would make a 'good' marriage, a sensible one to a woman of means who would be in a position to help him in the impractical career he seemed bent on pursuing. Relations between them became increasingly frosty. Pissarro's allowance was temporarily terminated and for many years the couple lived in the most extreme poverty. Indeed, Pissarro never enjoyed the huge success and financial security found by Monet after 1883 and enjoyed by Renoir in later years.

After their marriage, the Pissarros moved frequently for economic as well as artistic reasons, switching between outlying rural towns and villages like La Varenne-St Hilaire, Pontoise and Eragny-sur-Epte, as the family finances rose, or, more usually, fell. Julie, who comes across in some accounts as a difficult, disappointed woman, prone to bouts of bad-temper and a bit of a nag, was nevertheless extraordinarily determined and persevering under often appalling conditions. Her roots were deep in the countryside and, like her mother, she was thrifty and industrious. Surviving at times on just twenty francs a week, it was Julie's skill as a housekeeper, her garden vegetables and the poultry and rabbits she kept in her backyard, that kept the growing family afloat during Pissarro's long lean years. Constantly dogged by money worries and struggling to bring up small children, it is hardly surprising that Julie gave vent to her frustration at times. In April 1887 she wrote to her son Lucien, complaining that 'Your poor father is really an innocent; he doesn't understand the difficulties of living. He knows that I owe 3,000 francs and he sends 300 and tells me to wait! Always the same tune. I don't mind waiting, but meanwhile one must eat. I have no money and nobody will give me credit. What are we to do? We are eight at home to be fed every day. When dinner time comes I cannot say to them "wait".' Unafraid of hard work, she would help the local farmers harvest their crops, taking her pay in potatoes, and Pissarro relied on her, finding strength and solace in the family unit she held together so magnificently. For home was vitally important to Pissarro. It was his social centre and, though the dispiriting necessity of hawking his work around dealers took him away frequently, he was always glad to return to the warmth of Julie's kitchen even if he might find his wife affectionately scolding the children or the maid – when they could get a maid – for Julie was a hard taskmaster and girls came and went with alarming speed at 'Eragny Castle.' Indeed, finding a new girl would be just one of the many errands Pissarro was expected to run for his wife while in Paris.

The average woman's day was filled with housework – washing, cooking, shopping, coping with fractious children, supervising servants of varying levels of competence. When Alice Hoschedé threw in her lot with Claude Monet at Vétheuil she exchanged a life of luxury and a fleet of servants for economic uncertainty and a *bonne à tout faire*, a single unskilled infrequently paid servant girl. It was a comedown after the huge staff she had had at her command in her previous homes in Paris and the Château de Rottembourg in Normandy, where housekeepers oversaw an 'above stairs' staff of ladies' maids, chambermaids and upper housemaids, and cooks presided over kitchen and scullery maids, with governesses and nursemaids occupying the hierarchal middle ground. Alice rarely complained, however, even when she found herself attacked by an irate grocer with a long outstanding bill.

Things improved when they moved to Giverny. Monet's stock was rising and now she was able to afford the household help she needed to release her from menial chores, leaving her free to elaborate, decorate and concentrate her efforts on making the domestic wheels turn smoothly. An average weekday might see her arranging for the floor polisher to come in the morning, sorting the linen with her maid Delphine, discussing the lunch menu with Mélanie or Mélanie's famous pupil and successor Marguerite, the garden with Félix, while remembering to despatch the chauffeur Sylvain to buy the bread and newspapers, perhaps urging him to call in on the way back at a nearby farm shop at Limetz to pick up some good asparagus, for they had guests for dinner.

Alice Hoschedé was, like many other middle-class French women, at that pivotal point of social change, a pioneer in the making of a modern lifestyle – though hers was complicated by the tyranny of

BERTHE MORISOT
In the Dining Room, 1884

The setting for this fresh and immediate painting of a young maid apparently interrupted in the middle of her chores is the dining room at Berthe Morisot's home in the rue Villejust. The open cupboard door and the lively little dog in the corner all contribute to the painting's sense of spontaneity.

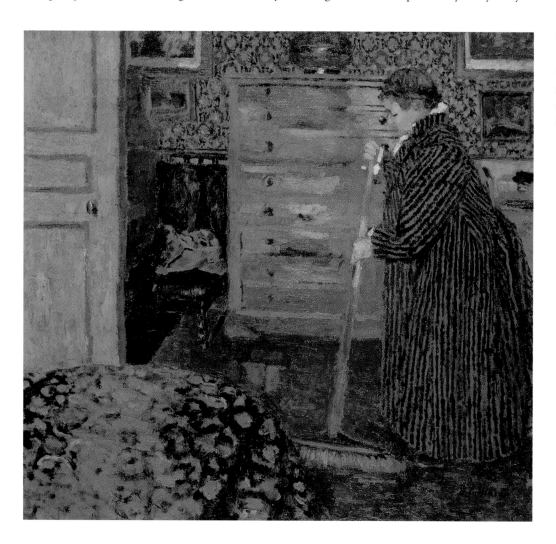

EDOUARD VUILLARD
Woman Sweeping, c. 1899

Vuillard focused on domestic tasks, capturing his subjects as if in slow motion, and setting them against a background of sensuous colour and pattern which sometimes threatens to subsume them.

JEAN MANNHEIM
Ironing Day, 1910

Ironing at home was a hot, tiring business, best tackled in numbers. Irons came in all shapes from tiny triangles for fiddly corners and small pleats through oval shapes for delicate fabrics to the heaviest box model for large linen sheets and had to be heated in a series on top of a hot range. In 1870, an American housewife called Mary Florence Potts patented a model with a detachable handle made of wood, but it was the advent of the electric iron which would revolutionize the chore.

Monet's painting schedule. It is unlikely that she resorted to manuals of domestic economy; however, if she had, she would have been bombarded with copious advice on the employment of servants. 'Integrity, sobriety, cleanliness and general propriety in manner and dress and a knowledge of the duties of the prospective department of household management,' were what she must look out for. The prompt payment of bills was also urged, something Monet rarely did – as Alice had found to her cost.

At a time when a gleaming home mirrored the shining character of its mistress and the villagers of Giverny were speculating on the bohemian appearance of this baffling new family, Alice was determined that her house should be in order. All self-respecting, house-proud French *maîtresses de maison* learned the formulas for household maintenance in their youth: the various polishes and soaps used on different pieces of wooden furniture, boots, stoves, windows and floors, which were made at home; the different solutions for removing candlewax from linen tablecloths; the use of angelica to sweeten chamberpots and the exotic ingredients used to paint over whitewashed corners to discourage bugs. Alice might not carry out all these tedious and messy chores personally, but she would certainly supervise them. Alice Hoschedé's was a large, complicated family and she was its manager, looked to to ensure its health and happiness. The home was her special province and there she operated as both employer and worker, responsible for domestic order and efficiency, an active agent in the family, no longer a pampered woman of leisure. She supervised the servants, saw to it that children were suitably occupied, and, most importantly, she smoothed the path for Monet, shielding him from unwelcome visitors and entertaining those they did both want to see.

The period saw the rise of a cult of cleanliness and an abundance of household management manuals bursting with practical advice. One even recommended removing all locks for cleaning and oiling during the annual spring cleaning. In America, Harriet Beecher Stowe and her sister Catherine published *The American Woman's Home* advising:

> 'If parents wish their daughters to grow up with good domestic habits, they should have, as one means of securing this result, a neat and cheerful kitchen. A kitchen should always, if possible, be entirely above-ground, and well lighted. It should have a large sink, with a drain running underground, so that all the premises may be kept sweet and clean...The walls should often be cleaned and whitewashed, to promote a neat look and pure air. The floor of the kitchen should be painted, or, what is better, covered with an oil cloth...A sink should be scalded out everyday, and occasionally with hot lye...Under the sink should be kept a slop-pail; and, on a shelf by it, a soap-dish and two water-pails. A large boiler of warm soft water should always be kept over the fire, well covered, and a hearth-broom and bellows be hung near the fire. A clock is a very important article in the kitchen, in order to secure regularity at meals...'

But new appliances were about to revolutionize housework, accelerate the pace of change and make the servantless household both possible and democratically desirable. The nineteenth century saw a passion for mechanization and the arrival of vacuum cleaners, which would finally banish rather than simply redistribute dust, and a plethora of electrically powered appliances – from irons to refrigerators – eased the domestic burden considerably. True, some of the quirkier labour-saving devices were often greeted with an enthusiasm not matched by the gadget's serviceability or performance, but some machines which we take for granted today originated in the time of the Impressionists. A patent for a dishwasher remarkably similar in design to some still manufactured today was first registered in America in 1865, though we have no evidence of any Impressionist – not even the gadget guru Monet – owning one and it would seem that, for all their willingness to embrace modernity as the key concept in their definition of themselves and their times, they hung on to their servants.

Laundry

The question of laundry concerned the Impressionists both practically and artistically. The Paris of the period was full of highly visible young women conspicuously moving about the capital collecting or delivering their customers' washing, or slaving over hot irons in basements, for French women tended to rely upon the *blanchisserie* to provide clean clothes, just as they used the *charcuterie* for complicated foods. Octave Uzanne, a contemporary commentator, presented laundresses as 'clean, coquettish, and often really pretty' though he fanned public fears when he warned: 'It cannot be said that their souls are as immaculate as the linen they iron. These girls have a shocking reputation for folly and grossness...they haunt the outskirts of the city, are inveterate dancers, descend sometimes to the lowest forms of prostitution and are also given to drink.'

In the collective imagination these young laundresses, seamstresses and poorly paid factory workers – many of whom were prepared to pose for painters – became linked with loose moral values. Young women ironing in a state of undress quickly became a popular subject for the first erotic photographs of the 1880s and the middle-class discovered that, by sexualizing these women, they could negate their feelings of guilt about class exploitation and defuse any power to distress they might possess. As long as laundresses were viewed as immoral, then the fact that they earned little and often lived in squalor was apparently deserved.

French Impressionist painters in their pictures of modern life made many images of laundresses at work and of newly washed clothes billowing on washing lines. It is noticeable, however, that they often chose to capture the most lyrical point in the cycle – the hanging out of clean clothes, rather than the backbreaking business of scrubbing them against a washboard in a tub or the gruelling work with the iron. Degas, of course, was the exception to this rule. His images of women wielding the traditional flat-irons show them actively engaged in hard, unremitting work. These paintings – and, excluding notebook sketches, they number almost thirty – have been said to exemplify 'an upper-class man's lingering sexual interest in, and disdain for, working class women as well as his unmistakable admiration.' But does he actually reinforce the traditional view of laundresses as sexually promiscuous women to be found in Zola's *L'Assommoir* (1876) or Edmond de Goncourt's *Manette Salomon* (1867), or prompt new questions about modern life, with its social

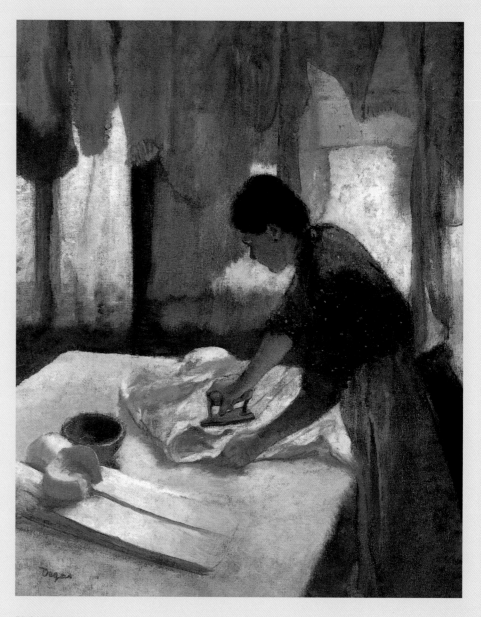

EDGAR DEGAS
Woman Ironing, 1882

BERTHE MORISOT
Hanging the Laundry out to Dry, 1875

WILLIAM MERRITT CHASE
Wash Day – A Back Yard Reminiscence of Brooklyn, 1886

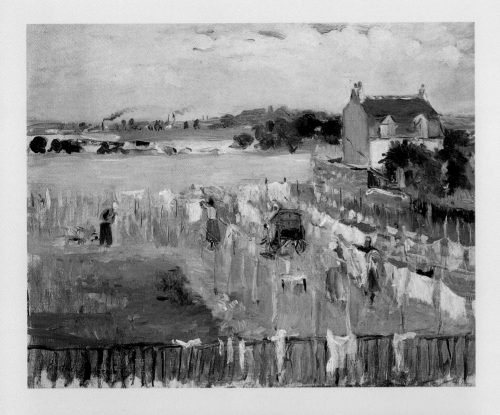

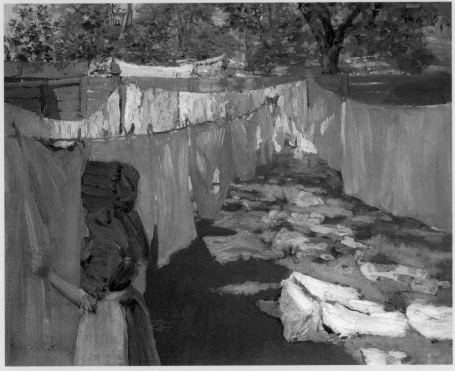

confusion and shifting values? Is he, a fastidious craftsman himself, perhaps commenting on, or acknowledging the skill and industry of a fellow worker?

Berthe Morisot would never have needed to touch an iron or rinse a chemise in a tub, but she chose to depict washing in her painting *Hanging the Laundry out to Dry* because it was an unashamedly 'modern' subject. Paris was surrounded by sites like the one she captured in her painting at Gennevilliers, six miles northwest of the city, where the Manet family had property. Here on a loop of the Seine the laundry lines met the fields and forests, causing complaints in the press that the environs of Paris, far from offering 'sun and greenery...cornflowers and poppies' had become 'great prairies covered with old clothes and detachable collars... laundresses everywhere and not a single shepherdess... factories instead of cottages...'

When tackled at home, laundry was an arduous, oppressive, time-consuming chore – 'the Herculean task which all women dread' – especially in the days before the advent of electric washing machines, dryers and irons. Before technology liberated women, the flat iron – weighing from three to twelve pounds depending on what was to be pressed – was the basic tool of the trade. New, more efficient and safer versions were brought out in the late nineteenth century, but it was the advent of the electric iron which revolutionized the chore. Electric irons were light, cheap to use and, most importantly, could be operated away from the hot stove. And at the Great Exhibition of 1878, seven types of washing machine were on display. 'What the sewing-machine is to the seamstress, the washing-machine is to the laundress,' trumpeted an 1883 edition of Mrs Beeton, 'the one will soon be as indispensable to family comfort as the other.'

Early rocking and oscillating machines were certainly too expensive for the cash-strapped Pissarros to consider. Pissarro – and Renoir – generally chose to paint ample women getting to grips with their weekly wash out of doors, though developments in plumbing and the arrival of piped water had largely done away with the need to hump laundry down to the riverside, and even eliminated the heavy chore of carrying water up and down several flights each day. Not that these advances necessarily lessened the workload for women: indeed it has been persuasively argued that the advent of modern machines created as much extra work as they saved, for they brought with them a new emphasis on hygiene and levels of cleanliness.

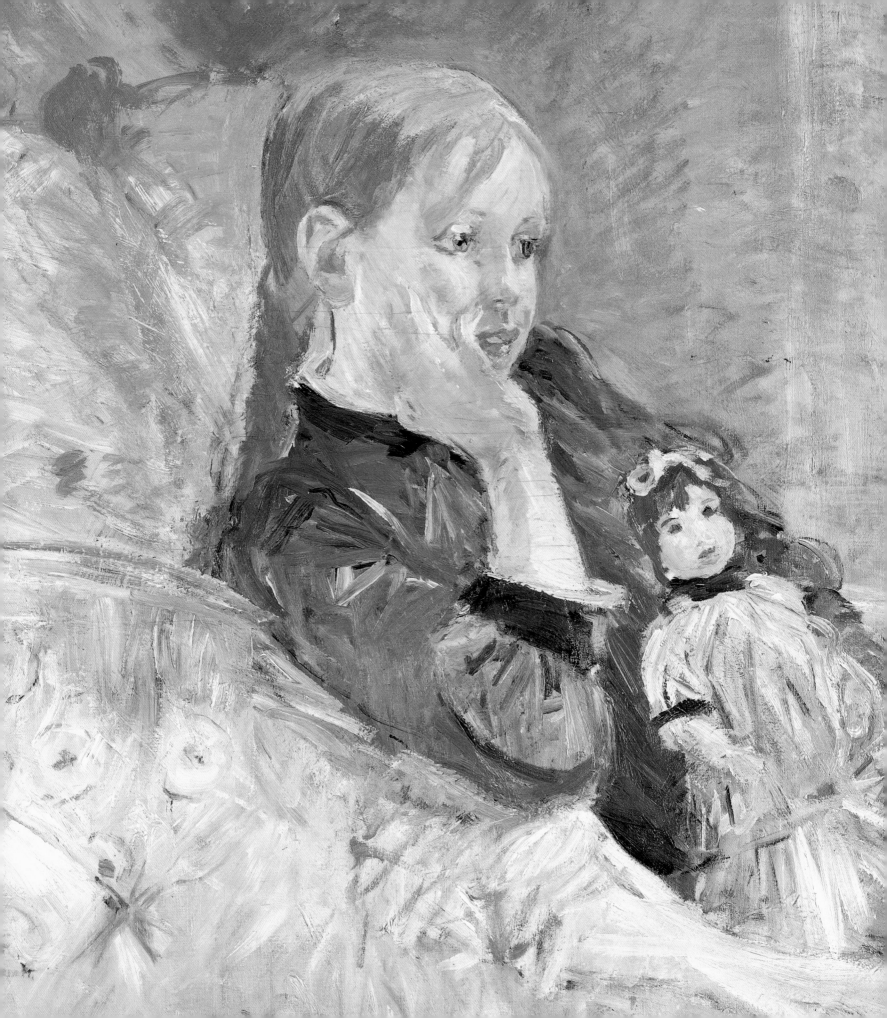

A Place to Play

CHILDREN AND CHILDCARE, FATHERHOOD AND FAMILIES

'Visit to Renoir. On a stand, a red pencil and chalk drawing of a young mother nursing her child, charming in subtlety and gracefulness. As I admired it, he showed me a whole series done from the same model and with about the same movement. He is a draftsman of the first order; it would be interesting to show all these preparatory studies for a painting to the public, which generally imagines that the Impressionists work in a very casual way.'

– entry in Berthe Morisot's diary Jan 11 1886

BERTHE MORISOT
Young Girl with a Doll (detail), 1886

The lightly worked, freely brushed surfaces of Berthe Morisot's canvases prompted commentators to call her 'the one real Impressionist' and to use adjectives like 'delicate', 'charming' and 'sensitive' when discussing her work. Paul Mantz believed that her greatest achievement lay in offering 'an original vision which is entirely feminine.'

The lives and paintings of the Impressionists are crowded with children, many of whom were illegitimate. Pissarro, Renoir, Monet and Cézanne were all fathers before they were husbands. Cézanne's model and mistress, Hortense Fiquet, was only nineteen when she gave birth to his son, Paul; Camille Doncieux just twenty when she gave birth to Monet's first child, Jean. Despite parental opposition Monet married Camille three years later and promptly had his allowance terminated. Cézanne, terrified his father would do the same, kept his liaison with Hortense a secret, and their son was fourteen before he plucked up the courage to disobey his family by marrying her, just six months before his father, Louis-Auguste, died.

Alfred Sisley had two children with his model and mistress, Marie-Eugénie Lescouezec, a well-bred but 'sensitive' young woman who, according to Renoir, had been forced to take up posing because 'her family had been ruined in some financial venture.' Renoir's double portrait of the handsome pair, painted in 1867, is known as *M. et Mme Sisley* or *The Engaged Couple*, giving weight to the idea that they had married just before the birth of their son Pierre. However, it seems that Sisley, a quiet, determined and extremely private man, and the beautiful Marie had never married – though they lived a devoted and outwardly respectable life for thirty years in various village locations just outside Paris and in increasingly difficult financial circumstances – for, the year before she died, on a trip to Wales, Marie made an application in the French consulate at Cardiff to have the 'natural children' of Alfred Sisley officially recognized so that they could legally inherit (as they did) and benefit from the posthumous sale of his pictures.

By the time Pissarro married Julie Vellay in London in June 1870, the couple had a seven-year-old son and a six-year-old daughter. The following year – Pissarro's forty-first and Julie's thirty-third – their second son, Georges Henri was born at Louveciennes and the couple went on to have a further four children – Félix-Camille, Ludovic-Rodolphe, Jeanne Marguerite Eva (nicknamed Cocotte) and Paul Emile – at regular three to four year intervals up to 1884, putting additional strain on already stretched finances. Pissarro was a great communicator and a passionately involved parent who encouraged all his children's artistic efforts. 'He could have taught stones to draw correctly,' Mary Cassatt said of her friend. The boys made books of sketches of everyday incidents – including a candid drawing of their mother Julie in a violent rage attacking her husband with her fists – and all the children contributed to an illustrated journal of life in the Pissarro household called *Le Guignol*, which was always proudly bound up in satin at the end of the year and for which Pissarro would provide a cover illustration. Money worries and Julie's flaming temper continued to dog him, however. In a letter to Lucien, away in England, he spoke of his 'heroic efforts to preserve my calm' in the face of 'darkness, doubts, quarrels.' Outsiders viewed their relationship with surprise and sadness. 'I do not think,' Theo van Gogh wrote to his brother Vincent, 'Pissarro has any great authority in his own house, where his wife wears the pants.' Yet their marriage endured for over thirty years and plainly provided Pissarro with a stable base, and boisterous child-filled centre, from which to pursue his artistic experiments.

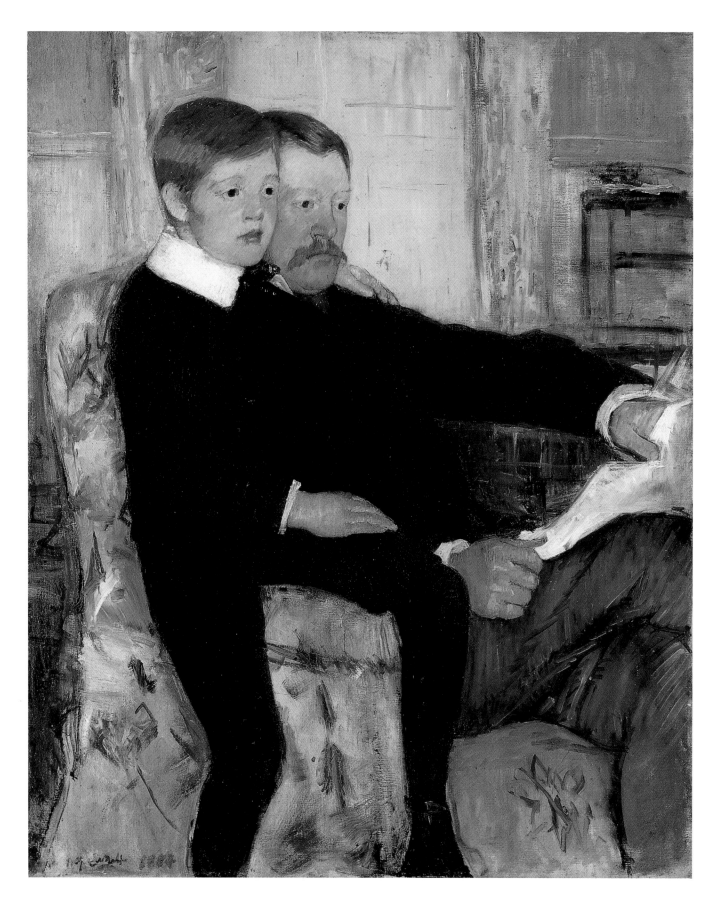

MARY CASSATT
Portrait of Alexander J. Cassatt and his son
Robert Kelso Cassatt, 1884–85

Portrait of a Little Girl, 1878

While she never had children herself, Cassatt seemed to specialize in painting them, and was exceptionally adept at portraying the tenderness of the relationship between a mother (or a father) and their children. Here we see her brother and his son together on the floral armchair which she often used in her portrait paintings. The masculine solidarity of the two figures is underscored by the way in which their black clothing is united by the artist into a single shape; their seriousness a stark contrast to the evident boredom of the little model on the right, whose mood is echoed in the dog opposite.

Approaches to child-rearing faced a sea change at the time of the Impressionists. Where once it had been common practice for many middle-class mothers to pass their children over to wet-nurses and a specialized group of servants – including a nanny or *bonne d'enfants* and, of course, the governess, with their own strict hierarchies, complex snobberies and fixed spaces within the home – now they were encouraged to spend more time with their children and to take a new, involved interest in all aspects of their upbringing and education. Children were no longer stashed away for most of the day in a nursery – usually located as far as possible from the salon or drawing room, often at the very top of the house, where they ate their meals, played and sat down to lessons – and a middle-class mother had to do much more than simply visit her child there after tea to prove her devotion.

Mary Cassatt never married or raised a child and yet she placed great importance on the experience of motherhood. 'I love to paint children,' she told her friend Louisine Havemeyer: 'They are so natural and truthful. They have no *arrière-pensée*.' Renoir, Berthe Morisot and Cassatt all endowed their mother and child images with serenity, grace and charm, but Cassatt became so associated with the depiction of motherhood and its themes of maternal devotion that her first biography, written by Achille Segard in 1913, was entitled *Cassatt: Un peintre des enfants et des mères* – a painter of children and mothers. What interested her most was the deep emotional and physical involvements between adults and children.

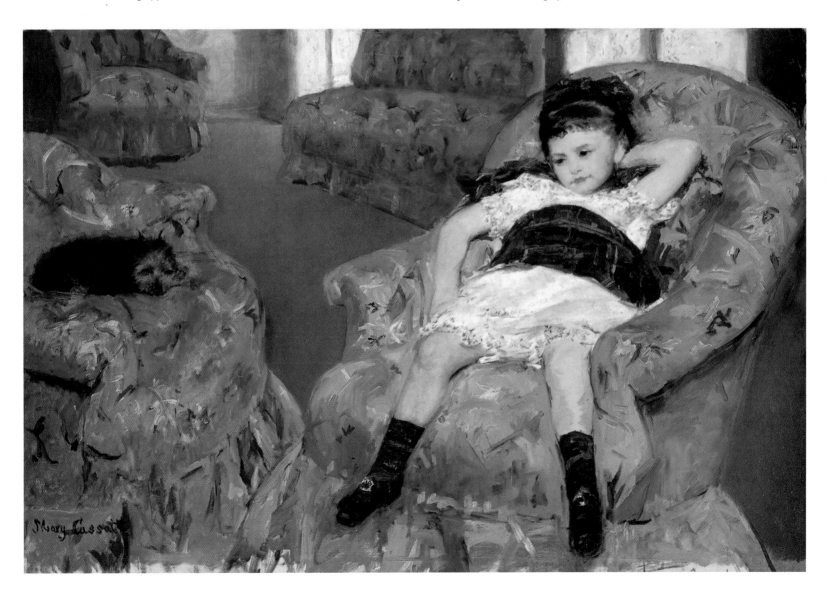

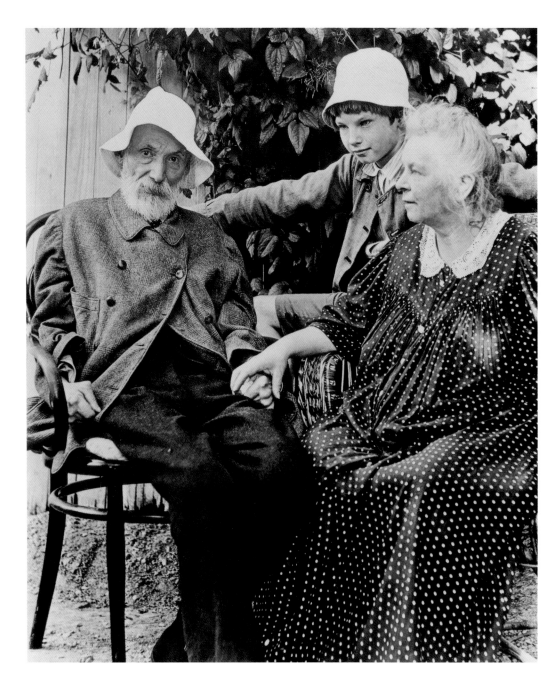

Renoir, Aline and 'Coco', 1912

Renoir adored his youngest son, Claude – known as 'Coco' – though he was already an old man when he was born.

A keen and careful observer of women's lives, she nevertheless successfully avoided the sentimental trap of idealizing motherhood. In 1880, the arrival in Paris of her brother Alexander with his wife Lois and their four young children, Eddie, Katharine, Robbie and Elsie (the oldest eleven, the youngest five), provided 'Aunt Mary' with ample access to child-models in everyday settings. The paintings she made after this date of children being bathed, dressed, read to, held while they fed or slept, show her keen appreciation of the most advanced ideas about motherhood and childcare, and the importance of forging an emotional bond. At the sixth Impressionist exhibition of 1881, the French writer J. K. Huysmans singled out her images of women and children together, praising them for their freshness and calling them 'impeccable pearls'. He noticed a special sensibility in her work, which he described as 'a flutter of feminine nerves.'

Renoir was in his mid-forties when Aline Charigot gave birth to their first son Pierre. He kept his little family quiet, however, and Gustave Caillebotte, who agreed to be godfather, was one of only a handful of Renoir's friends to know about the baby's existence. Yet the arrival of Pierre worked a great revolution in Renoir's life, according to Jean Renoir, who claimed in *Renoir, My Father* that 'the theories aired at the Nouvelle-Athènes were now made to seem unimportant by the dimples in a baby's bottom.' Before the birth of Pierre, Renoir had been restless, incapable of staying in one place. He would think nothing of jumping on a train in search of a softer light, but 'now, all at once he found himself in an apartment with a wife: meals at regular hours, a neatly made bed, and his socks mended.' They moved for a while to a house on the outskirts of Aline's home village of Essoyes, in the Champagne region, where a clearly entranced Renoir painted Aline breastfeeding. Ample and amiable, Aline was, in the words of her second son, 'a grape growers' daughter who knew how to bleed a chicken, wipe a baby's bottom, and clip the vines.'

When Pierre was five, Renoir married Aline in a ceremony at the administrative office of the ninth arrondissement in Paris, witnessed by four old friends, including the Italian painter Federico Zandomeneghi, which served to legitimize the boy. Four years later Renoir invited Georges Durand-Ruel, his dealer's son, to act as godfather to his second son Jean, who was followed, much later, by another brother. Claude, the baby of the family and always known as 'Coco', was born in Essoyes in 1901, when Aline was forty-two and Renoir sixty.

Despite his fairly feckless start, Renoir threw himself into family life and often painted his three children – especially Coco whose long blonde curls Renoir was reluctant to lose – in a variety of settings. Jean Renoir, the middle son, recalled how he was still going about with 'my curly red locks' at the age of seven and the relief he felt when, on the eve of starting school, the barber was finally called, though Renoir 'deplored the necessity for it' and 'Gabrielle wept.'

PIERRE-AUGUSTE RENOIR
The Alphabet (Jean and Gabrielle), c. 1897

Gabrielle Renard and Jean Renoir with a little Girl, 1895

Gabrielle worked for the family for over twenty years and became one of Renoir's favourite models. The children called her 'Ga' or 'Bee-bon' and Renoir drew and painted her hundreds of times, often with Jean or Coco, who were never admonished if they behaved badly while posing. 'Don't say a word to him!' Renoir would caution, 'it would make him hate the studio.'

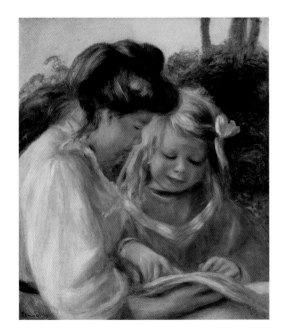

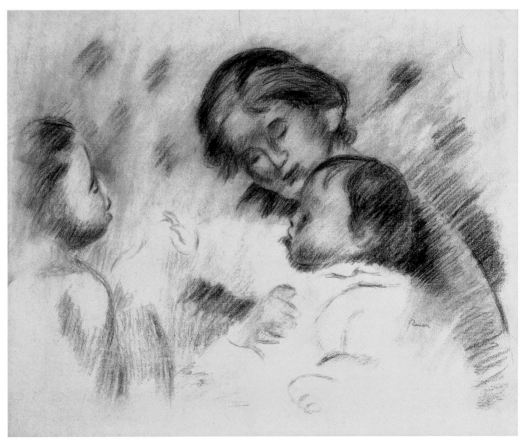

Renoir was an active and participating father, deeply concerned about the health and wellbeing of his children. When they were small he refused to have the wooden floors waxed and insisted they be washed with water only. For safety reasons he banned the use of bleach, and insisted Gabrielle keep all cleaning products and pharmaceutical goods well out of the children's reach in the kitchen. Needles, knives and matches were not to be left lying about and he even went so far as to break off the corners of a marble table and sand them smooth with sandpaper, so that his children would not hurt themselves too badly if they fell against it.

The picture that emerges of Renoir the family man is of a rounded, happy individual, at ease with himself and his situation, but he was careful to keep the fact that he had a common-law wife and child from his more bourgeois friends and patrons, including Berthe Morisot, whom he saw almost weekly at this time. She did notice that his studio was full of studies of nursing mothers but never guessed the relationship of the models to the artist. She wrote to Edma of her amazement on first meeting Aline, whom Renoir had not even introduced as his wife, in the summer of 1891, six years after the birth of Pierre: 'I cannot convey my astonishment on meeting this woman, who was so buxom that, I don't know why, I saw her as being like one of her husband's paintings...' The sophisticated Berthe was staggered to discover that 'this ungainly woman' was her friend's wife though she welcomed her into her home and, over time, they too became good friends.

The social chasm that initially separated Berthe from Aline is neatly summarized in two paintings, both entitled *Nursing,* one by Berthe Morisot the other by Renoir. Both paint their first-born infants being breastfed out of doors, but Berthe's daughter Julie suckles on the discreetly vague breast of an aproned wet-nurse, while Renoir's son Pierre feasts lustily on the ample, clearly defined breast of his mother.

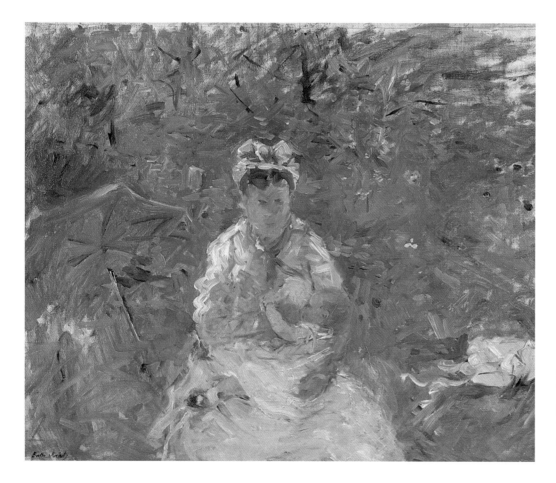

BERTHE MORISOT
The Wet Nurse Angèle Feeding Julie Manet, 1880

Berthe's only child, Julie, was born on 14 November, 1878, and this painting, showing her plump daughter with her wet-nurse in the garden, was made on a fine day the following year.

PIERRE-AUGUSTE RENOIR
Madame Renoir and her Children, 1886

In contrast to Berthe Morisot's spontaneous approach, Renoir made numerous preparatory pencil and pen drawings for his three finished oil paintings on the theme of 'Nursing', which shows an altogether more down-to-earth approach to the subject.

Renoir believed that 'a child should bury its nose in its mother's breast, nuzzle it, and knead it with its chubby hand.' Berthe Morisot conformed to the expectations of her class in employing a wet-nurse. At the beginning of the nineteenth century at least half of the infant population of Paris was fed in this way, though the period covered by Impressionism saw a decline in this practice. Upper- and middle-class mothers often sent their babies out of the city to be wet-nursed in the country, though Berthe, who had been married for four years and was considered old at thirty-seven when her much-adored daughter (and only child) was born, opted for the English practice of a live-in nurse. Unlike her sister Edma, Berthe had continued with her career as an artist after her marriage and she was not about to let motherhood interrupt it. By choosing to paint the aproned Angèle feeding Julie, she provides a neat solution to one of the perennial problems facing any working mother.

Age-old attitudes were changing, however. At the International Congress of Women's Rights, hosted in Paris the year before Julie's birth, powerful arguments had been mounted against the employment of wet-nurses and the case for equal educational opportunities for girls, as well as boys, as was already the norm in America, advanced. Over the next seven years laws were passed to create secular secondary schools, unregulated by the church, and to reform primary education, making it free. Teachers' salaries were rising and private philanthropists promoted the idea of greater professionalism in education, healthcare and social justice. Employing a child under twelve became unlawful. Childhood was extended and middle-class women like Berthe were urged to create sanctuaries for their children within their homes and to take a new, involved interest in all aspects of their upbringing and education. The role of the mother, indeed the whole process of motherhood from giving birth to bringing up a child, in both Europe and America, was undergoing change as economic and social changes reshaped family values.

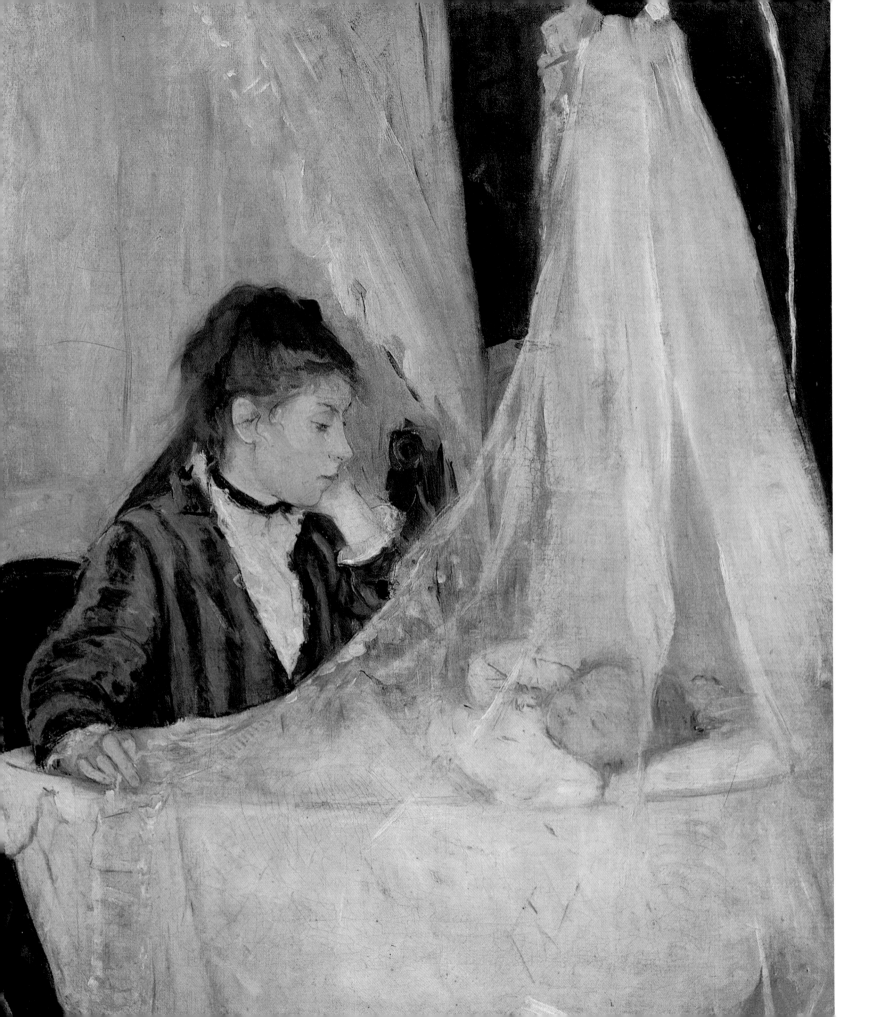

BERTHE MORISOT
The Cradle, 1872

Berthe's sister Edma was a frequent model and posed for this tenderly maternal image after the birth of her second child, Blanche, born late in 1871. Edma gazes upon her daughter half-hidden in the cocoon of gauzy hangings. *The Cradle* is a picture about looking, a favourite subject of Morisot's over the following years.

CLAUDE MONET
Michel Monet and Jean-Pierre Hoschedé, c. 1885

This impish pair of stepbrothers roamed the countryside around Giverny collecting birds' eggs, sometimes accompanied by the American painter Willard Leroy Metcalf.

Children were, of course, a source of anxiety. Julie was by all accounts a plump baby but she had a slight tendency to chestiness, exacerbated by the humid conditions of the capital. The family doctor recommended summers by the sea which stretched Berthe's budget: 'life is largely a question of money, which is not at all to my liking,' she admitted to Edma. Berthe took the precaution of having her baby daughter vaccinated against smallpox and cut her holiday in Italy short in 1882 when Julie came down with bronchitis in Florence. A bout of whooping cough ruined another holiday at Bougival the following year and a trip to Venice was cancelled altogether when an epidemic of cholera was reported in the city.

Advances in obstetrics had reduced infant mortality rates and increasingly efficient birth-control methods had given middle-class women some degree of control over their fertility, though most married women could expect to be pregnant at least once and sometimes as many as a dozen times in their lives. It could be a precarious business: Julie Vellay miscarried her first baby; Aline Renoir also lost a child in miscarriage just months after her marriage in 1890; Camille Monet never really recovered from the birth of her second son, Michel, on 17 March 1878, and died after a painful long-term womb infection; Eva Gonzalès, once seen by Berthe Morisot as something of a rival, died a few weeks after giving birth to her son on 19 April 1883 (on the same day, curiously, that Manet's leg was amputated). Anna Dwight Baker, the wife of the American Impressionist painter J. Alden Weir, died just three weeks after the birth of their third daughter, Cora, in January 1892. Weir's contemporary, William Merritt Chase and his wife Alice were unlucky enough to lose five of their thirteen children in infancy and Camille and Julie Pissarro were heartbroken when their little daughter Jeanne-Rachel died in April 1874. It was a distressing time for them both, but particularly for Julie, who was six months pregnant at the time.

Despite the establishment of specialized lying-in hospitals in France, England and America, most women gave birth at home at this time, for hospitals were considered places where only the very poor went, often to die, surrounded by strangers, far away from their friends, family and personal possessions. Jean Renoir goes so far as to suggest that 'to most French people' (and certainly his parents) 'the very thought of a woman going to a lying-in hospital to have her child seemed barbaric'. Hortense Fiquet gave birth to her son, Paul, in Cézanne's tiny apartment at 45 rue de Jussieu, a noisy street opposite wine warehouses and a market. Michel Monet, Camille's second son, was born at home in their apartment at 26, rue d'Edinbourgh, near Parc Monceau; Pierre Renoir in the four-room apartment on the rue Houdon that Aline and Renoir moved to in the autumn of 1883. Since Renoir was practically destitute at the time, he painted door frames for the doctor who attended her lying-in in lieu of fees. The traditional midwife found herself increasingly in competition with doctors, who could provide pain relief in the form of chloroform and access to an impressive array of new scientific instruments, like improved forceps and the curette, which could help with complicated, previously life-threatening, births.

French scientists and doctors, like Louis Pasteur, who had done so much to draw attention to the imperative need for doctors and midwives to wash and change their clothes between attending women in childbirth, began to campaign for a safe milk supply for infants and to involve mothers in the care of their children from the outset. They promoted the radical idea that breastfeeding was beneficial to the mother and to the baby, stressing that important emotional ties could be forged in the intimate moments it afforded. The claim that it helped a woman to recover her shape after pregnancy, however, was not borne out by Aline Renoir's experience, for her weight ballooned with each baby, and in 1895 Julie Manet recorded the ten-year-old Pierre Renoir remark, while learning to swim with his parents: 'Maman, when you are seen from below, you're even fatter.' (And Aline's size was undoubtedly a contributory factor in her death, at the age of fifty-six, from a heart attack in 1915 after an arduous, exhausting and anxious trip across France to check on the progress of her son, Jean, wounded in the First World War.) For those mothers who, despite the best advice, could not for medical reasons breastfeed, modern technological advances meant that bottle-feeding was becoming safer and easier. The use of glass bottles, rather than metal containers, the pasteurization of milk and the vulcanization of the rubber, which was used to make teats (as well as more comfortable condoms), all played their part in the march of progress.

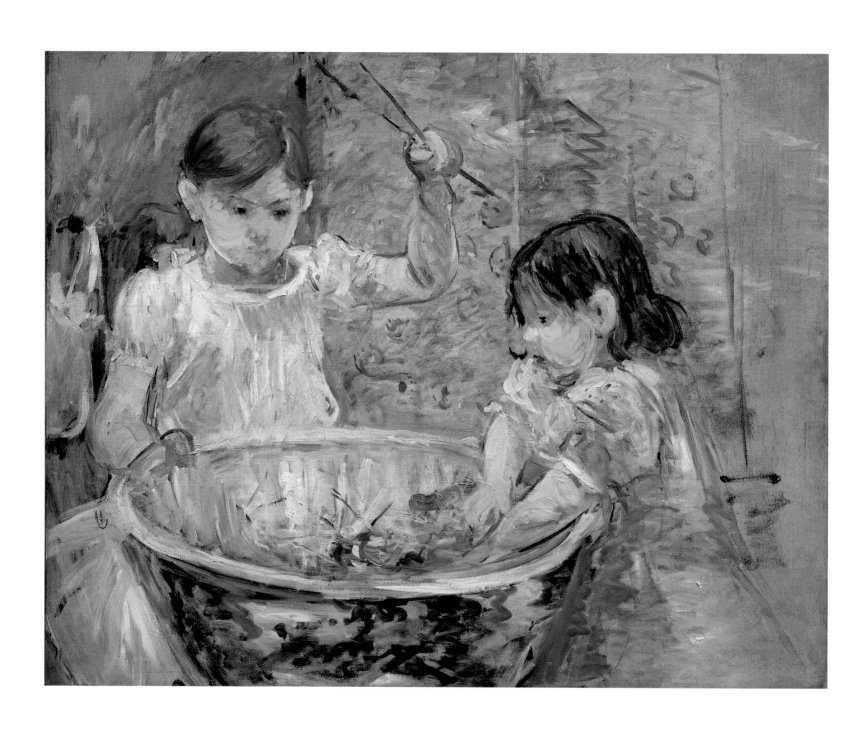

BERTHE MORISOT
Children at the Basin, 1886

A pair of little girls concentrate on catching 'fish' with
their magnetic rods in this classic children's game.

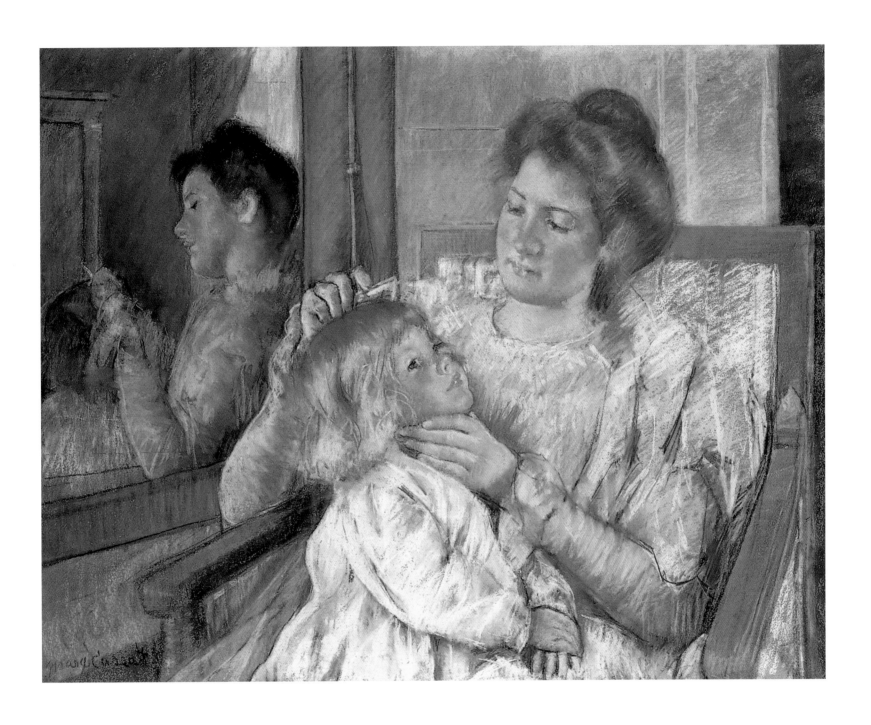

MARY CASSATT
Mother Combing her Child's Hair, c. 1898

The little girl sits patiently, one small hand resting on the other, as her mother tilts her chin gently backwards and combs her hair. The mirrored image captures the mother's total absorption in this routine daily task.

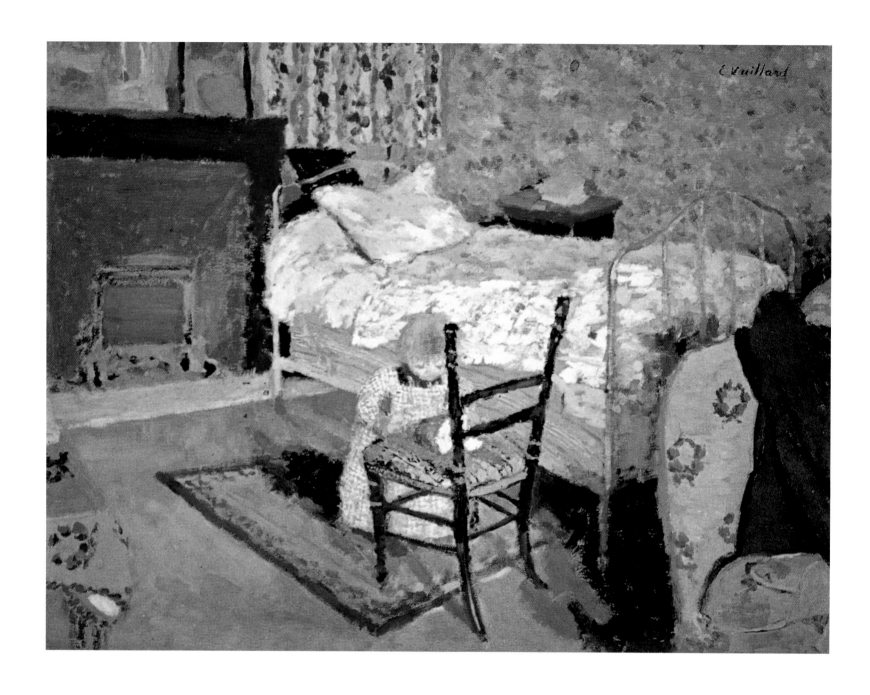

EDOUARD VUILLARD
Child in a Room, c. 1900

Vuillard, though a bachelor, demonstrated a fondness
for painting children, often seen from above, busy with
their own activities or discoveries. He was a popular
uncle and welcome visitor at the homes of friends
with children for he always arrived armed with exotic
toys and had a gift of establishing an immediate
rapport with his young sitters.

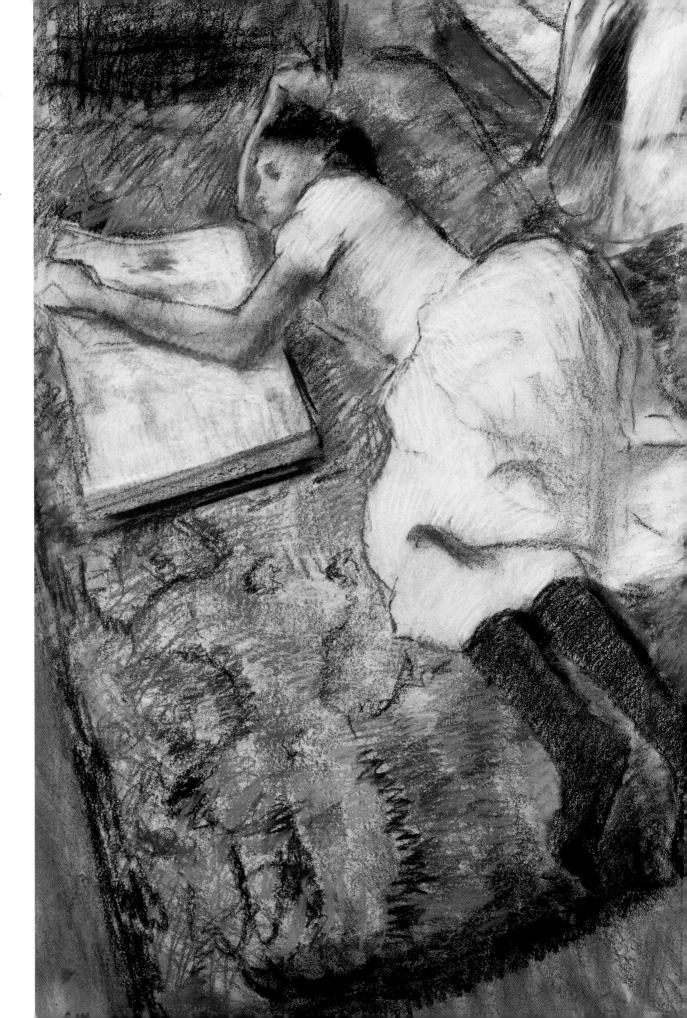

EDGAR DEGAS
*Young Girl Stretched out and looking
at an Album*, c. 1889

In 1872, in a letter to his 'dear
friend' Henri Rouart, Degas spoke
of his 'thirst' for order and
contemplated the idea of female
companionship. 'A few children for
me of my own, is that excessive
too?' he asked, though he would
never marry and indeed only joked
about it.

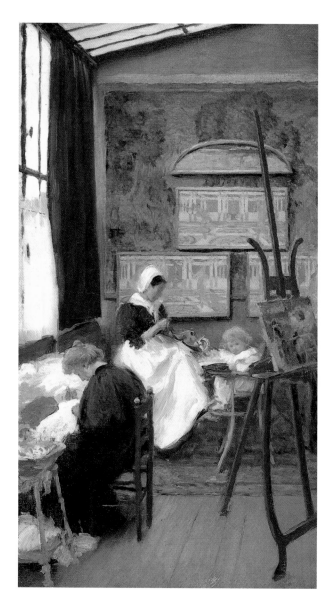

The new model for a modern family was premised on emotional commitment and love. It recognized and elevated the role of the mother, which had become a powerful and widening one, taking up a good deal of a woman's time and energy. She was now expected to be her children's teacher, entertainer, confidant, provider of motherly love and gentle discipline, as well as a wife and – in the case of Berthe Morisot and Mary Fairchild MacMonnies – somehow manage to continue with her own professional career. A modern mother was judged successful if her children grew to maturity healthy, happy, educated and successful. (Naturally it was easier for a middle-class mother to provide this close personal attention and entertainment than it was for a working-class one, burdened by chores and the added laundry or sewing she had taken in to make ends meet.)

In America, children were also encouraged to be free and open and to express themselves. Writers like Charlotte Perkins Gilman, Ralph Waldo Emerson, Henry David Thoreau and Henry Ward Beecher embraced the theories of Jean-Jacques Rousseau, asserting that children could be positively influenced by nurturing, rather than disciplining. Gentle methods of bringing up children were promoted and encouraged – and illustrated in the paintings of American Impressionists like William Merritt Chase, Theodore Earl Butler (Monet's son-in-law), Mary Fairchild MacMonnies, Willard Metcalf and Edmund C. Tarbell, who often focused on children's play. A growing number of toys, games and books had become available for middle-class American children who could now play with miniature versions of household objects – tea sets, furniture, cooking utensils – which would be set up in the nursery. Like the French Impressionists who had inspired them, they gave visual expression to the prevailing idea that the child was to be nurtured, sheltered from the hard vicissitudes of life and exempt from work. Play and enjoyment were emphasized over moral enlightenment, a shift in balance reflected in less moralizing, lighter children's literature. '[My children] are the greatest happiness that has come to me, in my varied and somewhat tortuous career', wrote Willard Metcalf, who, after a rocky personal life, settled into a period of contentment in his fifties with his second wife Henriette Alice McCrea and their two children. 'I am at an age now,' he confided to a relative, 'when they seem to me to be the most wonderful things life has to offer, and instead of being an incident, as they would have probably been had they come twenty years ago, they are now the all important center around which everything revolves: the sunshine of the passing years.'

MARY FAIRCHILD MacMONNIES
Dans la Nursery (Painting Atelier at Giverny), 1897–98

Mary MacMonnies paints herself at work in the large well-lit room at Le Moutier (the MacMonnies' house in Giverny) which doubled as her studio and her daughter Berthe's nursery.

JOHN SINGER SARGENT
The Daughters of Edward D. Boit, 1882

Sargent painted Mary Louisa, Florence, Jane and the three-year-old Julia Boit posed rather stiffly in the entrance hall of their family's Paris apartment. The little girls appear dwarfed by the monumental vases and remote from each other, or 'lost in space' as one commentator remarked. Childhood, for Sargent, appears to be a place of isolation, possibly even alienation.

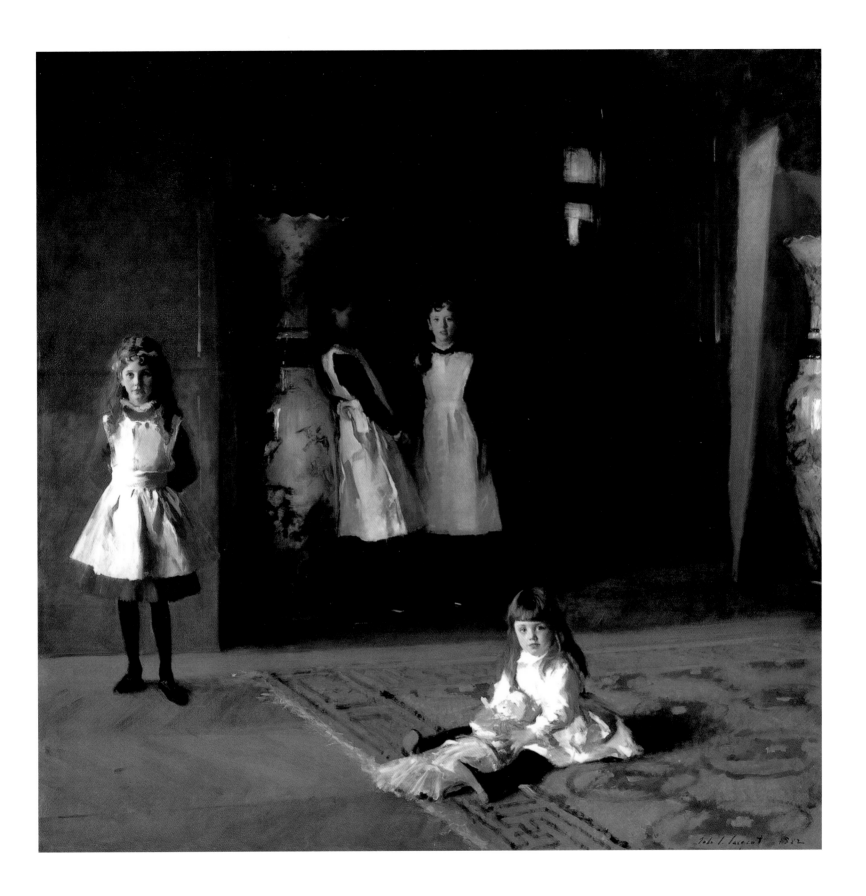

Education

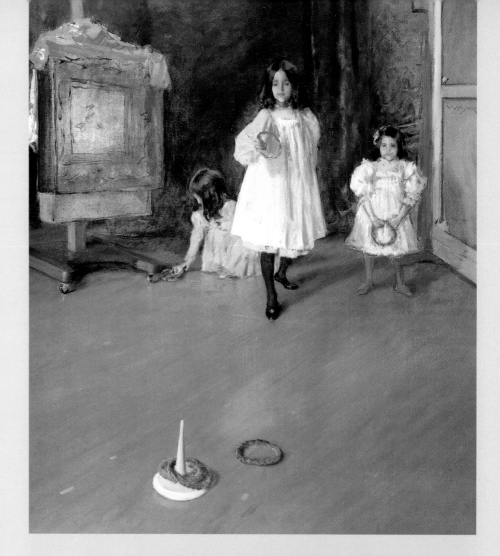

The temptation to assume that our Impressionist painters – brave, bold bohemians – naturally leaned towards a positive and loving approach to childcare and the question of discipline is strong and there is evidence to support this, up to a point. Certainly Mary Cassatt's and Berthe Morisot's loving images of mothers indulging their children speak of tenderness and love. But there are enough paintings of children industriously employed at school desks to suggest that they also took formal education seriously, and we know that finding the right school for his own and Alice Hoschedé's children was one of the main motivations behind Monet's move to Giverny. A rebel turned patriarch, Monet expected a good deal of his children. He imposed the kind of rigorous rules at mealtimes which he, as a young boy, had openly flouted, and meddled in his children and stepchildren's emotional affairs as they grew older. Yet he admitted that 'never, even as a child, could I be made to obey a set rule.' School had been 'like a prison', and he had often truanted.

In the more enlightened circles in which the Impressionists moved, mothers were encouraged to put themselves in the child's position, to learn patience and direct the child positively through love and kindness, while fathers were urged to take a greater role and shrug off their image as autocratic despots. Far from being distant figures, the evidence of paintings like Theodore Earl Butler's *The Artist's Children, James and Lili*, Edmund C. Tarbell's *The Lesson*, William Merritt Chase's *Ring Toss* and Alfred Sisley's *The Lesson* would seem to suggest that Impressionist fathers sought out the company of their children and enjoyed the proximity painting them afforded. Berthe Morisot often painted her husband Eugène Manet (the only man she ever painted) playing with their daughter Julie, his knees providing support for her toy village, or absorbed in some shared activity like reading or sketching. Mary Cassatt painted a touching double-portrait of her nephew Robert, sitting in an armchair with his father – her brother Alexander – which, though serious in tone, exudes paternal tenderness.

WILLIAM MERRITT CHASE
Ring Toss, 1896

PIERRE-AUGUSTE RENOIR
Coco Drawing, 1904

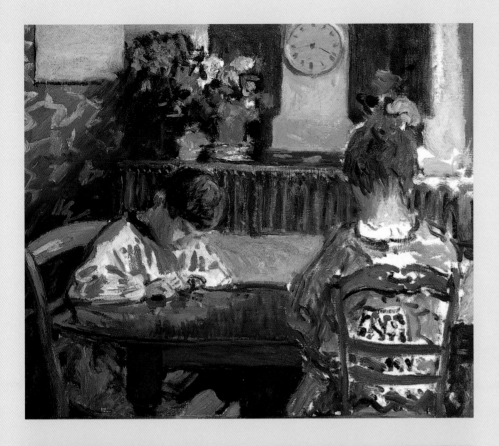

Renoir, too, took an active interest in his children and their education, perhaps because his own had been so brief and formal. He often painted Coco, the youngest, at his lessons, reading or writing. Cézanne was too frightened of his father to live openly with Hortense, but he adored his son Paul and never minded when the little boy's scribbles shared a page of his sketchbook with his own drawings. In 1886, with the question of education pressing, Cézanne installed Hortense and Paul in Gardanne, a small, romantic hill town seven miles from his parents' house, and enrolled Paul in the village school, but Cézanne still returned each night to the imposing and windswept Jas de Bouffan to dine with his parents and sleep in his own bed.

Berthe Morisot's own early education had been entrusted to an English governess named Louisa, to whom she had become deeply attached. 'I loved her as only children can love,' she wrote, 'I thought she was *perfect*, you understand, *just perfect*...She instilled in me, first, an absolute faith – even in miracles – a faith I've lost, or almost...'. Berthe herself followed the model of 'mother-teacher', using miniature watercolour copies of her own paintings as illustrations for words like *canard* and *dame* in an elementary reading primer she made for her five-year-old daughter Julie, affectionately known as 'Bibi'. Later Julie was sent to the same sort of exclusive private school Berthe and her two sisters had attended, which prepared good Catholic girls for marriage and motherhood, through a curriculum which gave as much weight to lessons in social etiquette as history, geography or natural science. Julie was expected to be able to shine conversationally and, from a very early age, was encouraged to sit at the 'big table' with intellectual heavyweights like Mallarmé and Degas. On one occasion she found herself seated next to James McNeill Whistler, whose caustic wit could be daunting even for adults.

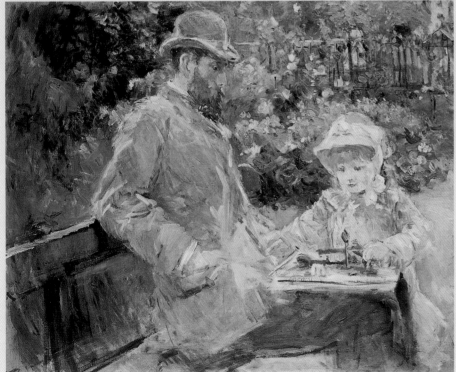

ALFRED SISLEY
The Lesson, c. 1874

BERTHE MORISOT
Eugène Manet and his Daughter in the Garden at Bougival, 1881

A Place to Paint
STUDIOS AND SOIREES, MODELS AND MISTRESSES

'Yesterday...spent the whole day in the studio of a strange painter called Degas. After a great many essays and experiments and trial shots in all directions, he has fallen in love with modern life, and out of all the subjects in modern life he has chosen washerwomen and ballet-dancers. When you come to think of it, it is not a bad choice.'

– Edmond and Jules de Goncourt, 1874

The difference between Manet's and Degas's methods of working was summed up by the painter Jacques-Émile Blanche: 'Manet liked to be looked at as he bent over his easel... He would have painted quite readily in the Place de la Concorde, with a crowd around him, just as among his friends in the studio, although at times he was impatient and scraped or rubbed out his work. But he would quickly get over that, and smile at the girl posing for him or joke lightly with a newspaper writer. Degas, on the contrary, double-bolted his door, hid his work, unfinished, or in the course of execution, in closets, intending to take it up again later, in order to change the harmony or to accentuate the form. His work was always in a state of becoming. Worry gripped him, for he was at one and the same time proud and modest.'

In the later nineteenth century the artist's studio functioned as a place of work, but also of recreation, domesticity and display. Where an artist lived and worked reflected his – or less commonly her – role and standing in the city. Status and position were determined by which floor of a building the studio occupied, for, from a practical point of view, it was much easier to move a large canvas in and out of a ground-floor studio, than one on the top of a six-storey block. A purpose-built studio such as Eugène Delacroix's capacious and comfortable free-standing double-height studio-house tucked discreetly into a delightful courtyard at ground level, just off the rue Furstenberg, was the ultimate sign of success. The high attic rooms the Impressionists inhabited during their early years represented the other end of the spectrum. Apart from a good north light, these often had little else to recommend them but they were cheap and by sharing studio space in popular areas like the Latin Quarter – close to the École des Beaux-Arts – and Montmartre the artists were able to make crucial savings. The boulevard de Clichy was particularly popular – Renoir, Bazille, Vincent van Gogh, Toulouse-Lautrec, Cassatt, Degas, Pissarro, Seurat and Signac all had studios there at one time or another – and younger artists like Pierre Bonnard and Edouard Vuillard shared a studio 'as big as a handkerchief' in the rue Pigalle with Maurice Denis in 1891.

In 1867 – before the term Impressionism had even been coined – the penniless Renoir and Monet were happy to accept the generosity of their wealthy friend, Frédéric Bazille, and joined him in his studio in the rue Visconti. Renoir was the first to arrive as Bazille explained cheerfully to his parents: 'I am putting up a friend of mine, a former student of Gleyre's, who for the time being has no studio. Renoir – that's his name – is very hardworking. He works from my models and even helps me in part to pay for them. It is pleasant for me not to spend my days entirely alone.' Soon he was writing again to let his parents – who were financing the operation – know that '[Monet] is going to sleep at my place until the end of the month. Along with Renoir that makes two needy painters to whom I am giving shelter. It looks like a real sanatorium. I am delighted about this. I have plenty of space and they are both very cheerful.'

Charles Gleyre's atelier on the rue Notre-Dame-Des-Champs proved an important seedbed for Impressionism. 'Under Gleyre I learnt my trade as a painter,' Renoir later claimed. There Monet found

PIERRE-AUGUSTE RENOIR
Frédéric Bazille at his Easel (detail), 1867

Renoir's painting shows his good friend Bazille at work on his still life *The Heron* in a corner of the studio at rue Visconti which he shared with Sisley and Monet, whose unframed snowscape *Honfleur* graces the wall above Bazille's head.

'companions to my liking, original individuals…of whom I was never thereafter to lose sight.' (Indeed he and Renoir remained friends for fifty-seven years, using the familiar pronoun *tu* whenever they corresponded.) The gregarious Gleyre crowd gathered at Bazille's studio in the rue Visconti and later the rue de la Condamine in the Batignolles district, to talk, laugh, bash out tunes on the piano, work and, on the evenings when Bazille had invited serious musicians along, listen to some of their revered Wagner.

Not all the painters in the group conformed to the stereotype of struggling artist starving in a garret, however. Manet's money, high social position and personal panache were made evident in his choice of studio – a converted fencing-school on the coveted ground floor of 4, rue de Saint-Pétersbourg – which he occupied for six years from July 1871. He furnished the huge west-facing galleried room eccentrically with crimson sofas, a piano with a green garden bench for a seat, a Louis XV console table, Japanese tapestries and his own paintings. The ceiling was high, the walls were wainscoted with gilt mouldings and there was a monumental oak chimney-piece. A cheval-glass tilted up to reflect the oak panelled ceiling and the four huge windows, each with a balustrade, which gave on to the rue Mosner (now rue de

Renoir painting in his studio at Cagnes, c. 1911

Hampered by his acute arthritis and confined to a wheelchair, Renoir spent his last decade working, under increasingly difficult circumstances, on, among other things, a sequence of paintings of seated nudes.

EDGAR DEGAS
Nude (Drying Herself), 1896

According to Paul Valéry, Degas was one of the first artists 'to see what photography could teach the painter – and what the painter must be careful not to learn from it.' The foreshortenings in his compositions and the distortion of the foreground forms appear to be the direct result of working from photographs and he aimed 'to combine the snapshot with the endless labour of the studio...the instantaneous given enduring quality by the patience of intense meditation.'

Berne) and the Pont de l'Europe. There he painted some of his most audacious paintings and entertained people from all walks of life. Habitués of the boulevard and the Bourse, flâneurs and financiers, dealers and patrons mingled with women of fashion and models like Victorine Meurent, who lent spice to the atmosphere. His studio became a fashionable place for the rich, or simply idle, to drop by, exchange gossip and watch Manet in action. Eventually it all became too much for Manet's landlord, who decided not to renew the lease of such a controversial figure and Manet was forced – reluctantly – to move to another studio in the same district at 77 rue d'Amsterdam.

Degas's studio provides yet another contrast. For twenty-two years he worked in 'savage isolation' in the long attic room, with its wide bay window, above his apartment on the rue Victor-Massé. It was a private place, guarded by the faithful Zoé Closier, who shielded her master from the encroaching outside world, but admitted the young working girls who modelled for Degas, leading them up through the vestibule, along corridors past the kitchen, dining room, and the two 'enormous salons' hung with paintings to his studio. Degas kept to regular hours and routines, painting or drawing for two or three hours each morning before breaking off to lunch at the Café de la Rochefoucauld in front of the little market, at the corner of the rue Notre-Dame de Lorette and the rue de la Rochefoucauld, before resuming work in the afternoon. His 'life was as ordered and arranged as a sheet of music', according to the dealer Ambroise Vollard, who had been told to time his visits 'at the end of the day, when it's *dark*'. Other accounts of his top-storey studio conjure a confusion bordering on chaos. Georges Jenniot recalled the room as 'dusty', Daniel Halévy 'sordid' and Paul Lafond was left reeling from scenes of 'indescribable disorder', presided over by an artist 'covered in pastel' and 'dressed like a pauper.' Degas did not care. 'To have no clothes and to own sublime objects – that will be my *chic!*' he announced, after buying two portraits by Ingres. One of his models, a girl known only as 'Pauline' left a vivid account of a studio she remembered as vast and gloomy, the high north-facing windows covered by a linen curtain, which admitted only a dim, filtered daylight. 'This feeble light was interrupted everywhere by cupboards, numerous easels jumbled together, sculpture stands, tables, armchairs, stools, several screens and even a bathtub used for posing models as bathers.

'The corners were no less cluttered; a quantity of pictureframes was arranged beside empty stretchers, rolls of canvas, rolls of paper. The only space left for Degas to work was very confined, at the front of the studio just under the windows. It was here, between the modelling dais surrounded by a screen, between the sculpture stand and the stove, that the mornings were spent...'

Despite their *plein-air* credentials, each of the Impressionists needed the calm of a studio in which to complete their canvases. Even Monet, who liked to assert that nature was his only workplace, maintained a studio in Paris during most of his years at Argenteuil and eventually had three at Giverny, while for Caillebotte and Pissarro the studio was a place for hard work. Toulouse-Lautrec's famously chaotic fourth-floor studio in Montmartre, though, was a place of work and play. On Friday evenings he would throw the doors open to great crowds who came to see how his work was progressing and to drink wild cocktails.

Toulouse-Lautrec painting *The Dance at the Moulin Rouge* in his studio, 1890

The Moulin Rouge opened in Montmartre in October 1889 and Lautrec was soon a regular. His ambitious painting, made the following year, provoked bourgeois anxiety and a surprisingly prudish response from Theo van Gogh, who wrote grudgingly to Vincent in Saint-Rémy: 'Not withstanding its scabrous theme it has great distinction.'

GUSTAVE CAILLEBOTTE
Studio Interior with Stove, c. 1872

The vogue for all things Japanese is evident in the porcelains, paper lanterns and two oblong panels which Caillebotte includes in his painting, though the viewer's eye is immediately drawn to the plaster replica of Jean Antoine Houdon's *Ecorché*.

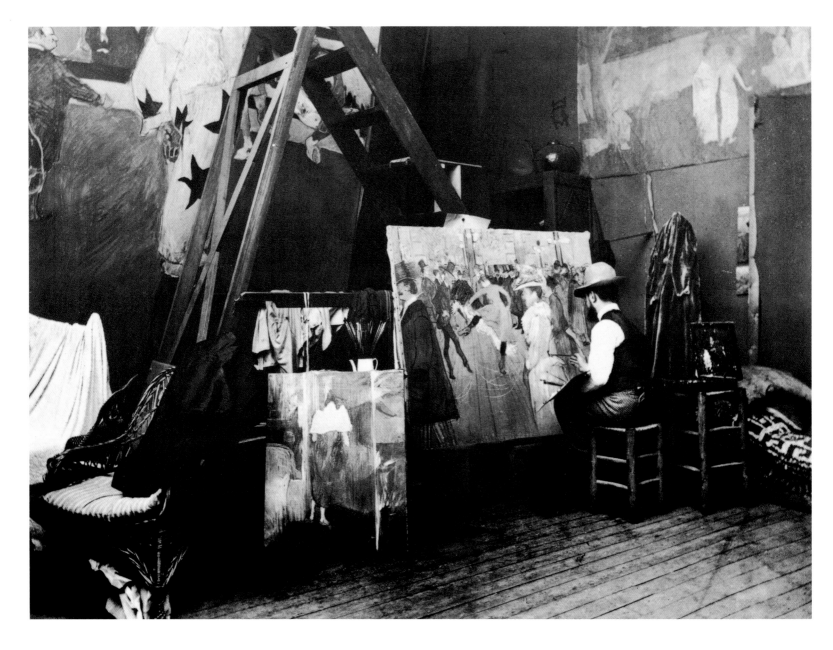

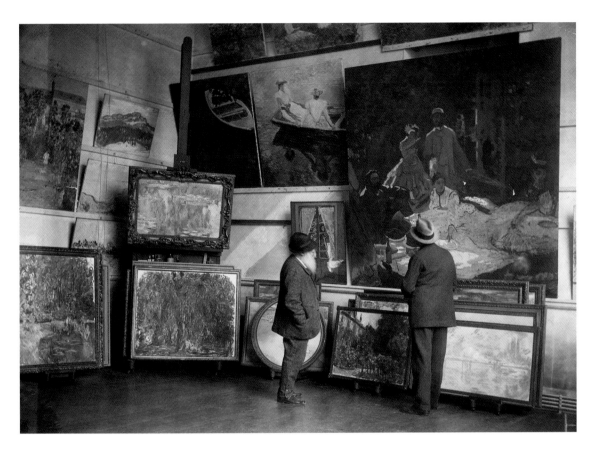

Monet with the Duc de Trévise in his studio at Giverny, 1920

Monet in his third studio standing in front of *Morning*, c. 1924–25

In his late seventies, and with almost frenzied energy, Monet began work on his his huge waterlily 'decorations' for the oval halls at the Orangerie in the Tuileries Gardens. A third studio, specially built to accommodate the panels, was completed in 1916 and inaugurated by the Académie Goncourt following a dinner given by Monet.

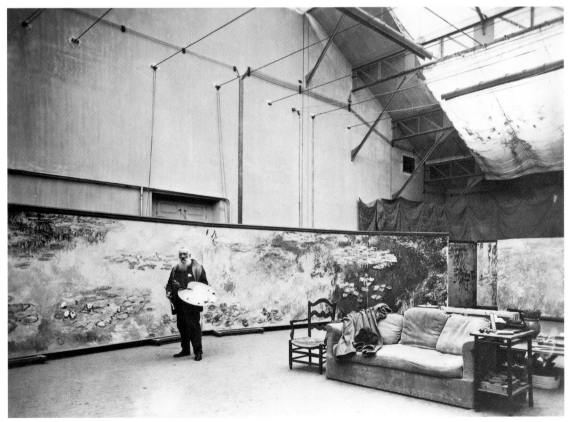

opposite
ARMAND GUILLAUMIN
Portrait of Camille Pissarro Painting a Blind, c. 1868

Cézanne introduced Guillaumin to Pissarro in the early 1860s when all three painters were studying at the Académie Suisse in Paris. This unconventional 'portrait' gives a glimpse of the less romantic side of nineteenth-century artistic life and presents the studio as a workplace rather than as a bohemian garret.

By the end of the nineteenth century, many American artists returning from Europe, and particularly from Paris or serial summers spent in Giverny, had overwhelmingly adopted the tenets of Impressionism. They sought to demonstrate their new sophistication and cosmopolitan outlook by emulating the extravagant, flamboyantly furnished studios of their European counterparts. The studio became an outward expression of their personae, a place to nourish their art, network, entertain and promote themselves. It became, crucially, a status symbol. William Merritt Chase – arguably the first painter to create Impressionist works in America – rented four studios simultaneously at the height of his fame, the most impressive of which, in the purpose-built Tenth Street Studio Building, was 'artistically' furnished with armour, tapestries and curios, and hung with paintings by Mary Cassatt, the society painter Alfred Stevens, John Singer Sargent and James Tissot. For almost twenty years, until a major financial crisis in 1896 forced him to dispose of it, he hosted regular Saturday receptions, dinners and music recitals in this studio, which operated not just as a place to paint or give private classes but also as the site and subject of many of his best-known paintings of the 1880s. 'It was true Bohemia when all the world was young and the possibilities were unlimited,' according to the painter Arthur Hoeber, who recalled 'glorious nights' in Chase's studio, spent discussing art and making monotypes and etchings.

WILLIAM MERRITT CHASE
In the Studio, 1880

A young woman pores over drawings in Chase's artistically cluttered studio. Long breathless lists of its copious contents often featured in the popular press for Chase was something of a celebrity.

Chase, with his pet wolfhounds, white suits and glittering rings, consciously cultivated an aesthetic personal image and was evidently a man of great personal flair and talent. 'My God,' he was fond of telling his students, 'I'd rather go to Europe than go to heaven!' He became the most influential art teacher in America and, from 1891 to 1902, presided over his famous outdoor summer school at Shinnecock, on Long Island, where he commissioned the great American architect Stanford White to design a large Dutch Colonial summer house for himself and his family as a retreat from their hectic city existence. In 1886 he had married one of his models, Alice Gerson, a great beauty who bore him thirteen children, though only eight survived past infancy. The studio, connected by a short flight of stairs to the main hall and living quarters, was very much a part of the life of the house. It doubled as a playroom for the children and a sanctuary for Alice, whom he paints *In the Studio* sitting in a comfortable wicker chair, gazing out reflectively, the newspaper or magazine on her lap momentarily forgotten, her introspective gaze meeting that of the viewer.

Chase and Alice furnished their Shinnecock retreat with antique furniture appropriate to the colonial-revival style of the house. His extravagant tastes and his mania for collecting frequently led to financial difficulties though his work – often autobiographical, always beguiling, depictions of a leisured

John Singer Sargent in his studio at 41 boulevard Berthier, Paris, c. 1884

In his elegant studio at 41 boulevard Berthier, Paris, with the repainted version of *Madame X*, 1884. Sargent's studio – with its oriental rugs and hangings, Japanese ceramics, sumptuous banquette sofa and Bechstein piano – made a strong aesthetic statement.

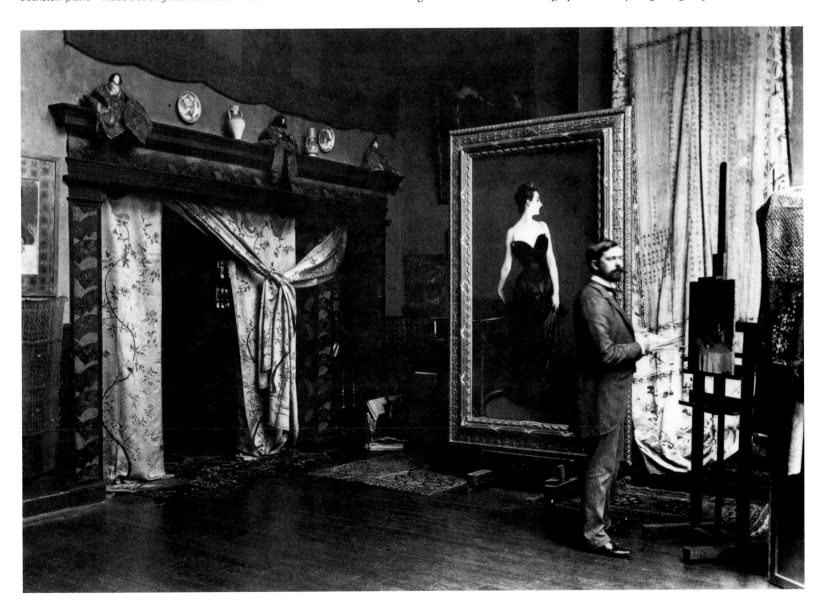

life in a quiet domestic setting – was selling well at this period to progressive collectors, and his wife and children served as models and inspiration for some of his best paintings.

Edmund Tarbell's Boston studio, on the other hand, was a spartan space, long and low, in which he arranged and rearranged a small number of props and models. Much inspired by Degas, his work attracted praise. Charles H. Caffin reviewing one of Tarbell's paintings in *Harper's New Monthly Magazine* in June 1908 declared: 'In the hush that pervades the room, the pensive tenderness of the various silhouettes of dark against light; in the reverence...that impregnates the harmony of the whole, I discover, idealized with inexpressible charm, the possible beauty of the home life.'

Paris remained the artistic Mecca for a great many American artists, most of whom returned home to pursue their careers, although some – like Mary Cassatt, John Singer Sargent and James McNeill Whistler – remained abroad, working as expatriate painters. Two who enrolled in classes at the popular Académie Julian included Arthur Mathews and Childe Hassam, and Mathews's painting *Paris Studio Interior* of 1887 provides a revealing glimpse of his own artistically cluttered Parisian studio. Hassam returned to America in 1889, settling in New York but making frequent trips back to Boston and spending his summers on the Island of Appledore among the Isles of Shoals off the coast of New Hampshire and Maine. He took studio space at 95 Fifth Avenue but spent much of his time at Old Lyme, Connecticut, which had been developing along the lines of a Barbizon-related artists' colony but became, under the influence of Hassam and his friend and colleague Willard Metcalf, a major Impressionist-oriented art colony – in effect, an 'American Giverny.' Metcalf also kept a studio in New York, at 12 East 15th Street, as did Edward Simmons, recently returned from Europe, and Theodore Robinson, hailed as 'the first American Impressionist.'

The question of how a painter's working schedule related to and informed the pattern of their home life throws up different answers when applied to the women in the group. Among the many challenges they faced was how to obtain a decent training. The École des Beaux-Arts in Paris did not open its doors to women art students until 1896, although female models had of course been daily visitors. Social conventions barred women artists from the study of anatomy and forbade them to draw nudes, ensuring that the world of high art was an overwhelmingly male preserve. Five years after opening for business in an old dance hall in the Passage des Panoramas, Rodolphe Julian reorganized and expanded his Académie Julian in 1873 to admit women, though he charged them double the fees paid by male students and Julian's teams of visiting instructors came only half as often to the women's ateliers as to those of men. The situation in America was rather more relaxed and forward-thinking though many talented young women still sacrificed their own artistic aspirations to their husbands needs on marriage (as Emeline Tarbell had), or, if they achieved prominence at all, it was in a subsidiary, decorative field, such as book illustration or stained-glass design (as was the case with William Merritt Chase's student, Dora Wheeler). A highly original and talented painter like Marie Bracquemond, who exhibited with the Impressionists in 1879, 1880 and 1886, found herself in an impossible situation at home because of her husband Félix's jealous attitude towards her work, according to her son Pierre. In the end she simply gave up painting altogether to avoid the domestic friction her work provoked.

To be taken seriously as a fine artist in France required a stubborn determination. When the single-minded Mary Cassatt arrived in Paris fresh from her studies at the Pennsylvania Academy of Fine Arts, she found access to art schools denied her and instead sought private lessons from Jean-Léon Gérôme, a professor at the École des Beaux-Arts, and organized a licence to copy in the Louvre. 'Museums,' she later asserted, dismissing the importance of her early formal training, 'are all the teachers one needs.'

The Louvre offered inspiration and challenge to Berthe Morisot, too, who registered herself as a copyist there on 19 March 1858, aged seventeen. She and her sister Edma had been having drawing lessons for a year and had recently been introduced to an inspiring new teacher, Joseph-Benoît Guichard, a follower of Ingres and Delacroix. Madame Morisot, who had originally initiated the classes with the idea that the girls might produce drawings as birthday gifts for their father, must have been taken aback to receive a letter from Guichard warning her of the consequences of his efforts:

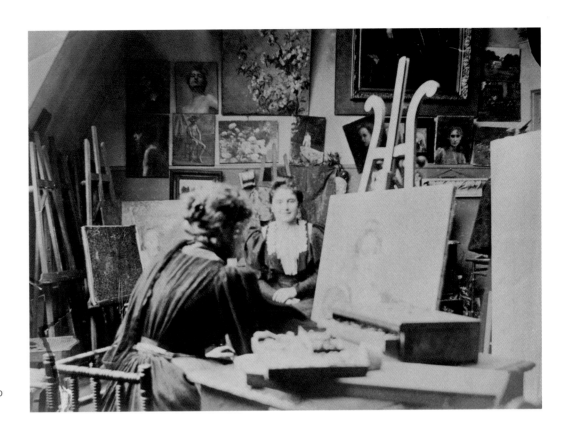

Berthe Morisot, aged forty-eight, at work in her studio at 10 rue Weber, Paris, 1889

'considering the character of your daughters, my teaching will not endow them with minor drawing room accomplishments; they will become painters. Do you realize what this means? In the world of the *grand bourgeoisie* in which you move, this will be revolutionary, I might almost say catastrophic. Are you sure that you will not come to curse the day when art, having gained admission to your home, now so respectable and peaceful, will become the sole arbiter of the fate of two of your children?'

She shrugged off his concern, however, and allowed the girls to continue painting. Monsieur Morisot even had a studio built in the large garden of their new house in the rue Franklin in Passy. However, when Berthe showed no signs of abandoning art for marriage, as Edma had done, her mother began to express some misgivings: 'Would anyone give even twenty francs for these ravishing things?' she wrote to Yves, confessing: 'I am a bit disappointed to see that Berthe won't settle down like everybody else. It is like her painting – she will get compliments since she seems to be eager to receive them, but she will be held at arm's length when it comes to a serious commitment.'

Excluded from active participation in the public sphere women artists turned inward, choosing to paint their own surroundings, the domestic intimate world of women and children, or of elegant spectators at the theatre, though not always through choice. Marie Bashkirtseff, a talented naturalistic painter who enrolled at the Académie Julian at the age of seventeen, described the difficulty eloquently in her diary in an entry dated 2 January 1879:

'What I long for is the freedom of going about alone, of coming and going, of sitting in the seats of Tuileries, and especially in the Luxembourg, of stopping and looking at the artistic shops, of entering churches and museums, of walking about the old streets at night; that's what I long for; and that's the freedom without which one cannot become a real artist. Do you imagine that I get much good from what I see, chaperoned as I am, and when, in order to go to the Louvre, I must wait for my carriage, my lady companion and family?...This is one of the principal reasons why there are no female artists.'

Female painters were also denied a chance to participate in the dynamic discussions that went on late into the night in bars and cafés like the Nouvelle-Athènes, which Mary Cassatt passed each day on her way to her studio on the Place Pigalle but never once went inside. She was on the outside, too, on the spring day in 1877 when she first saw some of Degas's pastels in the window of a picture dealer on the boulevard Haussmann. 'I used to go and flatten my nose against that window,' she wrote years later to a friend, 'and absorb all I could of his art. It changed my life. I saw art then as I wanted to see it.' Within months she had become acquainted with Degas, who had already seen her painting of a red-haired woman in a lace veil at the Salon in 1874 and is supposed to have said: 'It's true, *here* is someone who feels as I do.' Their mutual respect provided the firm base for an otherwise unlikely friendship between an aristocratic young woman from Pennsylvania and a difficult and often irritable French master.

When Louisine Havemeyer asked Mary Cassatt how she managed to maintain her long-time friendship with such a temperamental artist, she told her: 'Oh, I am independent! I can live alone and I love to work. Sometimes it made him furious that he could not find a chink in my armor, and there

HENRI FANTIN-LATOUR
A Studio in the Batignolles, 1870

Berthe Morisot, though she was on friendly terms with both Manet and Fantin-Latour, was not included in this celebration of the Batignolles group, neither did she appear in Bazille's *The Artist's Studio, Rue de la Condamine* of the same year (see p. 9). Here (from left to right) Otto Scholderer, Manet, Renoir, Astruc (seated), Zola, Edmond Maitre, Bazille and Monet pose in Manet's studio.

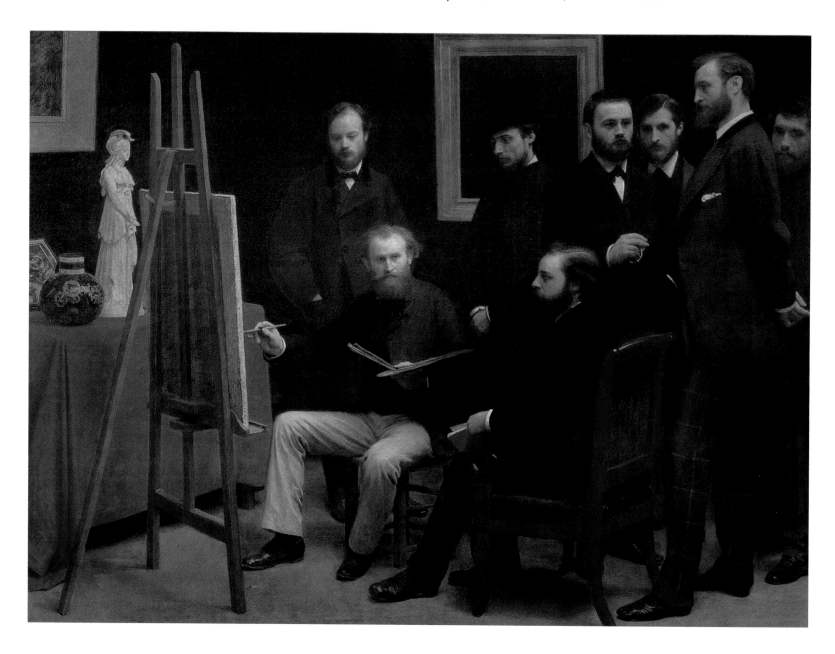

would be months when we just could not see each other, and then something I painted would bring us together again and he would go to Durand-Ruel's and say something nice about me, or come to see me himself.' Besides, she was fiercely proud: 'Oh the dignity of work,' she wrote to Louisine, 'give me the chance of earning my own living, five francs a day and self respect.'

Degas's friendship brought Mary Cassatt into the circle of Impressionism and was clearly important just as Berthe Morisot's was with Manet – though the former was prone to 'spicy estrangements' and the latter complicated by emotional attachments. Both women – fine, pioneering artists – suffered from the 'superiority' of the male painters. Manet painted Berthe frequently but never the other way around. Why? Was Manet unwilling to model, whereas it was expected of women? Or was it simply inappropriate for an unmarried woman to ask a man to sit for her? Degas often asked Mary Cassatt to pose for him and it seems that she did make one portrait of him but sadly it is lost. Degas and Manet thought nothing of 'correcting' their friends' paintings just before they were sent to be exhibited – a reversal of this situation would have been inconceivable – and although the women accepted the 'criticism', Berthe for one anguished over it, recounting her fury and impotence in a letter to Edma: 'He took the brushes and put in a few accents that looked very well: Maman was in ecstasies. That is where my misfortunes began. Once started, nothing could stop him: from the skirt he went to the bust, from the bust to the head, from the head to the background. He cracked a thousand jokes, laughed like a madman, handed me the palette, took it back; finally by five o'clock in the afternoon we had made the prettiest caricature that was ever seen...and now I am left confounded. My only hope is that I shall be rejected [by the Salon]. Mother thinks this episode funny, but I find it agonizing.' Despite Berthe's ambivalence, *The Mother and Sister of the Artist* was accepted by the Salon jury and in 1874 she submitted the painting to the first Impressionist exhibition.

Manet's public persona as an artist was shaped and framed by his flamboyant studio; Berthe Morisot worked out of her living room, calmly laying aside her canvas, brushes and palette in a cupboard whenever an unforeseen visitor was announced. She fought shy of publicity, especially the hectic kind which attended the public auction of Impressionist work which, newly married, she herself had organized in March 1875. The police had to be called to keep the peace and, when a detractor referred to Berthe as a whore, Pissarro punched him in the face tipping the whole simmering event into a brawl. The following year when Albert Wolff wrote so disparagingly in *Le Figaro* about the Impressionists' second group exhibition, calling them 'five or six lunatics – among them a woman – a group of unfortunate creatures stricken with the mania of ambition', Eugène Manet was so determined to defend his wife's honour that he wanted to challenge the writer to a duel.

It is hardly surprising that Berthe Morisot used her studio space as a retreat and sanctuary from such evident hostility. 'The peculiarity of Berthe Morisot...', Paul Valéry wrote, 'was to live her painting and to paint her life, as if the interchange between seeing and rendering, between light and her creative will, was for her a natural and necessary function, linked to her vital needs...her sketches and paintings keep closely in step with her development as a girl, wife and mother; her sketches and her paintings closely follow her situation...like the diary of a woman who uses colour and line as her means of expression.'

The white walls of the salon were hung not with her own, but her brother-in-law Manet's, paintings, and his death in 1883 hit her hard. To her sister she wrote: 'My old bonds of friendship with Edouard, an entire past of youth and work suddenly ending, you will understand that I am crushed... His richly endowed nature compelled everyone's friendship and intimacy with him, when I sat for him and when the charm of his mind kept me alert during those long hours.' A year after that she wrote again: 'I am not having as much fun as you think. I do go to the Beaux Arts [where the Manet exhibition was on], but the days of trysts are over.'

The Artist and his Model

The popular perception of models in the late nineteenth century was that they were simple women with few scruples, equally prepared to pose or to provide sexual services. They suffered from social censure surpassed only by that of prostitutes, and were paid little and respected less. In England at this time, society painters commissioned architects to design them houses with separate staircases, so that their

GEORGES SEURAT
The Models (small version), 1888

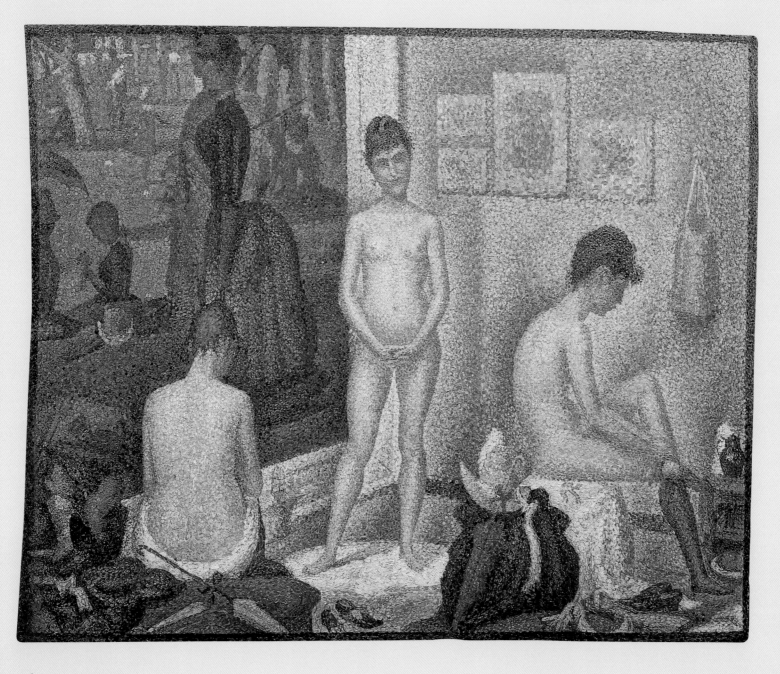

PIERRE-AUGUSTE RENOIR
Seated Bather Wiping her Arms,
1884–85

GEORGES SEURAT
Young Woman Powdering Herself,
1890

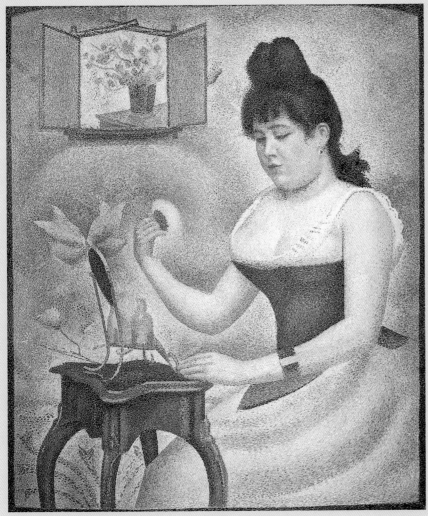

wives and children would not be contaminated by contact with models, although Whistler and Tissot openly set up house with their respective models-cum-mistresses in Chelsea and St John's Wood, and the Impressionists, who, we might argue, were more egalitarian, demonstrated a generally sympathetic and respectful attitude towards their models, often by marrying them, which ensured they deftly acquired a housekeeper, sexual partner and model all in one.

Renoir was a case in point. His roomy rue St-Georges studio provided a congenial space for his friends to gather in the evenings, attracted by the models, seamstresses, shopgirls, actresses and professionals who modelled for him and would still be in evidence at the end of the day, sitting about on the few cane chairs and the pair of squat armchairs covered in very faded floral rep which comprised, along with the easels, a table and a very worn out divan, the sum total of his furnishings. His favourite model and mistress for a time was a young woman called Lise Tréhot, the younger daughter of the post-master at Ecquevilly, who appears in *Lise with a Parasol* and *The Bather*. She went on to marry an architect, but there were plenty of others: Angèle; Estelle; Jeanne; Nini, the daughter of a theatre programme-seller and an assistant in a shooting-gallery; the rowdy but lovable Margot Legrand who died of typhoid; the tubercular Anna Leboeuf, who despite Dr Gachet's and Dr de Bellio's best efforts, also died in February 1879, and, eventually, Aline Charigot, the one he would marry. Aline appears very often in Renoir's work, both before and after their marriage. Renoir liked his female models well-proportioned, but more important than their figures was the quality of their skin – 'all I ask,' he told the dealer Ambroise Vollard, 'is that a woman has a skin that takes the light.'

Georges Seurat, on the other hand, was shy, secretive and sensitive to a painful degree. His large canvas, *The Models*, painted in 1887–88, shows three young women nude or almost so posed in a corner of his 'monastic' studio on the boulevard de Clichy with his most famous painting, *A Sunday Afternoon on the Island of La Grande Jatte*, in the background. Far from welcoming friends at the end of the day, the tall, timid painter would finish work punctually, bid his models a stiff farewell and hurry round to his parents' apartment for dinner. He was not an easy man to know and the existence of his mistress, Madeline Knobloch, who posed for *Young Woman Powdering Herself*, was unknown even to his intimate friends until the artist's premature death, aged just thirty-one.

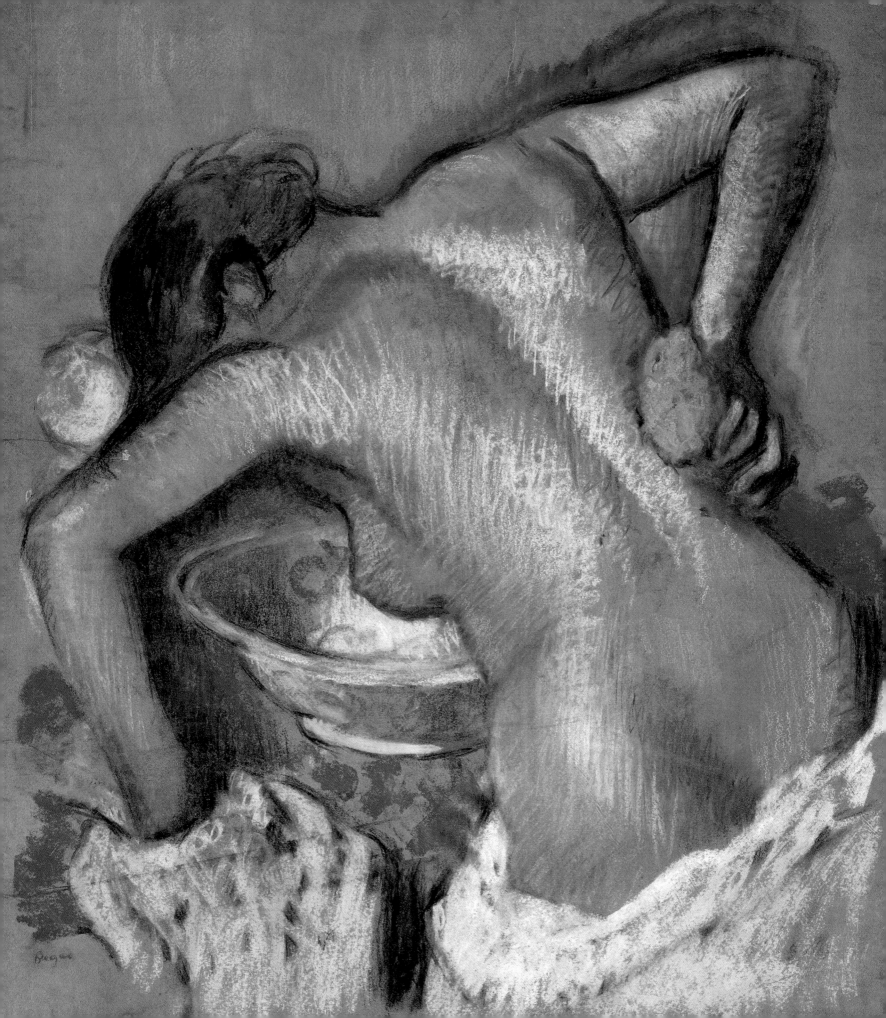

CHAPTER 7

A Place to Refresh

BATHING AND BEAUTY, CALM AND CONTEMPLATION

To look through Impressionist bathing images, from Degas's lovely pastels to the intensely personal, introspective and intimate paintings of Bonnard, is to chart the revolution that plumbing underwent in this period, as advances in sanitation, the development of a circulatory hot-water system, and changes in approaches to health and hygiene all came together.

We know that Degas washed every morning in a tub or zinc bath of the kind that appeared in his pictures. Renoir grew up in an apartment with no bathroom and sponged himself 'in a sort of wide tin basin' emptying the dirty water into an aperture on the landing, which shot the scummy suds out into the street below. Each of the six bedrooms in the austerely grand apartment block on the rue de Miromesnil where Caillebotte lived with his mother and brothers had a connecting dressing room, but there was only one bathroom with an enamelled, unplumbed, cast-iron bathtub serving the whole household. Cézanne found washing a problem in Paris. Encountering Manet in the Café Guerbois in the early days of Impressionism, he told the faintly scandalized older painter: 'I won't give you my hand, Monsieur Manet, I haven't washed for eight days.'

Renoir felt he had arrived when he had electricity and a state-of-the-art bathroom installed in Les Collettes at Cagnes-sur-Mer in the south of France in 1905, while Mary Cassatt struggled to bring the plumbing in her country home, the Château de Beaufresne, in Mesnil-Théribus fifty miles northwest of Paris, 'up to the American standard.' She acquired the house in 1894 and made the installation of indoor plumbing one of her first priorities though, as she confided to a friend, it put her 'so far beyond my French neighbours, that they think I am demented.'

In fact for most of the nineteenth century, few French families bathed frequently: some living in the countryside never bathed at all in the winter months and only occasionally in the summer. Not many homes could boast the novelty of a bathroom – even as late as 1908 only four per cent of households had one – and most made do with the 'Degas tub' filled to a depth of a few inches with hot water and set up before the fire in a bedroom, or, if they had sufficient servants to heat and haul the water up the stairs, a bigger, deeper bathtub, screened from draughts, where they could soak a little longer, secure in the knowledge that the arduous task of decanting the dirty water and cleaning and drying out the bath would fall to others. Bathing had been actively discouraged in the early part of the century when women were warned against taking more than one bath a month for fear of infertility or 'withered beauty.' Men risked weakening their sexual desire. The writer Pauline de Broglie, whose aristocratic family stroll in thin disguise through the pages of Proust, admitted to having her first bath at ten years old. The year was 1898 and, having just recovered from measles, the doctor prescribed a bath: 'It was a terribly complicated business, and it was talked about for several days. Naturally there was no bath tub in the house. No one in my family ever took a bath. We washed in tubs with two inches of water, or else sponged ourselves down, but the idea of plunging into water to the neck struck us as pagan, almost wicked!' Fortunately portable baths could be hired from Paris water-sellers and one was placed before a fireplace and the tin-plate was lined with a sheet before the little girl climbed in with her nightshirt on. However, by the

EDGAR DEGAS
Woman Sponging her Back, c. 1888–94

Although such pastels as this were carefully staged in his home studio, Degas went to great lengths to capture awkward, everyday movements and postures. The late nineteenth century saw the introduction to France of the first fully plumbed bathrooms, but Degas continued to portray women washing in tin baths or with sponges like this.

mid-1880s and in the face of several severe cholera epidemics, progressives on both sides of the Atlantic had begun to encourage the idea of regular bathing for cosmetic and medical reasons.

Degas, Monet, Bonnard, of course, and Mary Cassatt were all drawn to the bathing motif. For Cassatt it afforded opportunities to explore private worlds and to dwell on the sensuousness of water and the act of touching, particularly between women and children, in warm and intimate scenes, suggestive of enormous emotional and physical satisfaction. For Degas it became an obsession. In their art they both address related themes – the theatre, interiors, bathing – yet they approach their subjects quite differently. In a sense, each painter is picturing a world the other could not know. Mary Cassatt presents an exclusively feminine space, intimate and warm, where confidences can be exchanged, while many of Degas's pastels and paintings make discreet reference to prostitution and sexual trafficking between men and women. Her bathing pictures – which rarely depict adult nudes – are suffused with compassion and freshness, whereas Degas's bathers, often awkwardly posed climbing in or out of unplumbed baths in ornately furnished rooms, appear to be viewed with the complicity of a voyeur. His models are young, often attractive, drawn in pastels on surfaces as soft and seductive as skin.

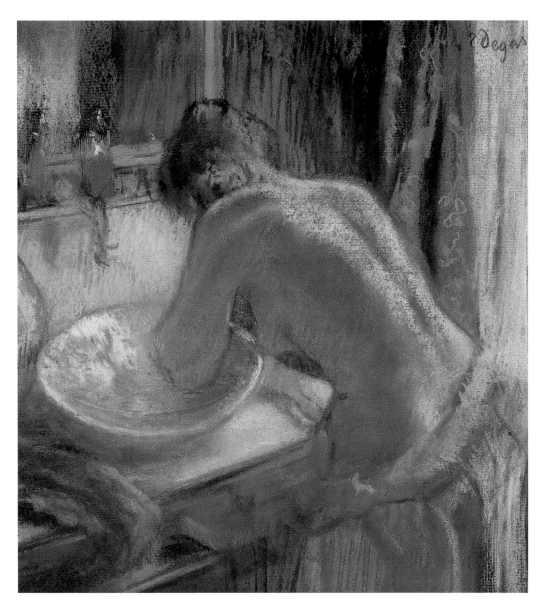

EDGAR DEGAS
The Toilette, c. 1884–86

After the Bath, Woman Drying her Hair, c. 1889

Degas's devotion to the nude and the bather is made evident in the hundreds of charcoal and pastel sketches he made of women washing and bathing. His curiosity carried him into the most private recesses of the woman's world and his determination to represent his subject in every conceivable pose and from every angle resulted in a great legacy.

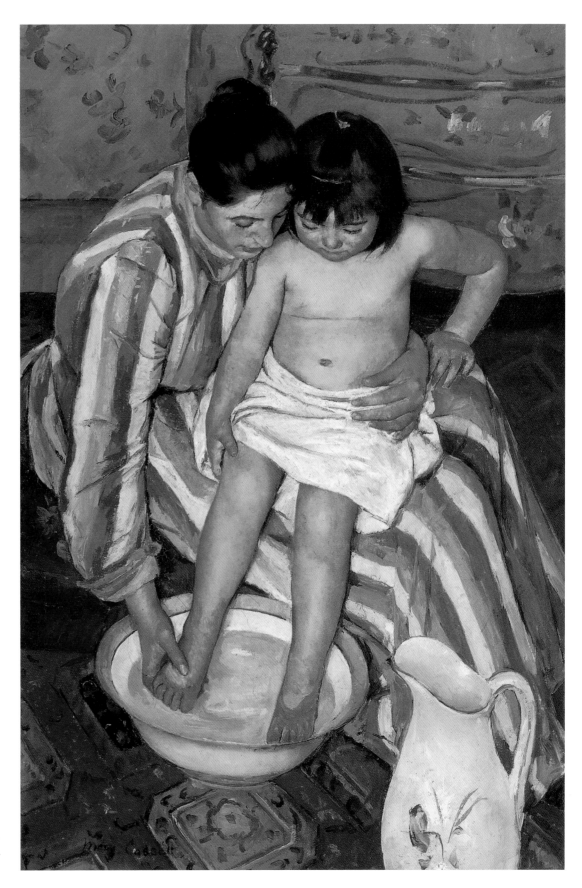

MARY CASSATT
The Child's Bath, 1893

Cassatt captures, with characteristic tenderness,
the care with which the mother bathes her child.
The two are linked by their shared gaze.

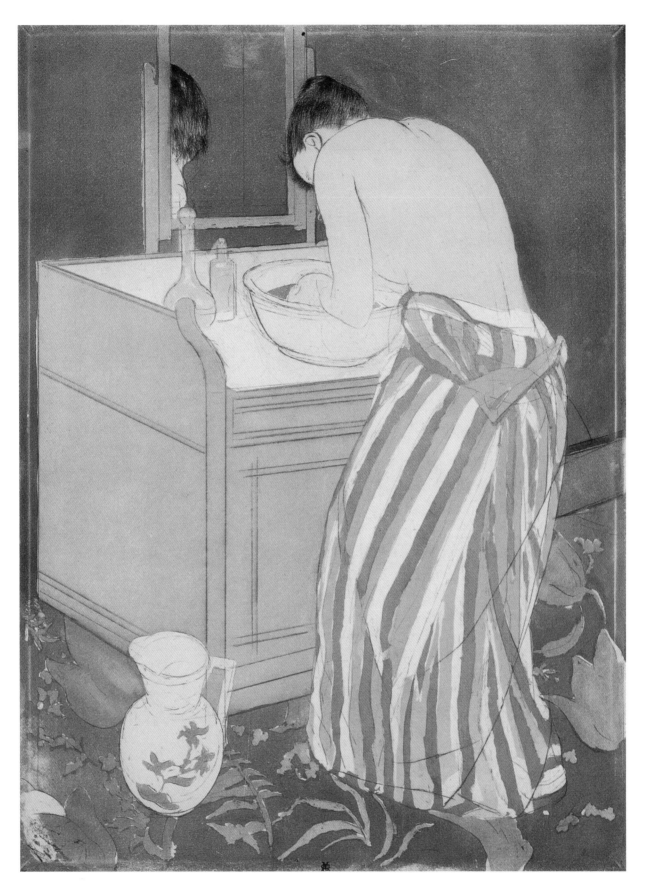

MARY CASSATT
The Bath, 1890–91

One of a series of ten drypoint prints shown in Cassatt's first solo exhibition at the Galerie Durand-Ruel in 1891, which clearly demonstrates her response to the Japanese ukiyo-e tradition.

EDGAR DEGAS
Woman at her Toilet, c. 1887

For a period of twenty years dating from 1885, Degas made over 250 pastels and oil paintings of solitary women absorbed in the business of washing or drying themselves, which emphasized the mild or mundane, as well as the mobile.

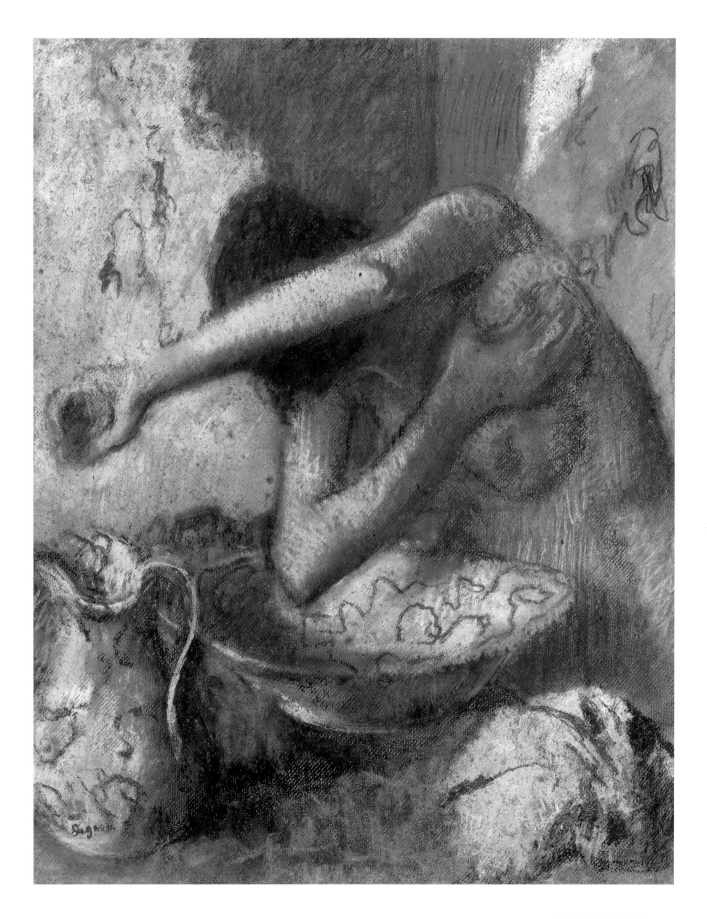

EDGAR DEGAS
Woman Washing in a Bath, c. 1895

The solitude of Degas's bathers has been interpreted in a variety of ways. Some comment on the women's 'blissful isolation', others see only the vulnerable loneliness of the prostitute. The discreet anonymity of the women, often shown crouching or concealing themselves, their arms across their faces or their breasts, their thighs in shadow, continues to provoke debate.

For Degas the 'melancholy spirit of isolation and disillusionment' which he identified with a modern sensibility was to be found in this singularly urban world of prostitution and entertainment. It held a special fascination for him and it is clear that he felt more at home in the closed nocturnal world of the ballet and the brothel than the sunlit spaces of his Impressionist colleagues. For his bathing pictures, he created a secret, interior realm, redolent of solitude and seclusion, the bather's body often turned away, her face almost always in shadow. 'I want to look through the keyhole,' he is reported as saying and, in his prints, pastels and the series of monotypes which he made at the height of his powers in the 1880s and 1890s, he seems to be doing just that. They appear to be done from a point outside the model's awareness, as though she did not know he was there, and was not, actually, posing.

Degas's modernity is signalled in the way he undermined the conventions of the nude, for, by turning his models away from the viewer's gaze and by painting them preoccupied with the mundane yet universal business of sponging an arm or drying a foot, he encapsulated 'the woman's intrinsic experience' and worked counter to the idea of a nude painting providing sexual spectacle or eroticism – unlike Manet, as we can see from his deliberately alluring *Woman in the Bath* (see p. 136).

Gustave Caillebotte was impressed by Degas's bathers and owned two pastels: *Squatting Woman Seen from Behind* and *Woman Leaving the Bath,* which shows a woman climbing rather awkwardly out of what looks like a freestanding unplumbed bath. She is about to be wrapped in a large white cloth or towel held aloft by a solicitous attendant servant. The room is sumptuously furnished, the walls darkly papered, the floor plummily carpeted. A capacious armchair over which a second towel has been casually thrown faces the bath and the woman's tiny red slipper stands in a pool of slopped water.

It is possible that Caillebotte's own electrifying *Man at his Bath* derived from Degas's many variations on the theme of female bathers. In this near life-size image, a muscular man is seen in back view, vigorously drying himself. One of a pair of paintings (the other shows a seated man drying his leg as it rests against the side of the bath), it was, quite simply, extraordinary for its time. The nude was supposed to be a feminine subject; and bathing itself a rather effeminate activity. And yet there is nothing effete about Caillebotte's powerfully built model, who stands with his feet planted firmly apart on a floor puddled by his impatient footprints.

GUSTAVE CAILLEBOTTE
Man at his Bath, 1884

An unusual male nude, painted with all of Caillebotte's customary robustness. The figure could almost be Classical, but the artist's interest is in stealing a scene from everyday life, creeping up on the man unannounced.

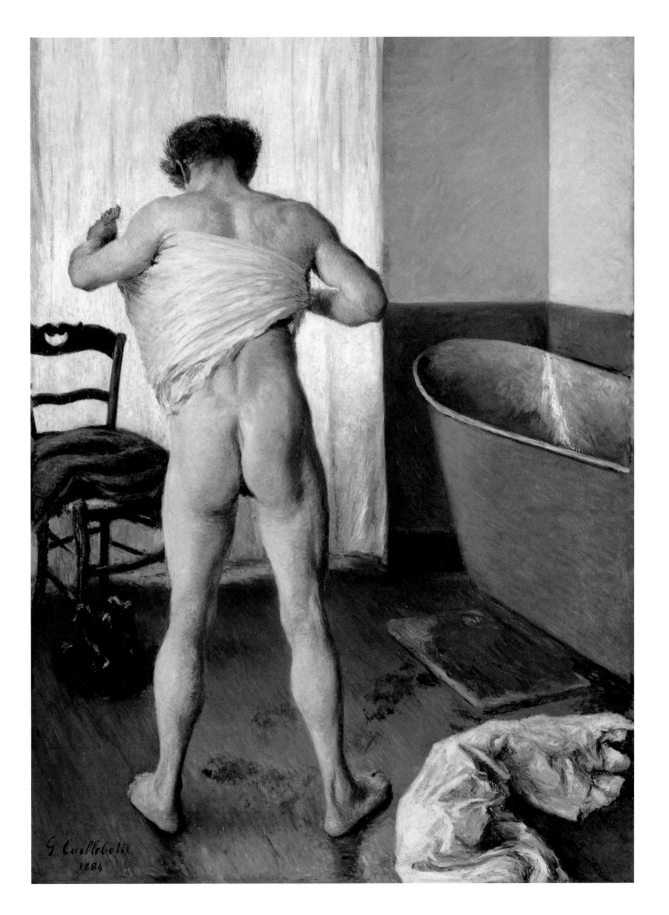

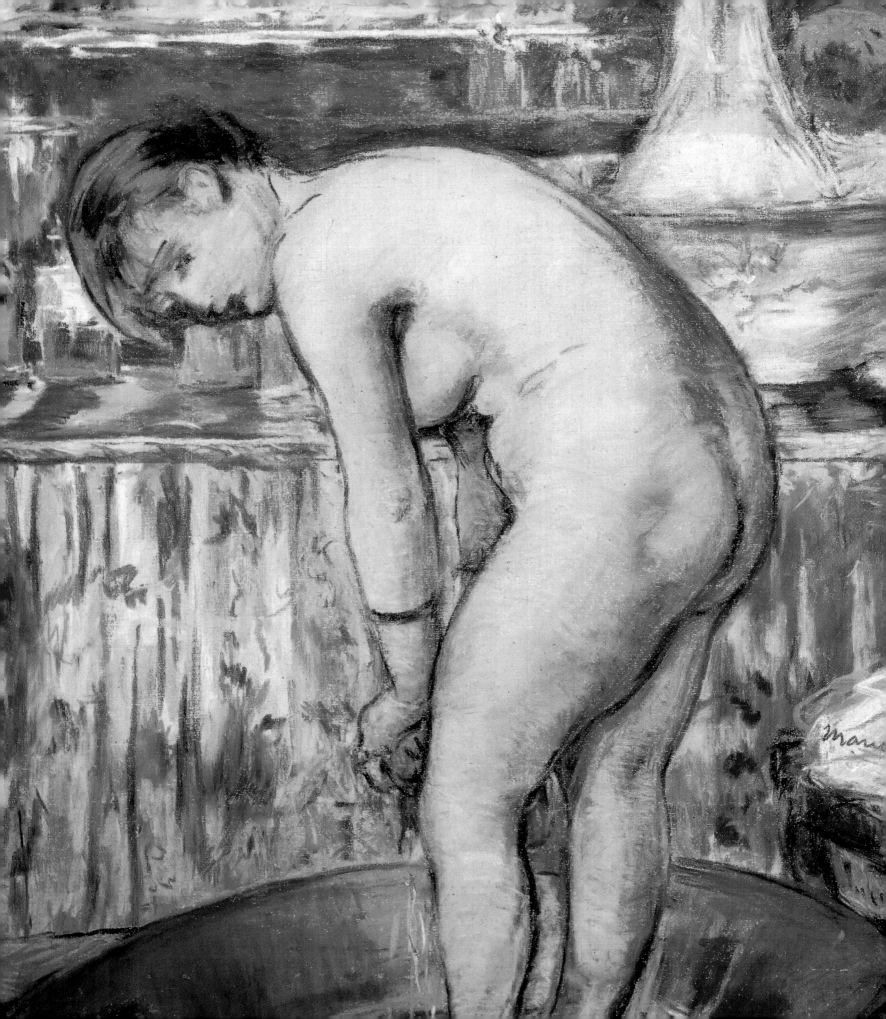

EDOUARD MANET
Woman in the Bath, 1879

CAMILLE PISSARRO
Young Woman Bathing her Legs, c. 1895

Woman Drying her Left Foot

Pissarro's models, like Degas's, look down or away, absorbed in the practical business of bathing their legs or drying a foot, and, in the absence of eye contact, we register neither expression nor engagement. But Manet's model – the actress and courtesan Méry Laurent – turns her rosy face toward the viewer, or the artist, and thus implicates him. According to George Moore, Méry and Manet were lovers and he painted her often. After Manet's death she became the mistress and muse of Stéphane Mallarmé and was immortalized not just in his poems but also in the pages of Proust, who based the character of Odette Swann in part on her.

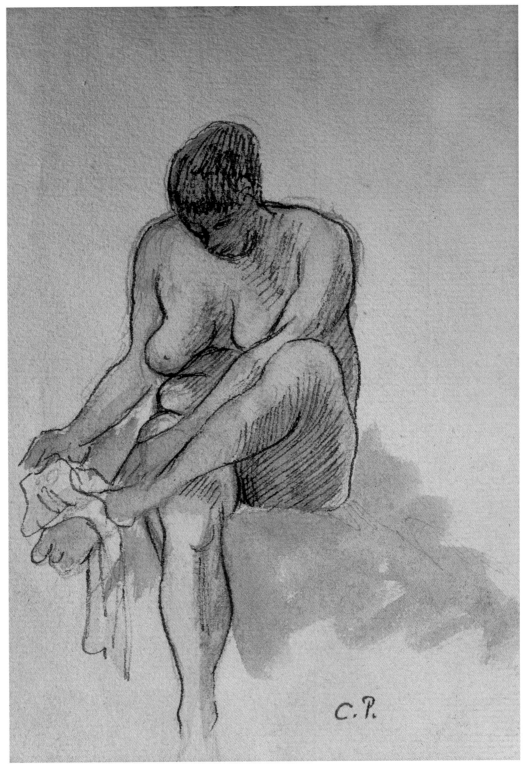

For Pierre Bonnard the daily routine of a woman taking her bath was to become one of his most popular subjects. 'I belong to no school,' he told Jacques Daurelle after his first exhibition at the Salon des Indépendants in December 1891, 'I am just trying to do something personal.' We now know that there was a strong biographical line in Bonnard's bathroom paintings, that the model, most often, though not always, was his 'petite amie' Marthe de Méligny (née Maria Boursin), whom he first met in 1893 when he was a struggling painter and she a Paris shop girl. The couple lived together, often unhappily, for almost fifty years, marrying impulsively in 1925 when she was fifty-six and he two years older, to assuage her feelings, according to Thadée Natanson, at being thought of as 'one of those women one did not marry.'

Marthe emerges in first-hand accounts as a difficult character, who held Bonnard back from socializing with Misia Natanson's glamorous crowd, which encircled Edouard Vuillard and would have welcomed him, though not – possibly – her, continually engaged in her lengthy, apparently obsessive, daily toilette. She hated to be left alone and was ill in some mysterious way which necessitated long stays in spa towns and caused them to move to Antibes, St Tropez and eventually Le Cannet, where, after living in various romantically named villas – the Villa l'Hirondelle, Villa Le Rêve – they finally moved, in 1927, into Villa du Bosquet where they would remain until their deaths in 1942 and 1947 respectively.

Pierre Bonnard bought the little pink house, half-way up a steep hillside, overlooking the bay and the red roofs of Le Cannet, for its views, which he enhanced by enlarging the existing windows and opening up new ones, rather than its convenience of access or spacious accommodation. Indeed the rooms were small and furnished in a spartan style – all except for the bathroom, the only luxury insisted upon by Marthe. During their time in the South of France Marthe's psychosis took the form of a persecution complex and she became increasingly unable to leave the house. The bathroom became her refuge and Bonnard painted it with a glowing radiance more usually seen in a cathedral in Constantinople. Often described as shy or retiring, there is nothing remotely timorous about his stunning and explosive use of colours which intensify almost to the point of incandescence. He liked to work against the light: the face of the model burning red, even in shadow, the long sweep of a leg licked by a light from some unseen source, so that his highly individual use of colours served subtly to unsettle our sense of the simple. His plunging perspectives, unexpected foreshortenings and surprising compositions work in opposition to the apparent ordinariness of his subject matter. There is an eerie stillness in many of the paintings, especially the nude images of Marthe reclining in the bath, seen from some ambiguous angle in precipitous perspective. And, of course, what makes them so unsettling is that Marthe never changes, her body never ages. Lithe, athletic, slim, proud, he paints her the same over a period of decades.

The Bath is a hauntingly memorable painting (see p. 140). Marthe's submerged body seems to float – and have floated – for a long, long time in that shallow bath, though her head, uncomfortably crammed up against the steep, cold, unyielding enamel, is fixed. Her expression is vacant. She seems entirely passive, entombed in the bath. The liveliness in the picture comes from the two bands of colour at the top and bottom of the painting which serve only to further underscore the immobility of the suspended stationary figure in the bath. Discomfort is articulated in Bonnard's weird-angle vision and the painting seems freighted with a buried narrative. Contrast this with the *Nude in the Bath* painted eleven years later in 1936. This time the model reclines in the bath as succulent as an oyster in her shell. The bath – shallower, more ornate – displays rather than imprisons the woman. Her legs are stretched, crossed, the toes pointed. The pose is more alluring, The flesh tones are rosy and alive, whereas before Marthe was shown as blue, ghostly. Here, the model rests her shoulders against the curve of the bath, her arms are freer, there's none of the hopelessness and resignation of the earlier pose. The model's pinkness – highlighted on the thighs and breasts – is echoed in the warmer tones of the water and the bathroom has been transformed into an exotic temple of rich colour, with glowing golds and pinks on the wall and a mauve mosaic showered with sunshine on the floor. When Marthe died in 1942 Bonnard was devastated and locked her bedroom, though he lived on in the house with his niece René Terrasse, making occasional trips to Paris, and continuing to paint. In his final years, he confided to the much younger Bazaine: 'I'm only just beginning to understand what it is to paint. One ought to start all over again...'

One of the first improvements Bonnard made to Le Bosquet was to install a tiled bathroom for Marthe. They kept their house in Normandy until 1938, as well as an apartment and studio in Paris, but spent increasing amounts of time in the South of France.

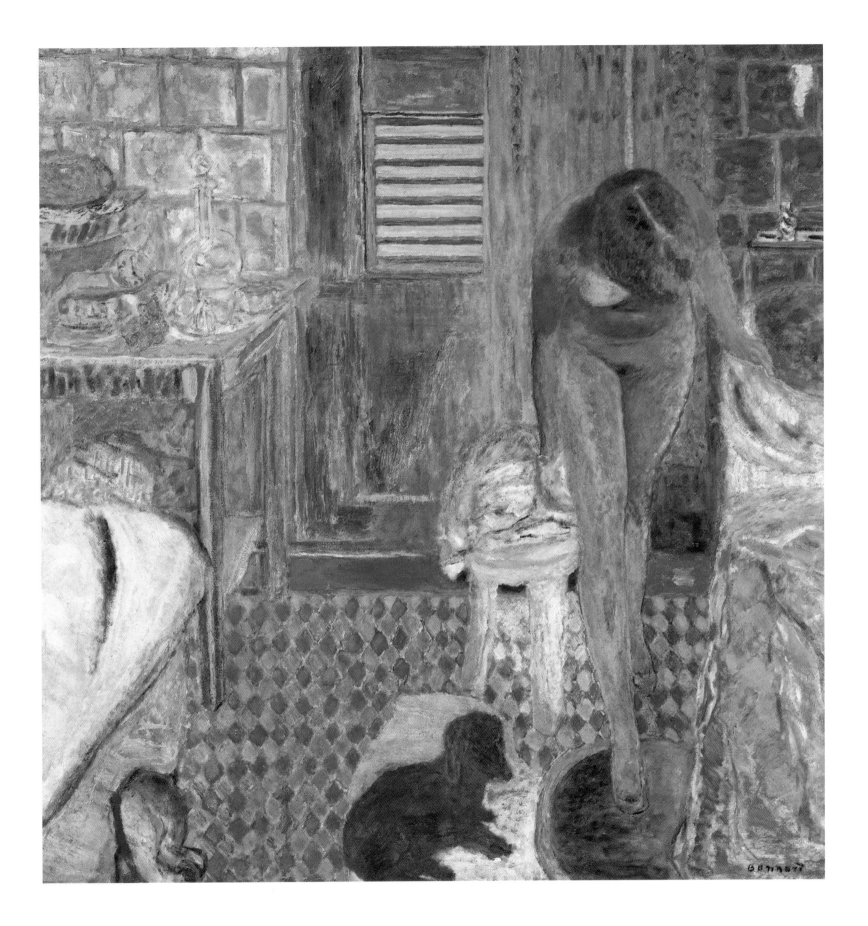

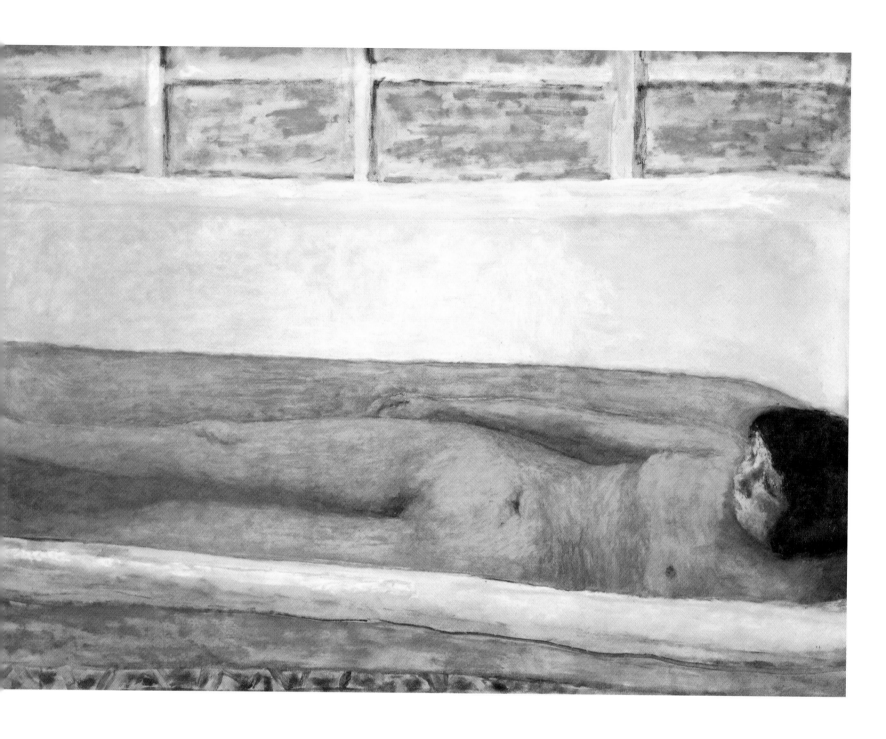

PIERRE BONNARD
The Bath, 1925

Bonnard, who married Marthe in 1925 after thirty-two
years together, was used to her daily regime of
frequent and lengthy bathing which involved her
spending several hours each day in the bathroom.

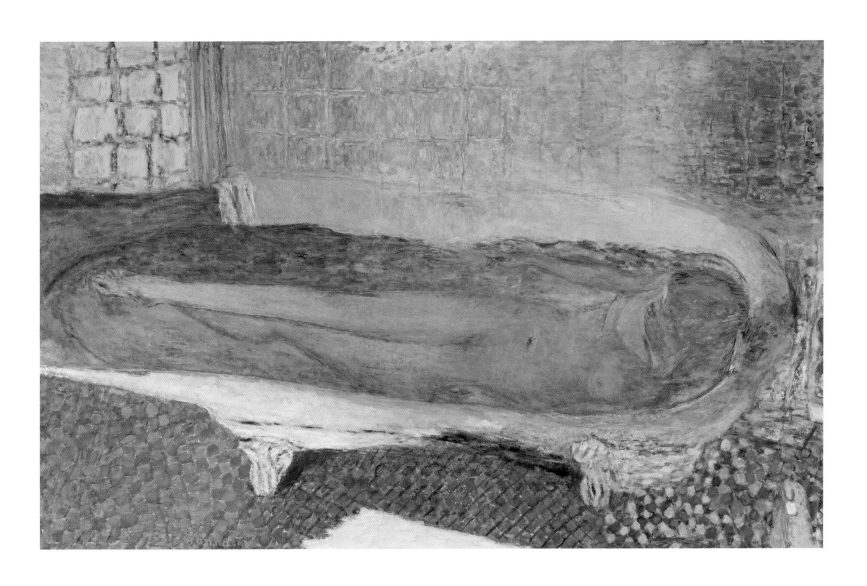

PIERRE BONNARD
Nude in the Bath, 1936

The sheer painterly exuberance of Bonnard's works
cannot fail to lift the spirit. His opulent bathroom,
which stands in stark contrast to Degas's tin bath,
is one of the best documented rooms in all
Impressionism, appearing countless times in his
wonderful series of bath paintings.

The Evolution of the Bathroom

Both the bath and the wash-basin were, at first, portable affairs, pieces of loose furniture or utensils without a room of their own which would be set up in a corner or recess of a bedroom, or, in more prosperous houses, in a dressing room with an armchair, footstool and mirror close by (as well as, of course, a dressing table). At the top end of the market dressing stands and shaving tables had been devised by famous cabinet makers like Hepplewhite and Sheraton with ingenious sliding and hinged folding parts which could flap open to reveal tiny drawers, additional gadgets like square bidets, basins, mirrors and china chamber pots for what their own advertising described as 'the accidental occasions of the night.'

A marble-topped dresser was pretty standard – a largish, rectangular piece of furniture similar to the one shown in Mary Cassatt's *Woman Bathing* or Gustave Caillebotte's *Woman at her Dressing Table* – on which would be placed a china bowl with a matching jug filled with water, various china soap dishes, sponge bowls and water bottles, all arranged in front of a mirror. A china slop pail (with a lid) would be housed on a lower shelf, for there was no waste and no overflow: running water did not reach bedrooms until some time after 1870. The presence of a tooth glass on the top of the dresser points to an awareness of oral hygiene, though it would seem that toothpowder was seldom used. Renoir, for example, used to wash his mouth out, night and morning, with salt water and clean his teeth with a little wooden tooth-pick, which was then thrown away.

Improved manufacturing techniques and expanding markets arising from the Great Exhibition of 1851 saw the arrival of an astonishing variety of baths: the Sponge Bath, which often had carrying handles and sometimes a spout to aid emptying, was now joined by the Full Bath or Lounge Bath, the Sitz Bath – oval or square with a small seat – the Hip Bath, the Fountain Bath, the Slipper Bath and the Travel Bath. Portable showers, which looked like a tent and poured water on to the bather from a tank at the top, were also advertised. Before the advent of cast-iron baths, around the 1880s, baths

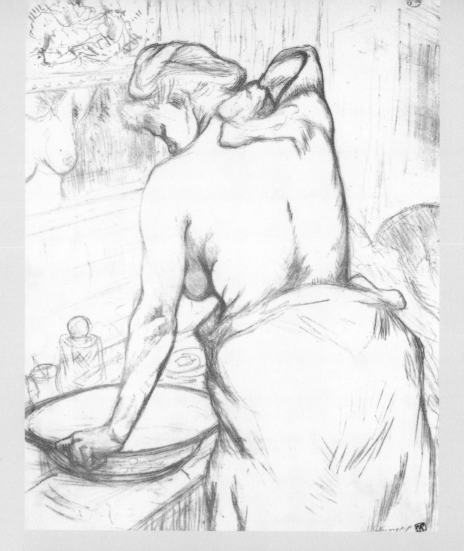

HENRI DE TOULOUSE-LAUTREC
Woman at her Toilet, Washing Herself, 1896

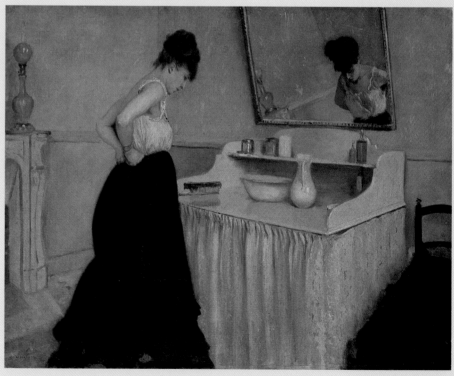

GUSTAVE CAILLEBOTTE
Woman at her Dressing Table, c. 1873

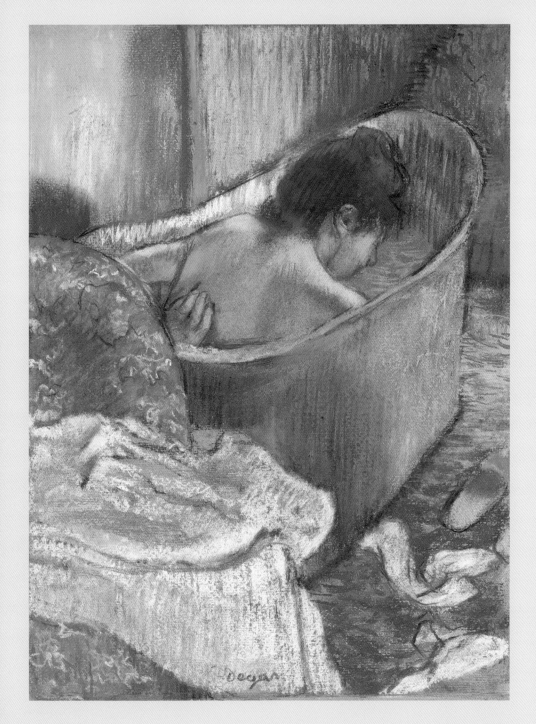

had been made out of marble – which was chilly and had to be lined with a sheet and sometimes even pillows – or wood, lined with lead or more preferably copper, for it was malleable and did not rust, though it was expensive and difficult to keep clean. Tin was sometimes used and zinc, painted or 'japanned' to look like imitation marble, was good when new, but deteriorated rapidly.

These large bathtubs gradually became the norm around the turn of the century and, as piped water and better drainage systems allowed fixtures to become plumbed in, 'bathrooms' were created from converted bedrooms or dressing rooms. At first these were showy affairs full of carpets, mirrors, pictures, armchairs and opulent furniture, very like bedrooms, but over time, bathrooms became smaller and more practical, becoming more like those we know today.

EDGAR DEGAS
The Bath, c. 1890

Jacob, Delafon & Cie advertisement from *La Vie Heureuse*, 1906

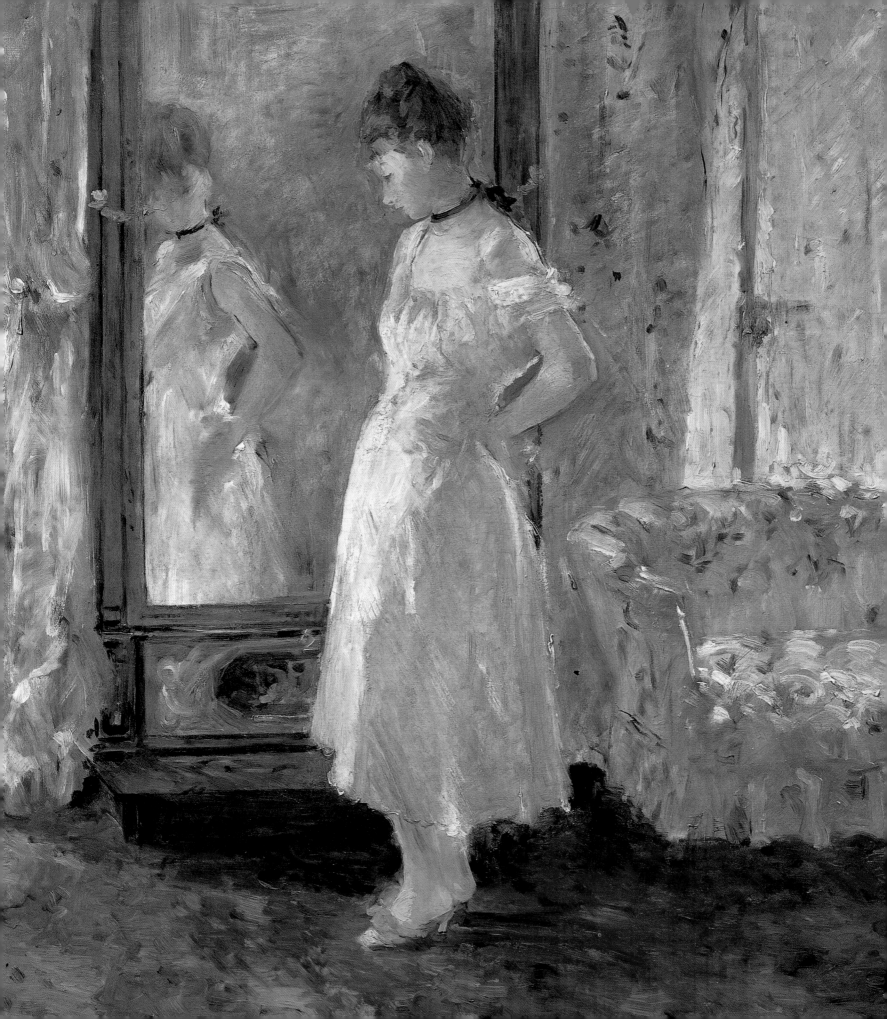

CHAPTER 8 # *A Place to Rest*
BEDROOMS AND BOUDOIRS, RELAXATION AND RECREATION

'Went to see Degas this morning...
he was still in bed at quarter past nine and
he said good morning in the way that he
does only in bed where he seems like a
child...Then he sat down to breakfast.
Zoé read the paper aloud and Degas
kept interrupting with extraordinarily
eloquent comments on the
subject of France.'
– Daniel Halévy, 22 December 1895

Van Gogh's Bedroom in Arles – one of a number of paintings Van Gogh made of his simple bedroom in the Yellow House on the Place Lamartine, which he rented for fifteen francs a month and shared with Paul Gauguin for a tempestuous period in 1888 – is undoubtedly the best-known image of a bedroom from the period. The narrow, neatly made bed leaning in towards the centre, with its two small pillows, watched over by the portraits on the wall, has about it the expectant air of a fairytale. The room is empty but fraught with the presence of its troubled owner: the clothes hanging on the hooks behind the bed, the towel by the washstand, even the placing of the rush-seated chairs has a poignancy which builds as Van Gogh paints the scene again and again, this time from memory, in the Saint-Paul asylum at Saint-Rémy in 1889, only now the colours, like his mood, have grown darker, richer, more intense. The bare boards of the floor have become a hectic green and the former feeling of repose has been replaced by one of urgency.

VINCENT VAN GOGH
Van Gogh's Bedroom in Arles, 1889

Vincent van Gogh sent a little preliminary sketch of this painting to his brother Theo in 1888. In his covering letter he explained that he wanted 'the amplitude' of the furniture to 'convey the feeling of unbroken sleep.'

BERTHE MORISOT
Psyche, 1876

Berthe Morisot's Psyche is a quiet, reflective young woman regarding herself rather diffidently in a large cheval glass. The picture hints at an awakening sexuality.

Van Gogh's is the only picture in this chapter which shows an empty room; Bazille's portrait of Monet after his accident at the inn in Chailly the only one to show a man in bed. Otherwise, from Eva Gonzalès's seductive *Morning Awakening* to Federico Zandomeneghi's languorous *In Bed*, the subject is women, often in their chemises, climbing sleepily out of gloriously rumpled beds or staring in a far-away fashion at themselves in mirrors. The mood is intimate – even when the subject is as full of saucy pride and satire as Manet's *Nana* – and frothily feminine. A fair number of Impressionists tackled the private daily ritual of combing hair, bathing, dressing or applying make-up, and it became a popular 'scene from modern life' subject for painters in the 1870s and 1880s. *Nana*'s impudent stare so scandalized viewers that the painting had to be removed from the Salon of 1877, but Morisot's shy young *Psyche* painted around the same time caused no similar outrage. Indeed, Paul Mantz made a high claim for the artist in *Le Temps* on 22 April 1877 when he stated: 'The truth is that there is only one Impressionist in the group

EVA GONZALÈS
Morning Awakening, 1877–78

Eva Gonzalès, the daughter of a well-known author of the period, Emmanuel Gonzalès, became Manet's pupil in the late 1860s.

at rue le Peletier: and that is Madame Berthe Morisot. She has already been acclaimed and should continue to be so. She will never finish a painting, a pastel, a watercolour…but when she plays with a range of light tones, she finds grays of an extreme finesse and pinks of the most delicate pallor.'

Some years later, Berthe Morisot noted down some observations on women's nature in her diary: 'The truth is that our value lies in feeling, in intention, in our vision that is subtler than that of men, and we can accomplish a great deal provided that affectation, pedantry, and sentimentalism do not come to spoil everything.' Her *Woman at Her Toilette* (see p. 159) has been called a visual poem worthy of her friend Mallarmé. She stressed the fragility of the image and the moment by signing her name along the bottom of the mirror and the picture caught the eye of the American Impressionist William Merritt Chase, who bought it for his own collection in the 1880s and went on to paint a number of pictures in the manner of Berthe Morisot – *On the Lake Central Park*, for example, which echoes her *Summertime*.

FEDERICO ZANDOMENEGHI
In Bed, 1878

A young woman, captured unawares, as she sleeps on in her comfortable-looking bed.

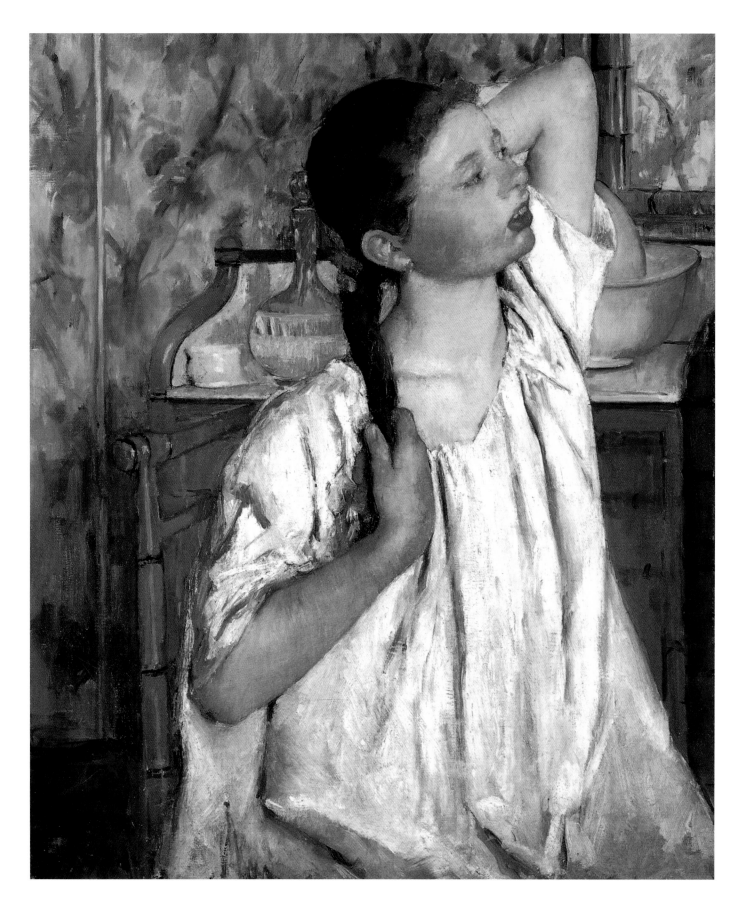

MARY CASSATT
Girl Arranging her Hair, 1885–86

EDGAR DEGAS
The Coiffure, c. 1896

During the cataloguing of the contents of his studio after his death Mary Cassatt's picture was, for a while, wrongly attributed to Degas. Both painters were fascinated by the subject of women's toilette. Though a bachelor, Degas made copious notes on hair colouring and styles and, as a young man, asked to watch a friend at work on her coiffure. Later he spent hours in his studio posing models with brushes and combs.

Alongside Berthe Morisot's touching and tender paintings of girls and women combing their hair, or having it combed by others, we can place a number of pictures by Degas, whose meditations on feminine grooming offer a different commentary on modern life and on the nature of intimacy. It was a theme that would preoccupy him during his last years, firing his imagination and providing a rich narrative vein for scores of charcoal sketches and warm pastel compositions.

Inevitably, Degas's presence, as a male painter, disrupts the idea of feminine sanctuary, whereas his friend Mary Cassatt, was able to make this private female world her special study. Her picture of a young *Girl Arranging her Hair* was so admired by Degas – 'What drawing! What style!' he wrote to her – that he exchanged it for one of his own and hung it in a prominent place on the walls of his salon for the next twenty-seven years. A photograph Degas himself took in the mid-1890s shows the painting hanging alongside a pastel portrait by Manet of his wife, which Degas had traded for a thousand francs' worth of his work in a deal brokered by Alphonse Portier.

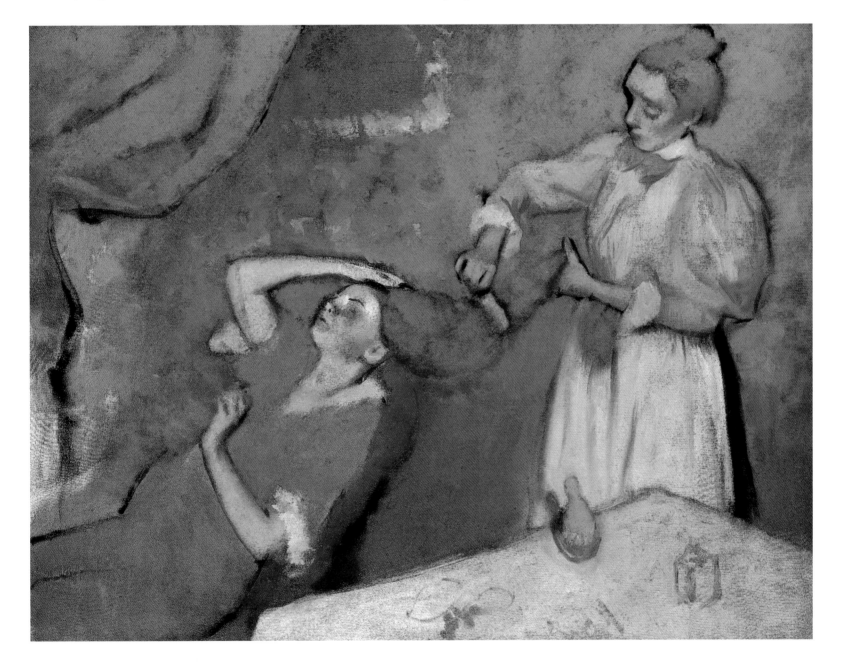

PIERRE-AUGUSTE RENOIR
Camille Monet Reading, 1872

The influence of Japanese art is revealed in Renoir's vertical portrait of Camille propped practically upright on a plump sofa as she reads a book. Behind her hang three Oriental fans – part of Monet's extensive collection of Japanese artifacts and prints.

Monet's bedroom at Giverny

The walls of Monet's bedroom at Giverny were lined with damask tablecloths sewn together.

Claude Monet's creamy, light-filled bedroom at Giverny, overlooking the gardens and the tall poplars beyond, was also hung with paintings by friends like Renoir, Berthe Morisot and Cézanne, and elegantly furnished with ample armchairs and rich red rugs, but he did not sleep well: 'at night I am obsessed with what I am striving to achieve', he wrote. 'In the morning I get up broken by fatigue. The dawn gives me courage, but my anxiety rushes back as soon as I set foot into the studio. How difficult it is to paint...it really is torture.'

Cézanne's bedroom, one feels, was always a fairly cold place. His relationship with his model Hortense Fiquet, a tall, handsome girl with brown hair, large black eyes and a docile temperament, begun in 1869 when she was just nineteen, suffered from his insistence on secrecy and, although they did eventually marry in April 1886 and move to Aix, Hortense does not seem to have liked provincial life, and their marriage, corroded by the years of elaborate deception, was not a happy one. After long periods of living alone with her son Paul – who was fourteen at the time of his parents' marriage – in cheap apartments in Paris and, occasionally, L'Estaque and Marseille, Hortense found it hard to settle into a routine with the famously taciturn Cézanne – especially since the household continued to be run by Cézanne's mother and his unmarried sister, Marie – and she and Paul returned to the capital. Renoir, visiting Cézanne at Jas de Bouffan, in January 1888, sensed the unease and wrote darkly of 'the black avarice that reigns in the household.' He curtailed his brief stay, preferring instead to move on to the Hôtel Rouget in Martigues.

Jean Renoir's vivid memoir, *Renoir, My Father* provides an intimate glimpse of his parents' marriage. 'I never saw my father kiss his wife in public, or even in front of us children,' he wrote. 'A married couple or a pair of lovers showing their feelings too openly in public made him feel uncomfortable.

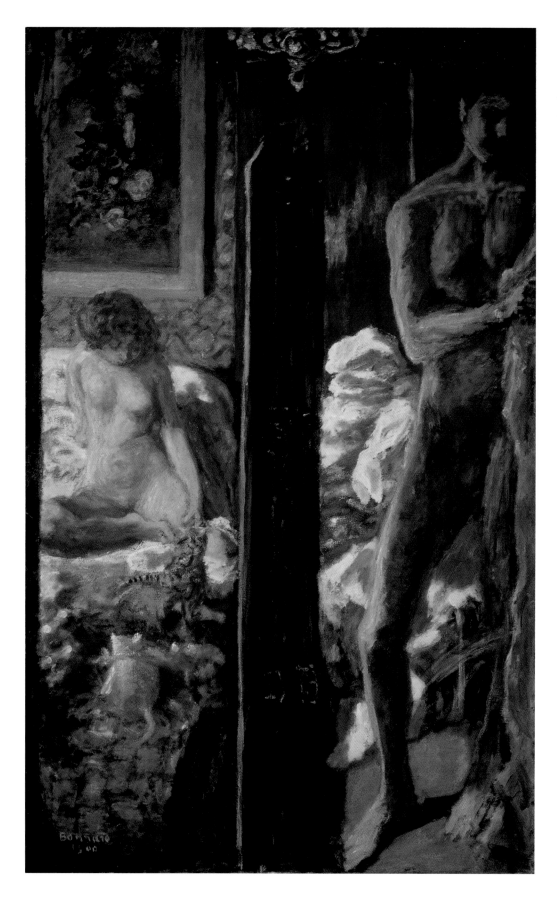

PIERRE BONNARD
The Siesta, 1900

Bonnard's disquieting double portrait of himself and
Marthe literally divided by the barrier presented by the
folded screen was unusual for its time and continues
to unsettle even now.

"It won't last long," Renoir would say, "they're waving it around too much.".' Curious sentiments in a way from a man who boasted that he would 'paint with my prick' when his advancing arthritis made it impossible for him to hold a brush any longer and who told his dealer Ambroise Vollard that he knew a picture was finished 'when I've painted a woman's behind so that I want to touch it.'

According to Jean, he bloomed both physically and spiritually when in the company of women and ensured that there were always plenty around, either in the shape of servants – whom he liked to sing, laugh and feel at ease when working around him – or models. He was forty-nine when he finally married Aline and, despite a long string of model-mistresses, remained faithful to her from that moment on, again according to Jean, who states: 'I am almost certain that he never deceived his wife.' He even discussed the question with the lovely Gabrielle, who had caused Aline such agonies of jealousy: 'During Gabrielle's last years,' Jean wrote, 'she and I got into the way of discussing everything quite openly. Sometimes we talked about the sexual relations between my father and mother. We both thought that their love life had been very active and affectionate and that their physical relations had only ended after illness had rivetted Renoir to his invalid's chair once and for all. I hope my parents will forgive me for not respecting the intimacy which meant so much to them, but I think it is of sufficient importance to justify my taking this liberty, if only to stress how normal Renoir was in everything, including sex.'

Like Polonius, Renoir had plenty of advice for his son. 'Before marriage do whatever you please,' he told Jean airily. 'You owe nothing to anybody... But afterwards, when you've given your word to a life-companion, that sort of behaviour is treason. And it always ends badly...' He warned his son that: 'It's not much fun to spend the night with a whore,' and urged him to: 'Get away from your wife often, but not for long at a time. After you've been away you'll be glad to get back to her.' 'As far back as I can remember, my parents always slept apart,' wrote Jean. 'They nearly always had separate, but adjoining rooms. "You have to be very young to be able to live in close contact continually without getting on each other's nerves," he explained.'

Pierre Bonnard's private life is shrouded in shadow, though his paintings provide clues to what was, at times, an enervating existence. Take *The Siesta*, also known as *L'Homme et la Femme* – a powerful picture redolent of post-coital *tristesse* and division. It depicts a naked female figure on a bed, her head lowered sadly, and a daringly full-frontal male figure, standing to the right, reaching for a towel. The terrible sense of emotional distance between two people who have just made love is further reinforced by the folded screen which creates a bold barrier between them. *The Siesta* is, in fact, a double portrait of Bonnard and his mistress of seven years Marthe Boursin. The couple would remain locked in a troubled, frequently tormented and at times stifling relationship for over half a century, baffling their friends yet providing Bonnard with an undeniable muse who defined and dominated his painting.

They married late in life, Bonnard stung into action by the casual comments of an upper-class friend, with only the concièrge and her husband on hand to witness the ceremony. Yet marriage – inevitably and intimately linked with money – mattered a great deal to women at this time. Those outside its protective embrace – like Hortense Fiquet and Camille Doncieux – suffered from poverty, loneliness and society's censure. Camille had often been left alone with her baby son because of pressures from Monet's family, who held the purse strings and threatened to cut him off entirely if – as he finally did – he married his mistress. Camille felt the injustice very keenly, especially since she believed that she was the victim of hypocritical condemnation by Monet's family, for hadn't Monet's own father had an affair with a maid, who had subsequently borne him a child – a daughter, Marie? It now transpires that, for all his bourgeois bluster, Cézanne's own father had only regularized his union with his mother four years *after* the son's birth, and an 'adventure' with a maid at Jas de Bouffan had caused Madame Cézanne considerable pain.

Berthe Morisot's marriage to Eugène Manet would appear to be the most traditional of all the French Impressionist marriages, prompted neither by the need to legitimize children nor to regularize some otherwise irregular arrangement. As was customary a civil ceremony took place at the *mairie* (on 22 December 1874) and a religious one at the local church in Passy. The bride described herself as having

'no profession' despite having participated in prestigious exhibitions for years. Eugène Manet described himself as a 'man of property.' However, at thirty-three the bride was a little older than was usual for the time, a fact she herself remarked on in a letter to her brother Tiburce: 'I went through this ceremony without the least pomp, in a plain dress and hat, like the old woman that I am and with no guests.'

Her mother gave her little practical advice. A few days before the wedding, Cornélie Morisot delivered a little homily on duty and fugitive nature of happiness, recommending that her daughter 'fight against that part of ourselves which disposes us to excessive sensibility and melancholy.'

Berthe's marriage was, it would seem, fairly successful. Eugène supported his wife's artistic ambitions and proved a loyal and indulgent husband. If he seemed unexciting at times she could always escape the marital home under cover of visiting her sisters, which was an acceptable custom of the time for women of Berthe's class, and one she exercised sufficiently often to suggest that she valued, or perhaps even needed, the freedom it provided.

The bedroom would seem to be the appropriate place in which to discuss prevalent ideas about birth control, though naturally we cannot know for sure what – if any – methods the Impressionist painters or their wives or mistresses employed. France was of course predominantly Catholic at this time, but despite the legal and religious restrictions on practising contraception, the birth rate dropped dramatically within a couple of generations, proving that various methods were employed, particularly by women, who found their own health improved dramatically if they limited the size of their families.

By the end of the century a typical middle-class family in England had three children, in France two. Enlightened doctors had begun to encourage the use of various contraceptive methods, including the condom, coitus interruptus, an assortment of pessaries, an early form of the diaphragm and the sponge, a popular, simple and convenient device which appealed greatly to women for it gave them some degree of control and independence. All a woman needed was a suitably sized piece of sponge attached to 'a bit of narrow riband' which she could insert before and withdraw after sex. Generally the stress was on the health benefits of fewer pregnancies rather than any enhancement of sexual enjoyment which a woman, freed from the anxiety of pregnancy, might experience. Dr Richard Carlile in his book *Every Woman's Handbook or What is Love?* assured his readers that the sponge 'can be pleasantly introduced' and 'neither lessens the pleasure of the female nor injures her health.'

Access to and acceptance of such modern ideas was largely a matter of class. Middle-class women welcomed the idea of exercising some control over their destiny and preferred female contraceptives, which did not involve the cooperation of the man and so gave them independence – indeed such devices were even explicitly advertised in women's magazines as usable without a husband's knowledge. Working-class women, on the other hand, were more reluctant to tamper with nature. Their choice was between abstention or abortion, although by the middle of the century, the development of the douche marked another milestone and was gratefully employed both by respectable wives and the kind of desperate working girl who frequently modelled for the Impressionists. Many different types of syringe were manufactured with an impressive list of douching solutions designed to destroy sperm, if employed immediately after coitus, though their effectiveness varied. We can see this revolution in birth control as part of the same general pattern of scientific advance and innovation which so intrigued and motivated the Impressionists. The newly emerging modern woman – now better able to shape the modern family – took a more explicit interest in pleasure-seeking.

In 1884 women secured the right to initiate divorce in France but none of the French Impressionist marriages – though not without their difficulties at times – ended in this way, or even began, in the case of Monet and Alice Hoschedé, who might have married sooner if the deeply conventional Alice had felt able to seek a divorce from her husband Ernest. But it was simply not an option. Perhaps we should not be surprised. A combination of Catholicism and, in some instances, a long struggle to achieve a married status mitigated against any casual casting aside of the hard-won role of wife.

However, a number of American Impressionist painters, including Frederick MacMonnies and Willard Metcalf, made marriages which ended in divorce in the first decade of the new century, though

A sleepy young woman fumbles for her slippers as she sits on the edge of an elegant bed. Berthe Morisot never painted the theatres or music halls of the modern city, instead she turned inwards and set up 'scenes from modern life' in her own home.

others proved more durable. William Merritt Chase met his future wife when she was just fourteen. Alice Gerson, the youngest of three beautiful sisters, was living with her widowed father Julius in New York when the thirty-one-year old artist asked her to pose for him. Six years later they were married. Alice proved to be eminently 'paintable' and over the thirty years of their marriage modelled for her husband with patience and good grace. Chase, despite his flamboyant personality, proved to be a devoted father and uxorious husband who, whenever they were apart, wrote vivid, gossipy, yearning letters to his wife each night.

Chase's contemporary Edmund C. Tarbell is also supposed to have experienced a *coup de foudre* on first seeing Emeline Arnold Souther, a student at Boston's newly founded Museum School. He hastened his return to America from Paris when she looked in danger of falling in love with another man and they married in 1888. Unlike Berthe Morisot, however, Emeline forfeited her own claims to a career, for Tarbell, according to his biographer, 'made the narrow Victorian rule that there would be only one painter in their family.'

Willard Metcalf's personal life was extremely complicated. In the summer of 1887 he rented a house in Giverny with a group of American painters, including Louis Ritter, Theodore Wendel, John Breck and Theodore Robinson and is thought to have fathered a child by the housekeeper-model the artists hired. Unlike his French counterparts in similar situations, he did not go on to marry the girl. Instead he returned to America where he began a tempestuous relationship with another model, the youthful divorcée and stage performer Marguerite Beaufort Hallé, with whom he lived in stormy circumstances, spending lavishly, drinking heavily, arguing often.

When Marguerite discovered that he had begun an affair with a young actress named Pauline French, she attempted suicide, which propelled him into marriage in 1903. It was always doomed, however, and a few years later Marguerite took off with Robert Nisbet, a student of Metcalf's. The resulting divorce caused a great scandal.

Metcalf's critical and commercial success soared, however, in direct proportion to his declining personal circumstances, until, in 1910 he met Henriette Alice McCrea, almost thirty years his junior and married her in January 1911. Apparently settled, Metcalf entered a period of great – though short-lived – personal contentment, during which his daughter Rosalind and son Addison were born. However, his second marriage began to unravel when Henriette discovered that he and Pauline French were still in touch and, in 1924 after a protracted triangular period, they too divorced.

Finally, the bedroom functioned as a site of repose and recreation, but also as a place of recuperation and refuge: for the young Monet at Barbizon, for Marguerite Hallé in New York and for the elderly Renoir, crippled by rheumatoid arthritis, in Cagnes-sur-Mer. He described the early symptoms to Berthe Morisot in a letter written in 1888: 'I am in the grip of a cold I caught in the country, and I have a localized rheumatoid facial paralysis. In short, I cannot move the whole side of my face, and just for a treat am having a two-month course of electrical treatment. I am not allowed to go out and catch cold again. It is not serious, I think, but at the moment I can't move anything.'

Sadly, as we know, his condition would only worsen as time went on. The arrival of a third child provided the impetus for a rush of tenderly painted family portraits and groups but it is ironic that, at sixty, after a lifetime of struggle, just as Renoir found himself in the enviable position of having a capable

CHILDE HASSAM
The French Breakfast, 1910

Hassam, who had studied at the Académie Julian for three years, made frequent return visits to Europe with his wife Kathleen, and lived in Paris for two years with her and her sister Cora.

wife who looked after him with great care, three much-adored children, devoted servants and an impatient market for his work, the one thing he needed in order to be able to paint as freely as before was denied him: his health.

'For five weeks I haven't left my bedroom,' he told Paul Durand-Ruel in November 1916: 'That's not funny.' He grew increasingly frail and in December 1919 was back in bed suffering from pneumonia. His son Jean Renoir knew it must be the end. Yet when the maid came in with a vase of freshly picked anemones, he sat up in bed and insisted on making a sketch of them. 'I think I am beginning to understand something about it,' he whispered as he lay back. Later that afternoon he died.

FRÉDÉRIC BAZILLE
The Improvised Ambulance, c. 1866

An affectionate portrait of Monet, shown recovering in bed from an accident to his leg which he suffered shortly after his arrival at the inn in Chailly, by his great friend Bazille.

Boudoirs

A number of Impressionist paintings provide a glimpse of the intimate world of middle-class women, who spent their mornings in their bedrooms or boudoirs, writing letters and menus, extending and accepting invitations, dealing with household bills and affairs, organizing shopping trips and planning entertainments. Renoir's two paintings of Camille – *Camille Monet Reading* and *Madame Monet Reclining on the Sofa, Reading* Le Figaro – and Berthe Morisot's *Portrait of Madame Hubard* invite us into this private space. The pictured women are all dressed in 'morning gowns', a special garment worn over a light corset which the woman's maid would have laced her into before going on to brush her hair and twist it up into a chignon. The use of informal clothing in these paintings suggests private moments and – especially in the case of Renoir – a special familiarity with the household and its mistress.

Renoir was indeed a close family friend and fond of Camille, whom he paints, youthful and radiant, prettily perched on a sumptuous divan or reclining in a morning gown of duck egg blue, in marked contrast to her husband's *Madame Monet au canapé,* painted the previous year, which shows Camille, serious and distant. Renoir presented the second painting to Monet and it hung for many years in his bedroom at Giverny.

Camille Monet, Madame Hubard and other women of their class did not dress properly until it was time for lunch, after which they might receive guests at home, or go shopping, take a promenade, drive round in a carriage to visit female friends, attend a matinée theatre performance, or a dress fitting. This was familiar territory for Berthe Morisot. The world of young women *en deshabille* busying themselves with their toilette, having their ballgowns fitted, or their hair arranged was the intensely feminine world she and her sisters inhabited. Similarly, Mary Cassatt often used a modestly furnished bedroom as a favourite setting for paintings. It was – together with a brightly lit parlour and a walled garden – one of the pleasant private spaces she returned to again and again. Here a woman could spend

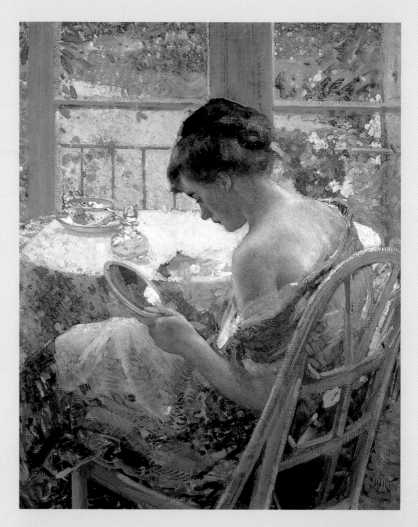

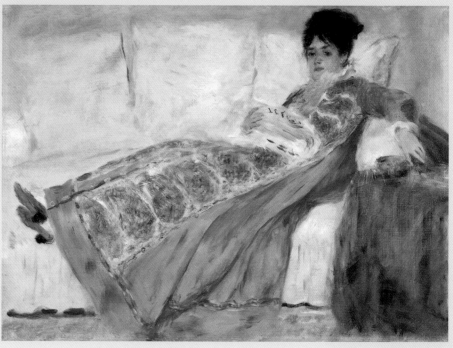

RICHARD MILLER
The Toilette, c. 1914

PIERRE-AUGUSTE RENOIR
Madame Monet Reclining on the Sofa, Reading Le Figaro, 1872

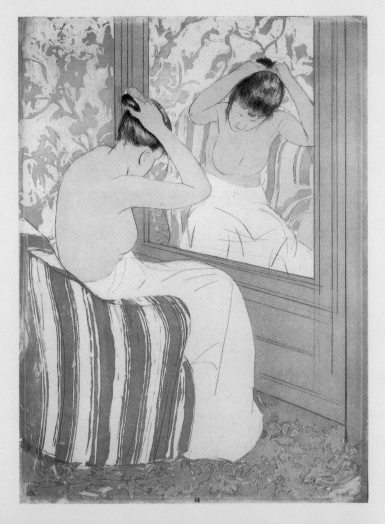

her time alone, absorbed in her reading or her sewing, happy, as she was, in her own company. Her own bedroom was a serene space, which boasted a painted Rococo-revival bed with a matching green-painted nineteenth-century Rococo-revival commode, and was kept in order by Mathilde Valet, Mary Cassatt's faithful housekeeper-companion.

Like Berthe Morisot, she painted her own world, one of leisure and discreet servants gliding soundlessly into bedrooms with jugs of warm water and a breakfast tray. Her drypoint *The Bath* (see p. 132) captures a private moment as a woman, naked to the waist and bent over a bowl of blue water, is on the point of splashing the water up onto her face. Ranged along the marble washstand are bottles of toilet water which the woman, as part of her morning ritual, would apply after lightly sponging her upper body.

Women's magazines of the time are full of advertisements for skin creams and hair dyes. Women were concerned with their appearance and with prolonging their youth, or at least the illusion of youth, for as long as possible. The 'New Parisian Vaporizer' promised a smooth white complexion; 'Beethan's Glyceran and Cucumber Lotion' guaranteed to make women years younger. 'The Specialité Corset' claimed to 'lead the way all the world over to Women's greatest ambition: a Good Figure.' And an advertisement for 'Diano', a mysterious treatment, claimed: 'WOMEN MADE BEAUTIFUL. Develops the Bust; fills all hollow places...Beautiful women everywhere owe their fame and loveliness to Diano.'

'A self respecting woman,' *Fin de Siècle* announced in 1891, 'must have a morning corset, a dress corset, and a bathing corset.' These constricting garments could severely hamper a woman's breathing and interfere with her digestion, even her fertility. Renoir, outspoken as ever, declared that 'corset-makers ought to be put in prison' for 'deforming' the natural shapeliness of women. But corsets were big business and clothes of extreme importance. 'If I were shabby,' says Lily Bart, the doomed heroine of Edith Wharton's *House of Mirth,* 'no one would have me: a woman is asked out as much for her clothes as for herself. The clothes are the background, the frame, if you like: they don't make success but they are a part of it.'

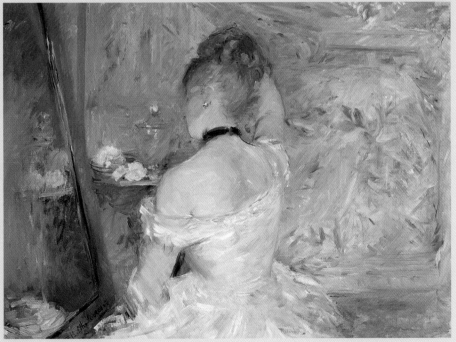

MARY CASSATT
Study, 1890–91

BERTHE MORISOT
Woman at her Toilette, c. 1875

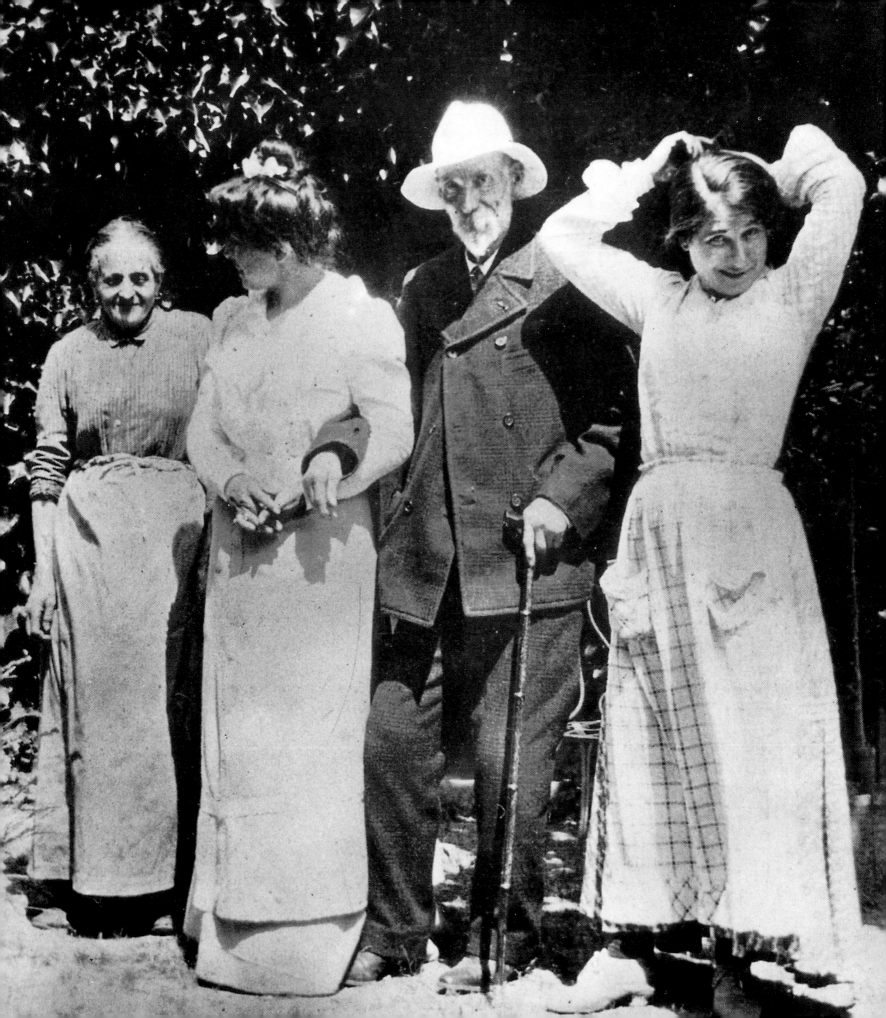

BIOGRAPHIES

BAZILLE, Frédéric (1841–70) Born in Montpellier to a wealthy family, the tall, handsome Bazille arrived in Paris at the age of twenty-one to study medicine but soon enrolled at the studio of Charles Gleyre where he met Sisley, Renoir and Monet. He shared a studio with Monet at 6 rue de Furstenberg and later another with Monet and Renoir. A talented artist, his friendship and financial support were important to the young painters and the tragedy of his early death during the Franco–Prussian War deprived the Impressionist movement of one of its most promising painters.

BENSON, Frank Weston (1862–1951) An American Impressionist who studied at the Académie Julian and painted with Metcalf and Simmons. He returned to America in 1885 and married Ellen Perry Peirson three years later. Benson spent long summers on the island of North Haven, where he eventually bought a house known as Wooster Farm, and often used his wife and daughters as subjects for paintings.

BONNARD, Pierre (1867–1947) Born in a suburb of Paris, Bonnard abandoned law to concentrate on art, studying at the Académie Julian. In 1893 he met Marthe de Méligny, a Paris shopgirl, who would become his model, constant companion and eventual wife until her death in 1942. In 1912, Bonnard bought a small house in Vernonnet, only a short distance from Monet at Giverny, but Marthe's chronic ill health led them to the south of France where, in 1926, Bonnard bought Villa du Bosquet in Le Cannet, a short drive from Cannes and not far from his friend Matisse.

BRACQUEMOND, Marie (1841–1916) A highly original artist, she married the painter Félix Bracquemond and exhibited with the Impressionists in 1879, 1880 and 1886, but abandoned painting altogether apparently because of her husband's jealous attitude towards her work.

BRECK, John Leslie (1860–99) American Impressionist who, after studying in Munich and at the Académie Julian in Paris, found his way to Giverny. Breck was the catalyst for the colony of American artists who 'discovered' Giverny in 1887. For five years he lived in close proximity to Monet, becoming romantically involved with his stepdaughter Blanche Hoschedé. However, opposition from Monet and Alice Hoschedé scuppered the friendship, causing him to return to America where he died aged thirty-nine.

BUTLER, Theodore Earl (1861–1936) Ohio-born American Impressionist, friend of Sargent, in 1892 he succeeded where Breck had failed, and married one of Monet's stepdaughters, Suzanne Hoschedé. The couple initially lived in the Maison Baptiste, a cottage near Monet's estate, where their two children James (Jimmy) and Alice (Lili) were born, though tragically Lili's birth in 1894 left Suzanne paralysed. She died five years later. In October 1900 Butler married her sister Marthe. The Butlers spent the war years in America, but returned to Giverny in 1921.

CAILLEBOTTE, Gustave (1848–94) The son of a wealthy Paris businessman, Caillebotte trained as an engineer, but became increasingly interested in painting, enrolling at the École des Beaux-Arts. He helped organize the Impressionist group exhibitions, and was an important patron, donating his entire collection to the nation. A passionate yachtsman, he helped Monet to construct the covered floating studio he used at Argenteuil. Caillebotte lived in a house on the banks of the Seine at Petit Gennevilliers with his mistress, Charlotte Berthier, and her daughter, Jenny, until his premature death aged just forty-five. He was buried in the Père-Lachaise cemetery, his funeral attended by all the major Impressionists.

CASSATT, Mary Stevenson (1844–1926) Born in Pennsylvania, Cassatt travelled to Paris in 1866 and was accepted by the Salon two years later. She enjoyed the strong support of her family and often used them as models in her paintings. Degas urged her to exhibit with the Impressionists, and for a time she was the near neighbour of Pissarro at Pontoise until in 1894 she bought and renovated the Château de Beaufresne, near Paris, though she kept an apartment and studio in Paris at 10 rue de Marignan. Deteriorating eyesight curtailed her career, though she remained active in the art world, advising American friends on the purchase of paintings. She never married.

CÉZANNE, Paul (1839–1906) Born in Aix-en-Provence, he disappointed his father by abandoning law in favour of the École des Beaux-Arts, where he met up with Pissarro, Monet and other members of the budding Impressionist circle. Apart from a brief interval working for his father's bank in Aix, he painted all his life, often struggling on an allowance from his father, especially after the birth of his son, Paul, in 1872 to his model and mistress Hortense Fiquet. He exhibited only twice with the Impressionists and divided his time between Paris and the family home at Jas de Bouffan. In 1886 he married Hortense and the same year his father died, leaving him a substantial legacy which removed all financial worries. In 1899 he built himself a studio on the road leading to Les Lauves, and he spent most of his last years in Aix.

CHARIGOT, Aline (1859–1915) Born in Burgundy, worked as a laundress and a seamstress in Paris before meeting Renoir in his local lunchtime restaurant and becoming first his model and then his mistress. Their first son, Pierre, was born in 1885, and the couple eventually married in 1890 before having two more children, Jean (who wrote a vivid memoir of his father), born 1894, and Claude, known as Coco, born 1901. Described as an almost compulsive eater, Aline died of a heart attack in 1915.

CHARPENTIER, Georges (known as Zizi) (1846–1905) Inherited a publishing business in 1871, and in 1875 purchased his first painting by

FRÉDÉRIC BAZILLE

PIERRE BONNARD

GUSTAVE CAILLEBOTTE

MARY CASSATT

PAUL CÉZANNE

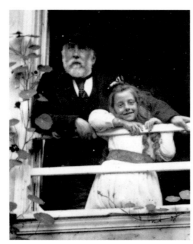

EDGAR DEGAS and niece

Renoir. He founded the weekly review *La Vie moderne* and supported the cause of Impressionism by organising exhibitions on the review's premises. A magnet for left-wing politicians and artists, he befriended Renoir in particular and introduced him to affluent potential patrons like the Bérard family.

CHASE, William Merritt (1849–1916) American Impressionist painter with a particularly European style. He studied in Munich and in Venice before returning to New York in 1878, where his Tenth Street studio became famous for its lavish decoration – just as he did for his own flamboyant appearance. He married Alice Gerson in 1886 and his work sold well, but his extravagant spending and mania for collecting often led to financial difficulties. A sought-after teacher, he conducted outdoor classes at his Shinnecock Hills Summer School on Long Island and took groups of students on annual trips to Europe. He bought a villa near Florence in 1908.

CLOSIER, Zoé (*c.* 1850–*c.* 1920) Degas's housekeeper, cook and, later, nurse, she became invaluable to the painter, reading to him when his eyesight failed and shielding him from unwelcome visitors.

DEGAS, Hilaire Germain Edgar (1834–1917) Born into a wealthy banking family of noble descent, he entered the École des Beaux-Art in 1855 where he worked under a pupil of Ingres, his great hero. His friendship with Manet and other members of the Batignolles group encouraged his interest in contemporary Parisian subjects. A lifelong bachelor, and famously prickly, he nevertheless excited great loyalty from his friends. His experiments with pastels, print-making, photography and sculpture give an idea of his breadth and innovation.

DONCIEUX, Camille (later Monet) (1847–1879) Monet's companion and mistress through the very hard early years and appears in some of his best-known paintings. They married in June 1870 three years after the birth of their first son Jean and she died a year after the birth of their second, Michel, in 1879.

DURAND-RUEL, Paul (1831–1922) One of the most important of the Impressionists' art dealers, he met Pissarro and Monet in London in 1871 (following the outbreak of the Franco–Prussian War) and mounted an exhibition of their work the following year. Almost ruined by continuing to buy Impressionist paintings, though his faith paid off and he passed a flourishing business over to his son.

ENSOR, James (1860–1949) Belgian painter whose father was English. Trained in Brussels but spent his life in Ostend, producing paintings which sit between Impressionism and Expressionism.

FANTIN-LATOUR, Henri (1836–1904) Slightly older French artist, responsible for introducing Berthe Morisot to his great friend Manet. He remained sympathetic to and friendly with the Impressionists, though his own style derived from the traditions of the École des Beaux-Arts.

FIQUET, Hortense (1850–1918) First met Cézanne in 1869 while working as an artist's model and shortly afterwards began living with him in Paris, L'Estaque and Auvers where the couple and their son, Paul (born 1872), were befriended by the Pissarros. Cézanne tried to keep his liaison with Hortense a secret from his family, only marrying her when Paul was fourteen in 1886, by which time the constant secrecy had had a corrosive effect on their relationship. However, Cézanne drew and painted Hortense often and with surprising tenderness, and petitioned his friends to send her small sums on a fairly regular basis.

FRIESEKE, Frederick Carl (1874–1939) Michigan-born artist who studied at the Académie Julian in Paris and, from 1900, spent his summers in Giverny, where he lead the American 'figural Impressionists' group. A permanent expatriate in France, he married Sarah Ann O'Bryan of Philadelphia in 1905 and the couple leased the house immediately adjacent to Monet's in Giverny. Closer to Renoir in style than Monet, he was heavily influenced by Vuillard, Bonnard and the work of the Nabis.

GACHET, Paul (1828–1909) Homeopathic doctor and enthusiastic engraver, who befriended the Impressionists – particularly Pissarro, Cézanne and Van Gogh – treating Pissarro's children and his mother Rachel, Renoir's model Anna Leboeuf, and taking charge of the troubled Vincent van Gogh when he came to live in Auvers-sur-Oise in 1890.

GONZALÈS, Eva (1849–1883) Became Manet's only pupil in 1867 and was possibly seen as a rival by Berthe Morisot, though Gonzalès never exhibited at any of the Impressionist exhibitions. Married the etcher Henri Guerard in 1879, but died a few weeks after giving birth to a son at the age of thirty-three.

GUILLAUMIN, Armand (1841–1927) A largely self-taught artist who joined Cézanne and Pissarro on painting trips in Pontoise and exhibited in most Impressionist group shows, though he continued to work as a civil servant in the Department of Civil Engineering. Shy by nature, he nevertheless introduced Seurat and Signac to Pissarro in 1885 and became friends with Vincent van Gogh through his brother Theo. After an early career dogged by financial difficulties he won a large sum of money in a lottery in 1891 which allowed him to paint without financial worries.

HASSAM, Frederick Childe (1859–1935) Boston-born painter who travelled throughout Europe. In 1884 he married Kathleen Maude Doane and two years later moved to Paris, living at 11 boulevard Clichy. He studied at

the Académie Julian for three years before returning to America where he painted impressionistic pictures recording pleasurable scenes from leisured life in New York and New Hampshire.

HOSCHEDÉ, Alice (1844–1911) Monet met Alice, who would become his second wife, through her husband Ernest Hoschedé, a major collector and patron of the Impressionists in the 1870s. In 1878 a financial crash ruined Hoschedé and Alice and her six children joined forces with the Monet family at Vétheuil, eventually moving, after the death of Camille, to Giverny where Alice ran Monet's household and helped him to plan his famous garden. They married after Ernest's death in 1892. Her eldest daughter Blanche married Monet's son Jean in 1897.

LAURENT, Méry (1849–1900) A woman of great charm and beauty, described as an indifferent actress but a courtesan of genius, who excited the devotion of, among others, Manet and Stéphane Mallarmé whose mistress and muse she was for seven years after Manet's death. When she first posed for Manet she was living in an apartment in the rue de Rome paid for by Louis Napoleon's dentist, who was also her lover. She sent frequent gifts of flowers and delicacies to Manet during the last years of his illness.

MACMONNIES, Mary Louise Fairchild (1858–1946) American artist who travelled to Paris on a scholarship in 1885 and studied at the Académie Julian. Married the American sculptor Frederick MacMonnies in 1888 and had one daughter, Berthe. Visited Giverny from 1890, then in 1898 moved into Le Moutier, an old priory, where both she and Frederick had studios. In 1908 she divorced her husband and married her longstanding admirer, the muralist and writer Will Low, returning with him to America in 1909.

MALLARMÉ, Stéphane (1842–1898) Symbolist poet and great friend of

Manet, Morisot, Renoir and Monet, whose art he supported in his writings.

MANET, Edouard (1832–1883) Wealthy, talented and controversial figure around whom a group of young Impressionist painters gathered in the 1860s. Began a secret affair with his mother's music teacher, Suzanne Leenhoff, whom he later married in 1862, after his father's death; while he never acknowledged Suzanne's son Léon as his own, he made generous provision for the boy in his will. His painting *Déjeuner sur l'herbe* was the talk of the Salon des Refusés in 1863 and *Olympia* caused a scandal two years later. Despite his close friendship with Degas, Morisot, Monet and Renoir, Manet never officially joined the Impressionists, nor did he participate in any of their group exhibitions. A sophisticated socialite, he owned property at Gennevilliers and Asnières and, with his friend Theodore Duret, tried to help the impecunious Monet by anonymously buying ten of his paintings. After years of suffering from syphilis, and ten days after the amputation of his left leg, he died on 30 April 1883.

METCALF, Willard Leroy (1858–1925) Massachusetts-born American artist who studied in Paris at the Académie Julian, spending his holidays at Grez-sur-Loing and Giverny. One of the first Americans to discover Giverny, he was invited to lunch at Monet's house in the spring of 1886 and later made a series of haystack paintings. On his return to America, in 1903 he married the young divorcée and stage performer Marguerite Beaufort Hallé, who frequently modelled for him, though the couple divorced a few years later. His second marriage to Henriette McCrea produced two children, Rosalind and Addison, but also ended in divorce.

MEURENT, Victorine Louise (1844–1885) Brought up in poverty and with a hankering to become an actress, the fair, almost red haired, beauty met Manet when she was just twenty and became his model for *Olympia* and

Déjeuner sur l'herbe as well as many other paintings. She had a passionate affair with Alfred Stevens but died in abject poverty.

MILLER, Richard Emil (1875–1943) Missouri-born American artist who joined the expatriate group in Paris studying under Benjamin Constant at the Académie Julian. An acknowledged colourist, he worked in the summer art colonies in St Jean du Doig in Brittany and Giverny in Normandy and became closely associated with Frieseke.

PAUL DURAND-RUEL

MONET, Claude (1840–1926) The eldest son of a Parisian shopkeeper, Monet was brought up in Le Havre, where Eugène Boudin encouraged him to paint out-of-doors. He enrolled at the Académie Suisse in Paris, where he met Pissarro, and two years later entered the atelier of Charles Gleyre, where he joined forces with Bazille, Renoir and Sisley. In 1866 he met Camille Doncieux, who modelled for *Women in the Garden*, and the following year their son, Jean, was born. His family disapproved of his relationship and he and Camille lived in straitened circumstances in a number of rented houses in the suburbs around Paris, including Saint-Michel, near Bougival, and Louveciennes. In 1883 Monet, by now a widower, moved with Alice Hoschedé and her children to the house at Giverny which would become his home for the next forty-three years. Monet and Alice were married in 1892.

EDOUARD MANET

MORISOT, Berthe (1841–1895) Born into a wealthy *haut-bourgeois* family, both Berthe Morisot and her sister Edma (1839–1921) showed early artistic promise. This was encouraged by their mother, who introduced them to Corot, Puvis de Chavannes and Fantin-Latour. Her work was exhibited regularly at the Salon from 1864 and won praise from critics. In 1867 she was introduced to Manet by Fantin-Latour and he became a keen admirer, inviting her to pose for some memorable paintings. In 1874 – the year of the first Impressionist show –

CLAUDE MONET

BERTHE MORISOT

CAMILLE PISSARRO

PIERRE-AUGUSTE RENOIR

she married Manet's younger brother Eugène and in 1879 – the only year she did not exhibit at one of the Impressionists' shows – her daughter Julie was born. She met Mary Cassatt in the late 1870s and collaborated with her in printmaking, but her closest friendship – after Manet – was with Renoir. She did not long outlive her husband, who died aged 59 in 1892, falling ill herself in February 1895 and dying a few weeks later. She was buried in the Manet family tomb in Passy alongside Eugène, Edouard and Suzanne.

PERRY, Lilla Cabot (1848–1933) American Impressionist from an aristocratic Boston family, she met Monet in 1889 and became one of the few Americans to maintain a longstanding friendship with him. With her husband and three young children, she lived in Giverny for many years, at one time renting a house next door to Monet, and shared Monet's passion for gardens.

PISSARRO, Camille (1830–1903) Born in the West Indies, Pissarro was sent to Paris by his affluent Jewish family to complete his education. His artistic abilities were immediately apparent and in 1855 he enrolled at the Académie Suisse, where he met Monet, and was a regular at the Café Guerbois, haunt of Manet, Degas, Renoir and Cézanne. A lifelong Socialist, he poured great energy into organizing the Impressionist exhibitions and was an indefatigable supporter of younger new talent, befriending Signac and Seurat, Van Gogh and Maximilien Luce. His affair with his mother's maid Julie Vellay was frowned upon, but the couple married in 1870 and went on to have six children, all of whom proved artistic. The family lived in and around Pontoise from 1872, and in 1892 Pissarro was finally financially stable enough to buy the house in the small village of Eragny-sur-Epte which he had rented since 1884. Thadée Natanson wrote of Pissarro: 'He did not look merely like a patriarch but like "le bon Dieu" himself'; '....what humanized him was a certain mischievousness in his smile.'

RENARD, GABRIELLE (1878–1959) Maid, model and nanny to Renoir's children for over twenty years from 1894. She was a distant cousin of Renoir's wife, coming from the same town in Burgundy, and occupied a central role in the lives of the Renoir boys, taking them to school, feeding, dressing, bathing them and tending them when they were sick. Renoir painted her literally hundreds of times, often with Jean or Coco. As the children grew older, she graduated from maid and nanny to secretary and assistant, preparing and cleaning Renoir's palettes. While living with the family at Cagnes she met the American painter Conrad Heusler Slade (a great admirer of Renoir) and married him in 1921, moving to the States.

RENOIR, Pierre-Auguste (1841–1919) The fourth child of a tailor and a seamstress, Renoir was brought up in humble circumstances. Apprenticed at twelve as a painter in a porcelain factory, he took on extra work to pay for art school. In 1861 he met Monet, Sisley and Bazille while attending Charles Gleyre's studio, and in 1862 was accepted by the École des Beaux-Arts. A man of great personal charm, he was adept at forging influential connections with patrons like Georges Charpentier and the banker Paul Bérard. From 1867 to 1872 Renoir's mistress and favourite model was a young woman called Lise Tréhot, younger daughter of the postmaster at Ecquevilly. In 1879 he began living with a young seamstress from Burgundy named Aline Charigot, and they had three sons together and married in 1890. The family lived first at Montmartre, then in Aline's home village of Essoyes, before moving permanently to the South of France for the sake of Renoir's failing health. In 1907 he bought a piece of land at Cagnes-sur-Mer and built Les Collettes, a substantial house with generous gardens.

ROBINSON, Theodore (1852–1896) Early American Impressionist artist who trained in Paris at the independent atelier of Charles-Emile-Auguste

Durand (Carolus-Duran) and at the École des Beaux-Arts from 1876–79. Profoundly influenced by Millet and Monet, whom he met in 1888 and became very friendly with. Spent most of 1884–92 in France, joined Metcalf, Harrison and Will Low at the artists' colonies at Barbizon and Grez, and established a small but important colony at Giverny with Twachtman and Weir in 1888. Despite critical recognition, he died young and impoverished in New York.

SARGENT, John Singer (1856–1925) The most European of the American Impressionists, Sargent was born in Florence, studied in Paris and lived in London. He experimented along the lines of his friend Monet, whom he visited several times in Giverny between 1885–89. He painted prodigiously and was devoted to his friends and his family, though he never married, or had children.

SEURAT, Georges (1859–1891) Born in Paris to solid middle-class parents, he studied at the École des Beaux-Arts and exhibited his major work *Sunday Afternoon on the Island of La Grande Jatte* in the last Impressionist exhibition of 1886. A meeting with Signac in 1885 led him to develop the pointillist style for which he is best known. Extremely tall, self-contained and regular in his habits, he was not an easy man to know. He died prematurely, aged just thirty-two, following a short illness.

SICKERT, Walter Richard (1860–1942) The son of a painter, Sickert studied at the Slade School of Fine Art, and, following a meeting with Degas, arranged by Whistler in 1883, became a leading light in English Impressionism. A flamboyant personality, he lived abroad in Dieppe, Venice and Paris, before returning to London in 1905, where he formed the Fitzroy Street Group and was taken up by younger painters.

SIGNAC, Paul (1863–1935) Largely self-taught artist, influenced by the work of Monet and Degas, and introduced

by Guillaumin to Pissarro, who invited him and Seurat to participate in the last Impressionist exhibition of 1886. More gregarious than Seurat, he became friendly with van Gogh and with Caillebotte, who sailed down the Seine with him to visit Seurat at the Ile de la Grande Jatte while he was working on his large canvas. He moved to the South of France in 1887, became president of the Société des Artistes Indépendants and had decidedly Anarchist sympathies.

SISLEY, Alfred (1839–1899) Genial Impressionist, born in Paris to prosperous English parents, he lived all his life in France and rarely visited England. Quiet, determined and rather shy, he enrolled at Charles Gleyre's studio and worked mainly in Paris and Louveciennes, Marly-le-Roi and Sevres, painting landscapes of great power, often tinged with melancholy. In 1870 his father's artificial flower business was ruined by the Franco–Prussian War, leaving Sisley without means, and he and his partner Marie Lescouezec and their two children, Jeanne and Pierre, experienced periods of extreme financial hardship. In 1882 he settled in Moret-sur-Loing and died in poverty in his sixtieth year after a lifelong struggle for the recognition that never came.

TARBELL, Edmund C. (1862–1938) Leader of the Boston Impressionists, he studied art in the School of the Museum of Fine Arts, Boston, and the Académie Julian in Paris for three years, before returning to America. In 1888 he married the painter Emeline Arnold Souther, persuading her to forfeit her own claims to a career and devote herself to him. Along with her four children, Josephine, Mary, Mercie and Edmund Jnr, she often posed for her husband and when asked in later life if she would marry an artist again if she had her life to live over, reportedly replied: 'Yes, if I could find another Tarbell.'

TOULOUSE-LAUTREC, Henri de (1864–1901) Born at Albi into an old aristocratic family, a rare bone disease stunted the growth of his legs after two fractures. He studied at Cormon's studio in Paris with Van Gogh and produced vibrant paintings and pioneering posters depicting Parisian nightlife, but his wild lifestyle and excessive drinking contributed to his premature death aged thirty-seven.

VAN GOGH, Vincent (1853–1890) A Dutch pastor's son, Van Gogh's early sombre palette was lightened by his contact with the Impressionists and exploded into vibrant colour on his move to Arles in 1886. His last two years were spent in asylums at St-Rémy and at Auvers-sur-Oise, where his brother Theo – manager of the Montmartre branch of the Bousod and Valadon gallery and constant supporter – had sent him to recuperate under the care of Dr Gachet. There he died a few days after a suicide attempt.

VELLAY, Julie (1838–1922) Daughter of a Burgundian vine-grower, Julie Vellay came to Paris in 1860 to work as a maid to Pissarro's mother Rachel. Embarking on an affair with Pissarro, the couple had two children by the time they married in London in 1870 and went on to have four more, though one, Jeanne-Rachel, died tragically young at nine. Hard-working and resourceful, Julie supported her husband during years of privation.

VUILLARD, Edouard (1860–1940) Born near Lyon into a lower-middle-class family, Vuillard's artistic promise was nurtured by his widowed mother, who ran a corset-making shop in Paris. After an early academic apprenticeship, close association with the Nabis led to a radical shift in style, and alongside Bonnard and Maurice Denis he became one of the great Post-Impressionist painters, specializing in intimate interior scenes. Dedicated, reserved, he moved shyly in the circle and never married.

VOLLARD, Ambroise (1867–1939) A flamboyant figure in the art world who opened a gallery at 39 rue Laffitte with an exhibition of sketches by Manet and went on to champion Pissarro,

Renoir and Degas. He gave Cézanne his first one-man show in 1895 and promoted Bonnard, Vuillard and Van Gogh, as well as Picasso and Matisse.

WEIR, Julian Alden (1852–1919) American painter who studied academic painting at the École des Beaux-Arts before gradually converting to Impressionism. His marriage in 1883 to the wealthy Anna Dwight Baker provided financial support at a time when he was struggling for recognition. His first child, Caroline, was born in 1884 and from that time on he often depicted his family and home life in his paintings. He divided his time between a townhouse in New York and a farm in Branchville, Connecticut, and corresponded regularly with Mary Cassatt in Paris.

WHISTLER, James Abbott McNeill (1834–1903) American-born artist whose aesthetic ideas had a profound effect on Gauguin, Monet and other Impressionists in Paris and on painters like Sickert and Menpes during his sojourn in London. His painting *The White Girl* was exhibited along with Manet's *Déjeuner sur l'herbe* at the Salon des Refusés in 1863. In 1888 he married E. V. Godwin's widow and they settled in a small house in the rue du Bac. Regularly attended Mallarmé's famous Tuesday evening soirées in company with a select circle of Symbolist poets, painters and critics.

ZANDOMENEGHI, Federico (1841–1917) Venetian-born artist who lived in Paris from 1874 and exhibited with the Impressionists at the fourth, fifth, sixth and eighth exhibitions. Closest to Degas in style.

ZOLA, Emile (1840–1902) French novelist and champion of 'realism' who moved in Impressionist circles but lost the friendship of his old classmate Cézanne after the publication of his novel *L'Oeuvre*, a *roman à clef* about the Parisian art scene, which included an unflattering description of a struggling artist named Claude Lantier who bore a striking (and painful) resemblance to Cézanne.

WALTER SICKERT

HENRI DE TOULOUSE-LAUTREC

EDOUARD VUILLARD

The forest of Fontainebleau provided our young artists with sites for *plein-air* painting in the 1860s and the small villages of Barbizon, Marlotte and Chailly-en-Bière cheap lodging in simple rustic inns, like the Hôtel du Cheval Blanc, where Monet, Renoir and Sisley stayed. The Auberge du Père Ganne at Barbizon is now a museum. The Musée Municipal de l'École de Barbizon is also worth a visit. The village of Moret-sur-Loing was home to Sisley at the end of his life, and his house at 9 rue du Donjon, though in private hands, boasts an (indistinct) plaque over the front door. Sisley and his wife Marie are buried together in the cemetery at Moret.

The Normandy coastal town of Fécamp was frequented by Monet and Berthe Morisot. Deauville and Trouville were also favourites with Monet, who was brought up at Le Havre. Mère Toutain's Ferme Saint-Siméon at Honfleur – frequented by artists, including Monet and Pissarro – still exists today on the route Adolphe Marais on the edge of town.

Hardly any of the Impressionists' homes and studios in Paris survive, though the streets in which they were located do, and a stroll around, say, Montmartre or the Batignolles district can, with a little imagination, be a rewarding experience, especially if it is preceded by a trip to the Louvre, the Luxembourg, or the Musée d'Orsay, which are all packed with paintings by the Impressionists.

An idea of what an artist's studio might have been like is provided by Eugène Delacroix's in the rue de Furstenberg, which is open to the public and wonderfully evocative of the period. Bazille and Monet shared a studio in the same street which looked out over Delacroix's much grander ground-floor atelier, but, like the studios at 20 rue Visconti and 9 rue de la Condamine, it no longer exists. Berthe Morisot's house in Passy has gone, as has Durand-Ruel's gallery, and we are no longer sure of the exact site of Charles Gleyre's atelier, where Monet, Bazille, Sisley and Renoir all chose to work, though we know it was in the same quarter as the École des Beaux-Arts. Some streets have been renamed – the rue

de Laval is now rue Victor-Massé – and others renumbered since the time of the Impressionists, but a plaque commemorates Manet's birthplace at 5 rue Bonaparte. The Folies Bergère still stands on the rue Richer, though the Nouvelle-Athènes is no more and the Café Guerbois, where the painters met in the evenings to energetically debate the artistic questions of the day, is now a shoe shop. One of Sisley's brief addresses in Paris – 27 Cité des Fleurs, off the Avenue de Clichy – a run-down four-storey house with a palm tree in the front garden, still stands though, again, in private hands. Montmartre offers the most rewards, though many of these are merely glimpses, through, say, the impressive iron gates of the lovely Villa des Arts on the intersection of the cobbled rues Pierre-Ginier and Hégisippe-Moreau, where Signac had a studio for a period, as did Cézanne – it was here that Ambroise Vollard posed 114 times for Cezanne's portrait of him – or over the wall of Renoir's house at 6 rue Girardon, which is now in private hands. More tangibly, the site of Renoir's old Montmartre studio at 12 rue Cortot has been turned into a museum of old Montmartre and is worth a visit.

Monet and Renoir spent the summer of 1869 painting in and around Chatou, St Michel and Croissy, site of the long-gone fashionable floating restaurant La Grenouillère. The central island has been renamed the Ile des Impressionistes and the Restaurant Fournaise on the Ile de Chatou, which provided the platform for Renoir's *Luncheon of the Boating Party* (1880), has been preserved as both a restaurant and a museum.

The suburbs to the west of Paris provided homes and sites for the Impressionists. Sisley is closely associated with Marly-le-Roi and Pissarro with Louveciennes, Monet painted his first major *plein-air* picture in Ville-d'Avray, but spent more time at Argenteuil, renting two houses from 1871, the first, the Maison Aubry, at the angle of the boulevard St-Denis and the rue Pierre Guienne, rented from a relative of Manet's and no longer remaining, the second, a creamy Dutch-

style house on the boulevard St-Denis still exists (though the street has been renamed the boulevard Karl Marx and modern concrete blocks stand in place of the flower-filled suburban gardens Monet painted). This is also Caillebotte country though his grand residence on the banks of the Seine at Petit Gennevilliers was demolished to make way for a large industrial complex and no trace remains at Gennevilliers of the Manet family property, which has long since been swallowed up in urban development.

Less spoiled are the towns of Pontoise and Auvers-sur-Oise, which were important locations for Pissarro, Cézanne, Gauguin and Van Gogh. Pissarro lived in Pontoise from 1872, attracting Cézanne to the area, though their houses have since been demolished, and Auvers is famous now as the final resting place of Vincent van Gogh, who committed suicide there and is buried in the cemetery. His brother Theo (buried beside him) put him in the care of Dr Paul Gachet, whose house at number 78 on the street now named after him still stands, as does the Auberge Ravoux on the Place de la Mairie, now named the Maison de van Gogh and open to the public. The museum dedicated to Pissarro at 17 rue du Château in Pontoise is also worth a visit and the Musée Daubigny at Auvers includes work by Armand Guillaumin.

Monet's three-year sojourn in Vétheuil is commemorated by a plaque on the (inaccessible) house at number 16 Avenue Claude Monet that he shared with his wife, Camille, and the Hoschedé family for three years from 1878, but the real jewel in any Impressionist pilgrimage is to be found at Giverny, where Monet's home for the last forty-three years of his life has been painstakingly restored to provide surely the most rewarding site for visitors, who can walk around the gardens, stand on the famous green Japanese bridge, and visit the house and its studios. The elegant and serene American Art Museum in the rue Claude Monet, which celebrates the work of the colony of pioneer American Impressionist painters, is also worth a visit,

as is the Hôtel Baudy, where the young American artists stayed when they first arrived in Giverny.

The limpid light and warm weather of the South drew Monet, Renoir, Morisot, Signac and Bonnard to Provence and the Mediterranean coast and reclaimed Cézanne, a native of Aix-en-Provence, who returned to the family home of Jas de Bouffan after an unhappy time in Paris. He sold the house in 1899 and built himself a studio on the road leading to Les Lauves (now named the Avenue Paul Cézanne) which is still preserved and open to the public. There you can find an exact list of Cézanne's painting haunts and the paths he took in and around Aix to reach them. Les Collettes, the house Renoir had built for himself and his family in the midst of olive and orange trees at Cagnes-sur-Mer, now houses the Musée Renoir and, along with the gardens, is open to the public, though the glass studio that Renoir had built in the middle of an olive field no longer exists.

Finally, although they did not paint interiors, it is possible to visit the prominent German Impressionist Max Liebermann's house at Wannsee, and J. Alden Weir's 153-acre farmhouse home in Connecticut, where, for thirty-seven years, he and visiting American Impressionist friends, like Childe Hassam and John Twachtman, indulged their love of landscape painting. His legacy is continued by the artist-in-residence programme offered to professional artists by the Weir Farm Trust.

CONTACT DETAILS (FRANCE)

Aix-en-Provence

Cézanne's Studio, Les Lauves
9, Avenue Paul Cézanne
13090 Aix-en-Provence
tel.: 00 33 4 42 21 06 53
fax: 00 33 4 42 21 90 34
email: infos@atelier-cezanne.com
www.atelier-cezanne.com

Auvers-sur-Oise

Musée Daubigny
Sem Château d'Auvers
rue de Lery
95430 Auvers-sur-Oise
tel.: 00 33 1 34 48 48 40
fax: 00 33 1 34 48 48 51
www.chateau-auvers.fr

La Maison de van Gogh (Auberge Ravoux)
Place de la Mairie (entrance rue de la Sansonne)
95430 Auvers-sur-Oise
tel.: 00 33 1 34 48 05 47
email: info@vangoghfrance.com
tel.: 00 33 1 30 36 60 60
fax: 00 33 1 30 36 60 61

Barbizon

Musée Municipal de l'École de Barbizon
92, Grande rue
77630 Barbizon
tel.: 00 33 1 60 66 22 27
fax.: 00 33 1 60 66 22 96
www.barbizon-france.com/Pages/Barbizon/villag/muse.html

Cagnes-sur-Mer

Renoir's House (today the Musée Renoir), Les Collettes
Chemin des Collettes
06800 Cagnes-sur-Mer
tel.: 00 33 4 93 20 61 07 *or*
00 33 4 93 20 87 29
www.cagnes-tourisme.com

Chatou

Musée Fournaise, Ile de Chatou
Ile des Impressionnistes
78400 Chatou
tel.: 00 33 1 34 80 63 22
www.musee-fournaise.com

Giverny

Monet's House
Fondation Claude Monet
84, rue Claude Monet
27620 Giverny
tel.: 00 33 2 32 51 28 21
fax: 00 33 2 32 51 54 18
email: contact@fondation-monet.com
www.fondation-monet.com

Hôtel Baudy
(today a restaurant, though it is possible to visit the studio)
1, rue Claude Monet
27620 Giverny
tel.: 00 33 2 32 21 10 03
www.giverny.org/gardens/baudy

Musée d'Art Américain (American Art Museum, Terra Foundation for the Arts), Giverny
99, rue Claude Monet
27620 Giverny
(about 100 yards from Claude Monet's home and garden)
tel.: 00 33 2 32 51 94 65
fax: 00 33 2 32 51 94 67
email: contact@maag.org
www.maag.org

Paris

The Museum of Old Montmartre
12, rue Cortot
Paris
tel.: 00 33 1 46 06 61 11

Musée national Eugène Delacroix
6, rue de Furstenberg
75006 Paris
tel.: 00 33 1 43 54 04 87
fax: 00 33 1 43 54 36 70
www.paris.org/Musees/Delacroix

Pontoise

Musée Camille Pissarro
17, rue du Château
95300 Pontoise
tel.: 00 33 1 30 38 02 40
fax: 00 33 1 34 43 34 05

CONTACT DETAILS (OUTSIDE FRANCE)

Berlin

Max Liebermann's House at Wannsee
Am Großen Wannsee 42
(entrance: Colomier Str. 3)
14109 Berlin
Germany
liebermann.im-netz.de/index.html

Ostend

James Ensor's House
Vlaanderenstraat 27
8400 Ostend
Belgium
tel.: 00 32 59 80 53 35
fax: 00 32 59 80 28 91

Wilton

J. Alden Weir's Home
Burlingham House Visitor Center
735 Nod Hill Road, Wilton, CT 06897
United States
tel.: 00 1 203 834-1896
www.nps.gov/wefa

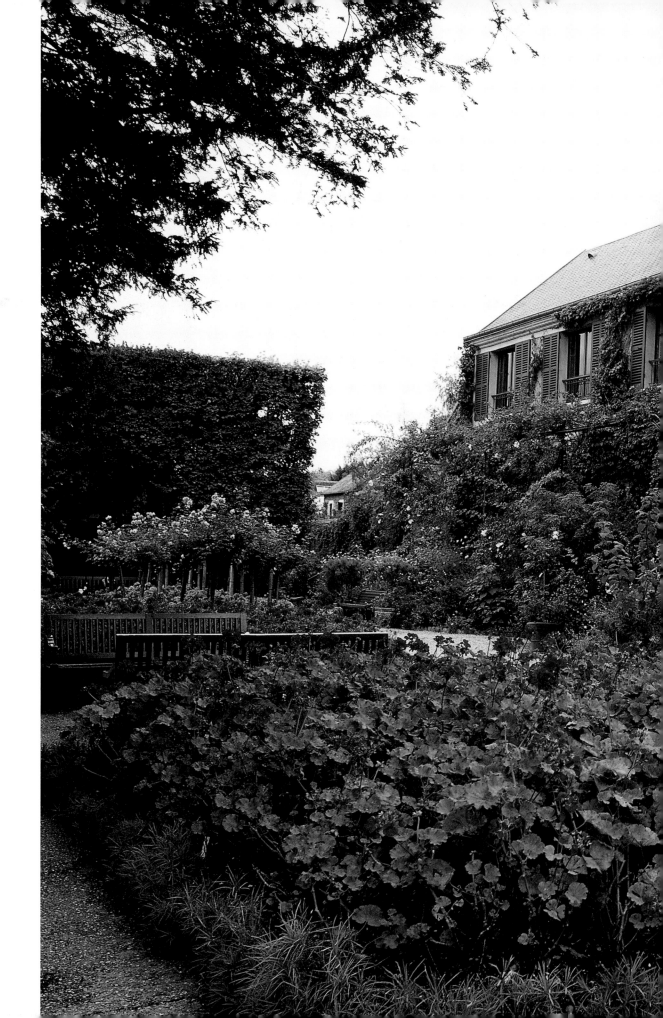

Monet's house and garden at Giverny

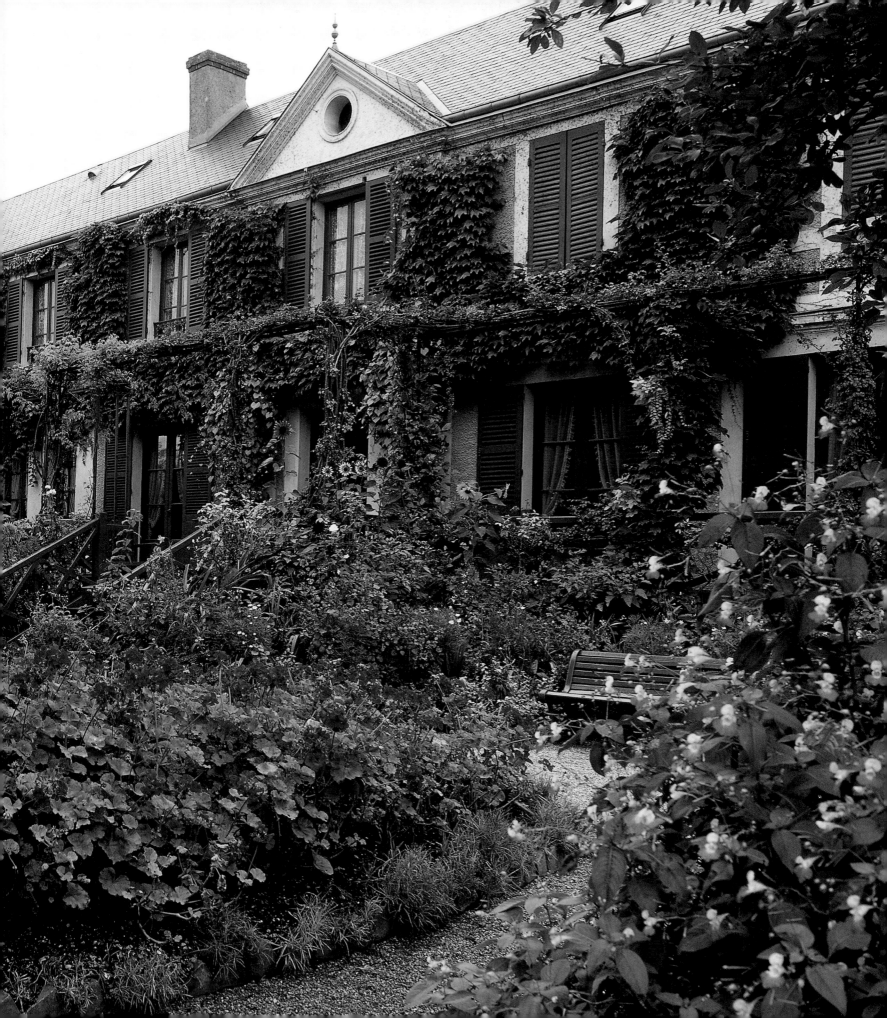

FURTHER READING

Adams, S., *The World of the Impressionists*, London and New York, 1989

Adler, K., *Camille Pissarro, a biography*, London, 1978

Adler, K., and T. Garb, *Berthe Morisot*, London, 1987

Allbutt, Dr H. A., *The Wife's Handbook: How a Woman Should Order Herself During Pregnancy, in the Lying-In Room, and After Delivery with Hints on the Management of the Baby and Other Matters of Importance Necessary to be Known by Married Women*, London, 1886

Aries, P., *Centuries of Childhood* (trans. R. Baldick), London and New York, 1962

Barter, J. A., *Mary Cassatt: Modern Woman*, exh. cat., The Art Institute of Chicago, 1998

Bashkirtseff, M., *Journal* [1891] (trans. M. Blind), London, 1985

Beecher, C. E., and H. Beecher Stowe, *The American Woman's Home* [1869] (ed. and intro. N. Tonkovich), Rutgers University Press, 2002

Beeton, I. M., *Mrs Beeton's Book of Household Management, a guide to cookery in all branches: daily duties, menu planning, mistress and servant, home doctor, hostess and guest, sick nursing marketing, the nursery, trussing and carving, home lawyer*, Ward Lock, 1890

Benjamin, W., *Reflections: Essays, Aphorisms, Autobiographical Writings* (ed. P. Demetz), New York, 1986

Blanche, J.-E., *Manet*, Paris, 1924

——, 'Les Dames de la Grande-rue, Berth Morisot', *Ecrits Nouveaux*, Paris, 1920

Bonnard at Le Bosquet, exh. cat., Hayward Gallery, The South Bank Centre, London, 1994

Bourdon, M., *Aux jeunes personnes. Politesse et savoir-vivre*, Paris, 1864

Branca, P., *Women in Europe Since 1750*, London, 1978

Brettell, R., *Pissarro and Pontoise*, New Haven, 1990

Broude, N., *Gustave Caillebotte and the Fashioning of Identity in Impressionist Paris*, Rutgers University Press, 2002

Cachin, F., et al., *Cezanne*, exh. cat., Philadelphia Museum of Art, 1996

Clark, T. J., *The Painting of Modern Life, Paris in the Art of Manet and his Followers*, London and New York, 1985

Clayson, H., *Painted Love: Prostitution in French Art of the Impressionist Era*, New Haven, 1991

Cogniat, R., *Sisley*, London, 1978

Couldrey, V., *Alfred Sisley: The English Impressionist*, Newton Abbot, 1992

Dawes, F., *Not in Front of the Servants, Domestic service in England 1850–1939*, London, 1973

De Veer, E., and R. J. Boyle, *Sunlight and Shadow, The Life and Art of Willard L. Metcalf*, New York, 1987

Distel, A., *Renoir, A Sensuous Vision*, London and New York, 1995

Dorment, R., and M. F. Macdonald, *James McNeill Whistler*, London, 1994

Dumas, A., et al., *The Private Collection of Edgar Degas*, exh. cat., Metropolitan Museum of Art, New York, 1997

Duret, T., *Manet and the French Impressionists* (trans. J. E. Crawford Flitch), London, 1910

Eastlake, Sir C. L., *Hints on Household Taste*, London, 1868

Filbee, M., *A Woman's Place: An illustrated history of women at home from the Roman villa to the Victorian town house*, London, 1980

Fosca, F., *Renoir, his Life and Work*, London and New York, 1961

Frascina, F., and C. Harrison (eds), *Modernity & Modernism: French Painting in the Nineteenth Century*, New Haven, London, 1993

Gerdts, W. H., et al., *Lasting Impressions: American Painters in France, 1865–1915*, exh. cat., Giverny, Musée American, 1992

Goncourt, E. and J. de, *Pages from the Goncourt Journal* (ed., trans. and introd. R. Baldick), Oxford, 1978

Guerin, M., *Degas Letters* (ed. and trans. M. Kay), Oxford, 1947

Halévy, D., *My Friend Degas* (trans. and ed. with notes by M. Curtiss), London, 1966

Hardyment, C., *From Mangle to Microwave: The Mechanization of Household Work*, Cambridge, 1988

Havemeyer, L., W., *Sixteen to Sixty: Memoirs of a Collector* (ed. S. A. Stein, intro. G. Tinterow), Ursus Press, 1993

Haweis, M. E. J., *The Art of Housekeeping*, London, 1889

Herbert, R. L., *Impressionism: Art, Leisure and Parisian Society*, New Haven, 1988

Hiesinger, U., W., *Impressionism in America, The Ten American Painters*, New York, 1991

Higonnet, A., *Berthe Morisot, a Biography*, London, 1990

Holmes, C., *Monet at Giverny*, London, 2001

Howard, M., *The Impressionists by Themselves*, London, 1998

Hyman, T., *Bonnard*, London and New York, 1998

Jacobs, M., *The Good and Simple Life: Artist Colonies in Europe and America*, London, 1985

Kendall, R., *Degas by Himself*, London, 1987

——, *Degas, Beyond Impressionism*, exh. cat., National Gallery, London, Art Institute of Chicago, 1996

Lipton, E., *Looking into Degas, Uneasy Images of Women and Modern Life*, Berkeley, 1986

Lloyd, C., *Pissarro*, London, 1979

Manet, J. [Rouart], *Growing Up with the Impressionists: The Diary of Julie Manet*, (trans., ed. and introd. R. de Boland Roberts and J. Roberts), London, 1987

Mathews, N. M., *Cassatt and her Circle: Selected Letters*, New York, 1984

Mauner, G., *Manet: The Still-Life Paintings*, New York, 2000

McMillan, J. F., *France and Women, 1789–1914, gender, society and politics*, London, 2000

Milner, J., *The Studios of Paris, The Capital of Art in the Late Nineteenth Century*, New Haven, 1988

Natanson, T., *Monograph Le Bonnard que je propose*, Geneva, 1951

Perruchot, H., *Manet* (trans. H. Hare), London, 1962

Pollock, G., 'Modernity and the Spaces of Femininity' in *Vision and Difference*, London, 1988

Radcliffe, W., *Milestones in Midwifery*, Bristol, 1967

Reff, T., *Degas, The Artist's Mind*, London and New York, 1976

——, *The Notebooks of Edgar Degas*, Oxford, 1976

Renoir, J., *Renoir, My Father*, London, 1958

Rewald, J., *Camille Pissarro, Letters to his son Lucien* (trans. by L. Abel), New York, 1944

——, *Seurat: A Biography*, New York, 1990

——, *History of Impressionism*, New York, 1973

Rothenstein, W., *Men and Memories*, London, 1931

Rouart, D., *Claude Monet*, Lausanne, 1958

——, *The Correspondence of Berthe Morisot* (trans. B. W. Hubbard, intro. and ed. K. Adler and T. Garb), London, 1986

Scharf, A., *Art and Photography*, London, 1968

Schivelbusch, W., *Disenchanted Night: The industrialisation of Light in the 19th Century*, Oxford, 1988

Shikes, R. E., and P. Harper, *Pissarro his Life and Work*, London, 1980

Shone, R., *Sisley*, London, 1979

Smith, B. G., *Ladies of the Leisure Class, The Bourgeoises of Northern France in the Nineteenth Century*, Princeton, 1981

Spate, V., *The Colour of Time: Claude Monet*, London and New York, 1992

Stevens, M., with R. Hoozee, *Impressionism to Symbolism: The Belgian Avant-Garde 1880–1900*, exh. cat., Royal Academy of Arts, London, 1994

Stuckey, C. F. and W. P. Scott, *Berthe Morisot: Impressionist*, London, 1987

Tucker, P. H., *Monet at Argenteuil*, New Haven, 1982

Vaillant, A., *Bonnard, with a dialogue between Jean Cassou and Raymond Cogniat* (trans. by D. Britt), London and New York, 1966

Valery, P., *Oeuvres*, Paris, 1960

Vollard, A., *Degas, An Intimate Portrait* (trans. by R. T. Weaver), London, 1928

——, *Renoir: An Intimate Record* (trans by H. L. Van Doren and R. T. Weaver), New York, 1925

Warren, E., *How I Managed my House on Two Hundred Pounds*, London, 1865

Weber, E., *France, Fin de Siècle*, Boston, 1986

Weinberg, H. B., D. Bolger and D. P. Curry, *American Impressionism and Realism - The Painting of Modern Life, 1885–1915*, exh. cat., Metropolitan Museum of Art, New York, 1994

Weitzenhoffer, F., *The Havemeyers: Impressionism Comes to America*, New York, 1986

Wright, L., *Clean and Decent, The Fascinating History of the Bathroom & the Water Closet in Great Britain, France & America*, London, 1960

Zeldin, T., *France 1848–1945*, Oxford, 1977

Zola, E., *Nana*, Paris, 1880

——, *L'Oeuvre*, Paris, 188-

LIST OF ILLUSTRATIONS

Dimensions of works are given in centimetres then inches, height before width.